A Life In Museums
Managing Your Museum Career

Edited by Greg Stevens and Wendy Luke

 The AAM Press

Published by The AAM Press of the American Alliance of Museums, 1575 Eye St. NW, Suite 400, Washington, DC 20005. www.aam-us.org

John Strand, Publisher.
Design: Susan v. Levine, Creative Director, AAM.

Third printing, October 2013.

ISBN 978-1-933253-70-1

A life in museums: managing your museum career / edited by Greg Stevens and Wendy Luke.
 p. cm.
 ISBN 978-1-933253-70-1
1. Museums--Vocational guidance. 2. Museums--Employees. I. Stevens, Greg. II. Luke, Wendy. III. Title.
 AM7.L49 2012
 069.023--dc23
 2012007686

Caminante, no hay camino;
se hace camino al andar.

Wanderer, there is no road;
the road is made by walking.

—**Antonio Machado,** Spanish poet (1875-1939)
from "Proverbios y cantares" in *Campos de Castilla,* 1912

Contents

PART 2: ON THE JOB

PART 3: MANAGING AND LEADING

PART 4: CAREER CHANGES

For Steve, who cared deeply.

For Michael, who endures and embraces.

About This Book

THE GENESIS OF THIS BOOK CAME FROM the success and popularity of the AAM Career Café at the annual meeting over the last four years. In 2007, based in part on survey results from AAM membership and our Emerging Museum Professionals (EMPs), we recognized the conference was missing a significant opportunity and obligation to help colleagues with career-related challenges. Thus we launched AAM Career Café at the 2008 Annual Meeting in Denver with nearly 50 sessions, workshops, mentoring roundtables and other activities. Topics included (and still include) resumé writing, personal branding, public speaking, and more. The program grew over the next three years to include "organizational skills labs" designed to help colleagues with challenges related to managing people and projects and communicating with staff, teams and bosses, to name a few topics. Throughout its growth, AAM Career Café maintained the distinction of being among the top-rated and best-attended set of activities at the annual meeting.

After the 2011 annual meeting, based on AAM member surveys that told us our colleagues want help from AAM in doing their jobs and managing their careers, we decided to more purposefully and holistically integrate the former AAM Career Café activities with the fabric of the annual meeting. Importantly, we have more clearly defined career, management and leadership development topics that help emerging, mid-career and senior-level museum professionals manage their work and their careers. Same great effort, new format. In addition, we decided to broaden the reach of the former AAM Career Café program by launching regional career-related events and publishing this book. We will continue to evolve these efforts in response to the needs of our members and the field.

We regularly get calls and emails from colleagues who are at various stages in their careers, in search of career advice. We get stopped in the hallways at the AAM annual meeting. We meet regularly with museum graduate students, many of whom are anxious about finding a job. And while there is a lot of great information scattered across the Internet and in some books, we've attempted to pull together here information and practical guidance for the museum field, building on our own experience and that of many fine colleagues in the field.

The book is organized in four sections: Getting Started, On the Job, Managing and Leading, and Career Changes. The book contains chapters focused on specific topics, punctuated by segments called "Practically Speaking," "Practicum," or "Career Path," each consisting of additional information, a practical exercise, alternative or supporting perspective on the topic, or career stories from colleagues like you. Some pieces have been written especially for this book; some have been adapted from AAM webinars or magazine articles and sessions at AAM Career Café at the annual meeting.

This book is a reference tool. For example, if you are focusing on your personal brand, you might want to read only that chapter. Or you may want to read the entire Getting Started section. You can read the book in any order that will be most valuable to you.

Emerging professionals or seasoned colleagues who have been in one job or with one museum for a long time may benefit from this book; sometimes people need refreshers and energizers to jumpstart a job search or navigate within an institution. Your resumé might be sorely out of date. You might not know the value of a great cover letter. You might wonder about becoming a consultant. You might have challenges communicating with your boss or preparing for your performance review. You may need reminders about the value and techniques of networking. There is wisdom in this book for all these situations. We hope you use this book any time you need to think about managing your career.

XI

Acknowledgments

First and foremost, we would like to extend our gratitude to the many fine colleagues who contributed to this book, sharing their insight, wisdom, expertise and experience. We are so glad to have your voices represented on these pages. Special thanks goes to our editorial readers for helping us see the "forest *and* the trees": Dixie Clough, Amy Duke, Stephanie Fitzwater, Kim Fortney, Julie Hart, Phyllis Hecht, Julie Johnson, Sharon Klotz, Elizabeth Kryder-Reid, Sarah Parsons and Mark Rosen who provided invaluable perspective and commentary on the various iterations of the manuscript. Our appreciation goes to our editor John Strand for proposing the idea and guiding the project, to Susan v. Levine for the beautiful design, and to the many colleagues who have attended various AAM Career Café sessions, workshops and activities at the annual meeting over the past four years; your input has greatly informed the contents of this book.

Wendy would like to thank Greg for his creativity, vision, energy, invocation, and friendship. He has gathered, nudged, cajoled, and inspired colleagues, including

me, to contribute to this book and to participate in webinars, seminars and sessions at the AAM Career Café over the past handful of years. If you want to have a fun, stimulating and intense experience, consider collaborating, writing, and editing a book with Greg.

Greg would like to thank Wendy for her endless good cheer, passion, and depth of knowledge over many long months, late hours and multiple rewrites of the manuscript. That we emerged intact and still laughing is testament to the power of our relationship. Thank you for growing as my colleague, my mentor and my trusted friend these many years.

Lastly, thank you to our readers for being part of the community of practice we call the museum field. We're proud to have you onboard.

Wendy Luke, The HR Sage
Greg Stevens, assistant director, professional development, AAM

PART ONE: GETTING STARTED

Soon I am walking across the Atlantic
thinking about Spain
checking for whales, waterspouts.

—**Billy Collins**, former Poet Laureate of the United States
from "Walking Across the Atlantic" in *Sailing Across the Room* (2002)

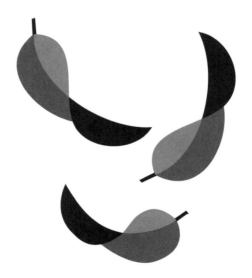

Chapter 1: Why Museum Work?

Wendy Luke, *The HR Sage*
Greg Stevens, *assistant director, professional development, AAM*

"WHY MUSEUM WORK?" IT'S A QUESTION that many of us have asked ourselves as we've made choices to enter the field. It may be a question we revisit at times throughout our careers as we ponder a career move or reflect on a career lifetime upon retirement. It's a question we frequently ask of participants when we facilitate professional development workshops and sessions, either in career activities at the AAM annual meeting, at university programs across the country, or at regional conferences. The varied stories our colleagues share with us and with each other in response to this deceptively simple question usually have to do with a love of and respect for art, history, objects, ideas, science, kids, nature, animals, education, or a combination of the above. We've never had anyone tell us they came to museums for the money.

And so, we ask it of you here and now: why have you chosen to work in museums?

Manage Your Career

All careers are made up of roads taken and not taken. Often we don't know where the roads will lead us, but the choices we make in our careers have a powerful influence on the path(s) we take to get to the destination—if there is, in fact, a "destination." Managing your museum career means asking and answering questions, weighing options, and assessing implications or risks at every decision point. Should you stay in a current job? Should you take a new position that might not have the same security but can broaden your knowledge and experience? Should you focus on one specialty or another? Should you go back to school? What if?

Managing your museum career also means overcoming roadblocks. What do you do when life throws you a "career curve ball"? What should you do if your boss is an ogre? What do you do when technology is radically changing your job and your opportunities? What happens if you get laid off or get terminated? Roadblocks come in many forms—changes in funding, boards, or management; shifting organizational priorities; not learning about the job of your dreams in time to apply; not getting your resumé in front of the right people. Anticipating these roadblocks, and putting

plans in place to avoid or overcome them, can help guide you along your career path.

When jobs are abundant and the pool of qualified employees is less, we have encouraged people to seek out a dream job. When the employment market is extremely tight, as it has been the last few years, our advice is pragmatic: try to make the job you have a fulfilling one. Think about how you can enhance your job, how you can have more fun in your work, and how you can build on your knowledge and skills. You might even have to take a lower level job than you want, prove yourself, become a star employee, and then move up. Granted, it is scary even to think about managing your museum career. From our experience, though, it is even scarier when you abdicate control and leave management of your career to others.

Checking Coats

Let's face it. Some museum jobs—especially entry-level and volunteer jobs, or jobs you've been in for a number of years—can be boring. There's no other word for it. You're an aspiring museum professional, a college graduate, and you're checking coats. You're an emerging professional and just finishing your third year at a museum and you're stuffing envelopes with fundraising appeals. You're collecting tickets. It's hard to show up day after day to a job like this, much less seem interested. Or you're a mid-career professional doing the same job in the same institution for ten years and you're looking for a new challenge (and advancement). Unfortunately, if you don't excel in this boring job, you are likely to get stuck in a boring job permanently. Or maybe you won't even have a job.

Time and time again, we have seen interesting avenues open up for aspiring, emerging and mid-career museum professionals because they stand out in unique ways. They create or find ways to consistently demonstrate value and distinctiveness in their work, having an impact on the institution. They take every assignment and make the most of it. They bring a positive attitude and point of view to everything they do.

How do you excel at checking coats (or any job)?

It's simple: you do what is expected, and more. You check coats with a smile on your face, in your voice. You make visitors feel really welcome. You ask people what brought them to the museum today, and you make a chart of their answers. You correlate them with outreach initiatives, like an interview with a curator on a local radio show or a newspaper review of a new exhibit. And you provide your boss with a daily report.

Excellent employees ask questions for clarification. They make suggestions. They are consistently dependable and reliable. They find creative ways to make things happen. You worked hard to finish a report and expected kudos from your boss. Instead, you're told that what you delivered didn't even come close to what was needed. Perhaps you never verified your assumptions with your boss; you didn't provide her with interim updates, and you didn't have a clue you went down the wrong path. A few well-placed questions might have brought some kudos your way. Perhaps there are communication challenges present seemingly beyond your control. How can you "manage up" to make the situation better for everyone, and do it in a low-maintenance way?

Exceptional employees collaborate

rather than compete. They enlist other coat checkers in the survey project and present the work as a joint report. They work effectively in cross-departmental teams, building trust, engaging in healthy conflict when it arises, holding each other accountable for results. They volunteer to help others. They treat everyone with respect.

Great employees don't stop working at 5:00 pm, although overworking isn't necessarily a sign of a great employee. What matters is that the passion you bring to your job manifests itself in the way you do your work, that you keep your eye on delivering the best (of whatever your job entails), and that your work helps the institution shine. Great employees are ambassadors for their institution. They talk about their museums with animation and interest. When you are at an evening event at the AAM annual meeting, you don't talk about checking coats and being bored; you talk about the museum's exciting new acquisition; or you talk about the successful new Saturday workshop for pre-schoolers. You are an ambassador. And you love it. If you choose to be a great employee (and the choice is yours), you are likely to get more interesting work. You'll find opportunities to expand your knowledge, skills, and experience. And don't overlook the personal fulfillment that comes with success. There are many examples of interns who, although they did not like an assignment, did great work. As a result, they were offered another internship, a contract position, or full-time job they really wanted.

Reality Check

Being a great employee is especially important in today's weak economy. Many museums have been forced to eliminate full- and part-time positions, especially mid-level and mid-career. Advancement is slower because Baby Boomers are not retiring from their upper-level museum positions as planned; instead they are working into their late 60s and beyond. Behind them, Gen Xers are not getting the advancement opportunities they anticipated—and simultaneously, they find themselves competing for jobs with out-of-work contemporaries who have decided to switch careers and pursue museum work.

This crush of applicants for mid-career positions complicates career advancement even further for the exceptionally large Millennial generation, many of whom are graduating from an ever-growing number of museum studies programs. The truth is this situation isn't likely to improve any time soon. In fact, it's the norm. The result, in supply and demand terms, is that there are many more candidates than there are jobs. While once upon a time you could hold out for your dream job, now you should take a job and make it as close to your "dream" as you possibly can.

As you read this book, you will be aware that compensation in the museum field, especially for entry-level through mid-career positions, is low. Over the past few years, salaries have frequently been frozen, and increases, when given, have been small. A number of people in the field partly solve compensation challenges through their housing decisions or decisions to work in low cost-of-living locations. Because of the low salaries, many entry-level and mid-career professionals are able to make it only with the financial assistance of a part-time job, a husband, a wife, a partner, parents, a trust fund, student loans—or a combination of the above.

Against that sobering backdrop, you

must be both strategic and pragmatic in managing your career. Whether you are an aspiring, emerging or mid-career museum professional, there are skills you can build and techniques you can use to strengthen your standing as an employee, a prospective employee, a mentor, and a trusted colleague in the field. You can help yourself and others by focusing on self-awareness, making smart choices, being able and willing, having a "can do/will do" spirit, and keeping an eye out for opportunities to pay it forward and pay it back as you travel through your career. Constantly honing your skills and knowledge will help you identify options and give you a sense of control. Our observations are that people who are willing and able to self-reflect and take action have richer lives with many more options. Having more options is a wonderful thing. Our goal is to help you on this path of discovery.

Career Path: Making My Way to Museum Work

Greg Stevens

"Why museums?" That's what my mom asked me when I announced to her over a decade ago that I was considering leaving my rewarding but not terribly lucrative job at a performing arts elementary school, practically a lifetime of theatre design work balanced with waiter/bartender/catering jobs, and my San Diego friends and family to move to Washington, D.C., for graduate school in museum education.

The answer to my mom's straight-from-the-hip question about my decision to uproot my life and pursue museum work, despite a hefty student loan and not-so-great compensation prospects, is slightly complicated, but here goes:

- As an artist-in-residence at Kellogg School, I had discovered my skill as an arts educator, but I didn't want to be a classroom teacher.
- After having dropped out of college at 20 (because I knew everything already!), I had recently returned to finish my undergrad work in theatre design and was soon going to be graduating (the 20-year plan) with a piece of paper I was fairly convinced I would never need or use.
- I've always been a creative person, so museums seemed like a good place for me (as a kid, "creative" usually involved transforming refrigerator boxes and Christmas lights into spacecraft, haunted houses, or drive-up mud-pie stands).
- A colleague convinced me that I'd be perfect as a museum educator and that the Museum Education Program (MEP) at The George Washington University (GWU) in D.C. was the perfect fit (it was).
- At 39, I was ready for a major change in my life. It was now or never. Plus, I didn't want to be in my mid-40s and still in school!
- I *knew* that museum work was the right work for me.

My mom's response to all of this rationale was as simple as her original question: "Well, honey, as long as you love what you do." I do, Mom.

"What Are You Doing?"

In October 1999, I applied to GWU MEP, was accepted in the winter, and graduated from San Diego State University in May 2000. Two weeks later, I packed up all my worldly possessions in a 15-foot Ryder™ truck and drove solo cross-country, armed with a carton of cigarettes and a stack of CDs. My chest ached with anxiety, my mind raced with seemingly unanswerable questions, the largest being something like, "What are you doing?"

I don't think I really knew exactly what I was doing, except I sensed it was right— as right as anything can be when it's so life-changing and 3,000 miles from home. I barely knew a soul in D.C. and had never lived anywhere else as an adult but San Diego. At that time I didn't know much about museum work aside from a vague and, alas, ultimately unfulfilled notion that I would probably land a job in an art museum because of my arts education background and theatre design degree.

I wasn't alone in my unknowing-ness. My San Diego friends looked at me perplexed when I told them I was going to be a *museum* educator ("What will you do, educate museums?"). It was another year before I landed my first museum internship-then-job at the Smithsonian National Air and Space Museum (NASM) and my hometown friends realized the "Smithsonian" is actually more than one museum. My job at NASM only encour-aged my mom, bragging to her friends that "Gregory Scott is working at the Smithsonian." My history-buff mom was equally proud of me when I earned my MAT in museum education, partly because

she got to see me graduate in May 2001 on The Ellipse south of the White House ("the White House"), which for her was about as close to perfect as you can get.

To be honest, the first years of my museum career were a bumpy ride of personal and professional highs and lows, marked by a variety of museum education jobs and contract positions, student loan debt, a lay-off, endless money woes—all contributing to growing self-doubt that perhaps I had made the wrong decision.

As it turns out, I did not make the wrong decision.

Although it was an emotionally challeng-ing few years, it was also an amazing time of perseverance, self-discovery, humor, and, well, growing up—this last point not always an easy thing for a man in his 40s to come to terms with. Even now, every day, I learn something new about myself, the people I work with, the field I've chosen for my career, and the remarkable world in which we live.

I'm a museum educator at heart, although I no longer work in museums. As assistant director for professional devel-opment at AAM, the nature of my work offers me the opportunity to learn about and learn from museums and museum professionals in ways that I would never have imagined. I consider myself lucky to be able to develop opportunities (like co-editing and contributing to this book) that help museum professionals in their careers so they can foster excellence in their museums, build a stronger community of practice, and contribute to a field that speaks with one voice about why museums matter. I believe in paying it forward and paying it back.

Chapter 2: Types of Jobs in Museums

N. Elizabeth Schlatter, deputy director and curator of exhibitions, University of Richmond Museums

WHEN I WORKED FOR THE SMITHSONIAN Institution, I joked with my coworkers, "If I'm not in your department now, just wait. I will be soon." During my five years of service I worked in three different departments (exhibition scheduling, public relations, and exhibition development) and was considering a fourth (registrar) until a job I realized that I truly wanted (curatorial) opened up at a liberal arts university in Richmond, Virginia. I should confess that prior to the Smithsonian, I gained experience as a fundraiser at a contemporary art museum in Houston.

This type of career zigzagging within the museum profession is common for four reasons: (a) museum jobs are extremely competitive and applicants take what they can find, often in the city they can find it; (b) some applicants, especially those just beginning their careers, don't know what role they will like and excel in until they try various ones; (c) no two museums have the same organizational structure; a curator in one museum may also wear the hat of exhibit designer and educator in another; and (d) increasingly, many museums have downsized budget and staff,

so that employees are assuming jobs that may have once resided in another department altogether. While this can be frustrating, the changing museum landscape and the experience and knowledge gained at each kind of position have the potential to form a wise and well-connected museum professional.

To keep things simple, I'll describe some jobs that perform six common functions at museums:

- working with and caring for collections, objects and exhibitions
- education, interpretation, programming, and evaluation
- marketing and communications
- visitor services and visitor experience
- fundraising and development
- administration and operations

Since there is no one standard organizational chart for museums, the size, budget, discipline (e.g. science, history, or art), institutional affiliations, community, and visitorship of each museum determine whether some of these jobs and functions are conflated, if they are re-assigned to other positions, or if they become even

more specialized. Also, jobs that I have described in one function may overlap with other function categories, depending on the same factors mentioned above. And of course, every department or function works in concert with others during phases of a project so that multiple departments touch every program and product of the museum.

Working With and Caring For Collections, Objects, and Exhibitions

In the past, this category was sometimes labeled "curatorial" after the curators who study the history, context, and unique qualities of a museum's subject specialty in order to improve and increase the museum's collection, to organize exhibitions, and to publish research. But often (and frequently in smaller museums) this robust group also includes registrars and collections managers who care for the safety and long-term viability of physical objects (e.g. art, artifacts, or species) in storage, in exhibitions, and when transported to other museums. Conservators utilize scholarship in material science and history to repair or restore objects in a collection, usually focusing on specific types of objects such as paintings, textiles, furniture, or even taxidermied animals.

Larger museums have exhibition departments that may feature managers, developers, designers, and fabricators who conceive exhibitions, collaborate with others to interpret objects and scholarship, and create the many components of exhibitions, from simple items such as cases and text panels to displays that rival stage sets, to complex computer interactive stations. Many museums have a preparator or fabrication manager who is the person responsible for

installing and de-installing exhibitions (e.g. painting walls, hanging artworks, cradling dinosaur bones, or mounting antique flags), as well as moving objects within storage or preparing them for shipment by packing them and building crates. Some museums also employ archivists, librarians, and intellectual property rights managers.

Education, Interpretation, Programming, and Evaluation

The role of education and interpretation may vary by institution, but the basic mission is the same: to create meaningful cognitive, affective, or social experiences with and for audiences, based on applied knowledge of educational theory and practice, knowledge of visitor needs and trends, and the mission, collections, scholarship, and themes of the museum.

At some museums the educators drive the exhibition program, considered a facet of the museum's public dimension, by selecting topics, interpreting objects and concepts, and writing exhibition text panels and labels while consulting on design issues. In large education departments, additional responsibilities can be divided by program type and audience segment. For example, one staff member might organize evening lectures and performances, another person creates short-term classes or activities for preschool-age children, and someone else runs a specially funded tour program for Alzheimer's patients and their caregivers.

An educator may serve as a museum teacher or gallery interpreter, connecting the public with collections and exhibitions. Management of docents and volunteers often falls within the education department but can also reside in other functions

(see visitor services, below). Educators also may write brochures and exhibition guides and contribute to the museum's membership publications, in consultation with the museum's curators and marketing staff. An educator also often provides extensive content for a museum's website or other technology-based delivery platforms (e.g. gallery interactives, mobile apps, podcasts, video), working in tandem with media and technology specialists.

Many museum educators have experience in evaluation methodology, and some museums have in-house staff to conduct audience research and evaluation. Other museums hire outside individuals or firms to conduct front-end, formative, and summative evaluation of exhibitions, programs, visitor experience, audience development, and other related activities. While usually in the education department, these functions may also be based in exhibition development, marketing, or administration/operations.

Marketing and Communications

A museum's marketing department is focused on the overall brand and promotion of the museum. These professionals consistently monitor and shape how a museum presents itself to the public, in terms of advertising, press, product development, wayfinding and promotional signage, and more, while also trying to maintain and attract more visitors, members, and prospective funders. This department often hires designers who unify the museum's graphic design on everything from outdoor signs and advertisements to stationery and publications, to various items such as mugs and napkins in the museum store and food service facilities.

Staff writers ensure that the press releases, exhibition brochures, and ad copy all use the same voice appropriate to the material as well as to the reader. The public relations team promotes the museum and its activities, such as a blockbuster exhibition, a weekend family program, community-related events, and a related series of Friday night movies to press outlets like television and radio programs, newspapers, bloggers, and internet media, including Facebook, Twitter, and other social media.

The PR team may work closely with the director and education department to extend the museum's image and connection with the community. The marketing department might also manage visitor services (see below) and the admissions or ticketing functions of a museum as part of its focus on the public and the overall museum experience, as well as a means of gauging how successful its efforts are towards building awareness of the institution.

Visitor Services and Visitor Experience

A staff member or volunteer performing this function is often the first person a museum visitor encounters, and as such provides a critical opportunity for a museum to ensure that visitors have a positive educational and social experience. A visitor services or, increasingly, a visitor experience manager may supervise the workers responsible for admissions, parking, audio tours or other interactive guides, gallery guides, visitor information desks, wayfinding and orientation, and any other service or product that affects a visitor's experience.

A volunteer and docent manager trains and coordinates the people who generously give their time to offer tours to the public, assist with events such as public workshops, increasingly work behind the scenes with collections, and in some cases run the museum's front desk and store. These workers may also work collaboratively with audience research and evaluation staff or contractors to gather feedback, demographics, and other data about visitors, which is used by this department, as well as by operations, marketing, education, and exhibitions where specialists in audience research, learning theory, and statistics create questionnaires and survey methodology.

With the increasing role technology plays in museum operations, visitor services staff may also serve as or work with technology professionals to manage the increasing complexity of ticketing, tour group management, and other information gathering and analysis systems related to visitor services.

Fundraising and Development

Sometimes termed "development" or "advancement," the fundraising department is tasked with a range of revenue-generating activities. The fundraising department may be responsible for garnering income for the museum outside of earned revenue (e.g. admissions fees or purchases from stores and food service facilities). For example, fundraising staff may collaborate with the marketing department on membership drives tied to a specific event or exhibition. The development department sometimes oversees upper-level membership groups, such as a director's council, young members group, and travel programs,

as well as coordinating special events like ticketed galas or benefit auctions.

Working closely with the museum's director and board of trustees, fundraising staff are involved in donor cultivation, meaning they help establish relationships with individuals and families who care greatly about the museum and have the resources to offer significant support to its growth and operations. This might mean a major contribution of funds towards a capital campaign (gifts to aid the museum's physical structure or an expansion), towards the endowment (a large amount of invested money that generates interest income for the museum), or a large gift of art or artifacts for the collection or towards a special project or exhibition (this latter function usually in close collaboration with collections staff).

Development departments also have staff who secure sponsorship from corporations for special projects or exhibitions, or who focus on applying for grant applications from foundations, corporations, and government agencies.

Administration and Operations

Although administration and operations might seem like a catch-all for everything that doesn't fit into the categories above, the responsibilities that fall under this group are the backbone of the day-to-day running of a museum, as well as key to its long-term success. The security and facility management personnel, for example, ensure that the collections and exhibitions remain secure and that the museum provides a safe and attractive environment for visitors and workers, caring for everything from lighting to air-conditioning and

heating systems to plumbing.

The IT staff's responsibilities have become increasingly critical with advances in hardware and software, as well as the infiltration of technology in all museum functions, such as accounting and admission systems, collections management software, and interactive exhibition components. Also within this category are income-generating services like museum stores, food service facilities, and facility rentals, such as renting out the museum's atrium for a wedding or a corporate holiday reception.

The administration department also encompasses the finance, accounting, legal, and human resources staff that, among many responsibilities such as complying with all tax and legal requirements for non-profits and managing the myriad contracts that service the museum functions, take care of the all-important payroll. Working closely with all of the organization's departments, administrators enforce and adjust the museum's budget, forecast financial needs, and oversee the museum's assets (e.g. endowments, physical property, and equipment). Administrative staff members spearhead major construction or renovation projects, work with advisory committees to develop and maintain overall strategic plans and feasibility studies, and manage special projects such as gaining or renewing accreditation from AAM.

A large museum might have a Chief Operating Officer and/or a Chief Financial Officer to manage the administrative arm of the museum or particular aspects such as earned income and facilities. But ultimately the responsibility falls upon the museum's director, who wears hats related to all of the functions mentioned above. She must be highly knowledgeable about the subject specialty of the museum, as

well as its exhibitions and collections. As the organization's primary spokesperson, she stays "on message" at all times, communicating the brand and aspirations of the museum to all variety of visitors, from a home schooling conference to a gathering of government officials, to gala patrons who spend tens of thousands of dollars to attend a special event. Meanwhile the budget and financial needs are never far from her mind as she works closely with her fundraisers and the museum's board to secure gifts, grants, and bequests.

Putting It All Together

Knowing how all the functions of a museum's departments complement each other and help fulfill the museum's mission is crucial to any professional intending to stay in the field long-term. For example, a curator who can write a grant application and network effectively will find it much easier to fund exhibition projects and to solicit donations for the collection. An educator with an understanding of marketing not only helps publicize events and projects but also assists in locating and encouraging core segments of the community to engage with the museum in meaningful ways. And an administrator who comprehends the priorities of the other departments can identify and allocate the best resources to support those goals in an efficient and effective manner. In smaller museums, many of these responsibilities are conflated to create hybrid positions, such as a manager of public relations and education, a director who is also the chief curator, and a fundraiser who also oversees marketing.

Every kind of museum job demands its own specialized knowledge, experience, and professional standards. No matter

where your path takes you in the museum world, if you respect and learn from the contributions your fellow coworkers bring to their roles and your collective work in support of the museum, the public, and the field, you will find it much easier to succeed in your own position and in your career.

Practically Speaking: The Informational Interview

Wendy Luke

The informational interview can provide you information about an industry, a museum, historic house, zoo, science center, etc., an individual's career path, how to enter a field, and the challenges and satisfactions of a field, among other topics. It can help you choose or eliminate certain career paths. It can help you expand your network, refine your job search strategies, and find out about specific job opportunities. It is not a job interview.

To get an informational interview

Tap your friends, family, faculty members, former employers, colleagues, alumni connections, and associates from clubs you belong to for names of people with whom you should meet. Write, call, or email for an appointment. Be specific that you want an informational interview and ask for 15 to 30 minutes, the typical length of an informational interview. If you get the interview, be sure you honor the time commitment.

Show up on time and only meet with the interviewer for the allotted time frame.

Prepare for the interview

In preparing for the interview, learn something about the person with whom you are meeting, the institution and the specialty in which you are interested. Prepare your list of questions and write them down. Remember, you will have limited time with the interviewer and you want to make the most of it. Don't ask questions about information that is readily available on the Internet or in annual reports.

Set up the interview

Informational interviews are best done in person. Be sure to show up on time dressed appropriately for the interview. Greet the interviewer warmly, with a firm handshake. Ask crisp questions. Listen. Take notes. Smile, make eye contact, and show you are interested in the information

the interviewer is giving you. An informational interview is about getting information. It is not about asking for a job. Your last question should ask for referrals. "Is there anyone else you can recommend I talk with, or organizations that I should contact?"

At the end of the interview

Follow up after the interview by sending a thank-you note. You might include an article that was pertinent to the conversation. If you meet with someone that the interviewer referred you to, send him or her a thank-you note for having made that introduction. If you keep the interviewer informed with your progress in finding a job, you are likely to build a cordial relationship.

Sample informational interview questions

1. Tell me about your typical workday.
2. What are the specific experience, skills, and knowledge you need to enter your field?
3. What educational programs, certificates, or licenses would be especially helpful to obtain for a job in this field?
4. What are the opportunities for advancement in the field?
5. What jobs and experiences have led you to your current job?
6. What are the key skills, knowledge, and attributes for someone who is successful in this field?
7. What compensation might I expect at the start of my career and as I move up in this field?
8. What are the most and least satisfying aspects of your job?

.

Chapter 3: Considering Grad School?

Laura B. Roberts, *Principal, Roberts Consulting and adjunct faculty, Harvard University Extension and Bank Street College*

ONE OF THE BIGGEST QUESTIONS facing an emerging professional is where, when and how to go to graduate school. The options for graduate education are proliferating at a confusing rate. At the same time, museum jobs are becoming increasingly specialized, suggesting that an all-purpose degree may not be the best preparation for all jobs. Additionally, tuition seems to be climbing faster than museum salaries, making the payback calculation more challenging. Fifty museum professionals will give you at least 50 different opinions. This chapter suggests the questions to ask yourself and others as you consider graduate school.

Do you have enough experience?

Conventional wisdom says that graduate school enrollments go up during recessions because people can't find good jobs. But for any professional school (and most museum graduate school options are in that category), work experience is an enormous asset. You will be a more attractive applicant if you can talk about relevant experience that has shaped your interest in museums. Once you are enrolled, you will get more out of your coursework if you understand the working environment of museums. And after you complete your studies, you will definitely have a competitive edge when you are back in the job market. How well honed are your communication skills, written and verbal? Have you worked on a team of people who bring different skills and perspectives to the table? Can you juggle multiple projects and meet deadlines? Experience does not have to be full-time, paid work. Seasonal or part-time work, internships, or good volunteer projects are all worthwhile.

What is your career goal?

As the Cheshire cat in *Alice in Wonderland* said: "If you don't know *where* you are going, any road will get you there." If you don't know what you want to do in museums, it may not matter what graduate school you choose. But your graduate education will set you on a career path, moving you forward but also, inevitably, closing off other options. Your choice of

graduate school should depend, in large part, on the kind of work you want to do. In general, I advise students to do significant career exploration before committing to a graduate program.

A "museum studies" program that offers a wide array of courses will prepare you for entry-level jobs or work in a small museum (where the ability to do many different things can be an asset), but unless you have significant prior experience, you may find you are not competitive for a mid-level job in a larger museum. It's also a good option for people who don't really know how their skills and interests will evolve.

If you have a more defined career goal, you should look at other professional training options. If you want to be a curator at an art museum with significant collections, for example, you will need academic preparation in art history, probably working towards a Ph.D. Some academic programs offer a companion certificate or diploma in museum work, but look carefully at just how much professional training they offer. On the other hand, if your goal is to be an educator in a science museum, you'll need strong training in educational theory and practice, an understanding of evaluation methodology, and enough science (perhaps from your undergraduate training or work experience) to master cutting-edge information. There are now many programs specifically designed to prepare some specialists, like museum educators. But for other jobs, like exhibition design, there are far fewer museum-specific programs. You may find that an art school provides the best hands-on education. When you are looking at any program that is not specifically designed to prepare people to work in museums, ask if there will be opportunities to apply what you are learning in museums

through course projects, internships, or service-learning. Have any graduates from the program gone on to work in museums?

The question of graduate training in an academic discipline is ever-present in these discussions. Some feel that directors and curators will always need advanced academic degrees in order to provide intellectual leadership to their institutions. Others say that most directors rarely call upon their academic training and need appropriate preparation for running complex organizations. In the New England Museum Association's 2010-2011 salary survey, only 11% of directors had a Ph.D., and 59% had a master's degree, a distribution that is almost unchanged since the 1992-1993 survey. In contrast, 31% of the most senior curators and 26% of mid-level curators had a Ph.D., more than twice the percentage with that degree in 1992-1993.

Perhaps as a reaction to people coming into senior management roles from outside of museums and in response to the challenges of organizational management, more museum professionals are looking at management training. There is a proliferation of programs offering degrees in arts management, nonprofit management or public administration. Armed with a management degree, people with good work experience can often move into senior leadership positions. People with less experience might find that they are competitive for jobs in marketing, development or financial management, but those are fields that rarely lead to senior management responsibility.

Do you know the basics?

Regardless of job responsibilities, everyone who works in museums should understand

the basics of collections stewardship, interpretation, ethics, and public service. Similarly, anyone in a professional position needs to be able to write professionally, prepare and manage a budget, manage people and projects, and understand organizational dynamics and culture. Some of this comes from work experience; professional training can fill in the rest. If the combination of your on-the-job experience and graduate school does not cover all of the basics, look for other ways to develop your skills. For people making the transition into museum work from other fields, state, regional, and national museum associations are invaluable resources and networks.

What kind of learner are you?

Different programs have different approaches and philosophies. Students are more engaged and successful when there is alignment between their learning styles and the pedagogical approach of the program. Ask yourself: do you learn best in lectures or in experiential settings? Do you crave theory or are you more focused on the application of theory? Do you want to spend your time doing research or completing projects? Do you need to interact with a cohort of colleagues? How important is it that you have an advisor or mentor for your studies?

Where do you want to work?

There are a few programs with well-deserved national reputations. They tend to be more competitive and graduates can call on a significant network of alumni throughout the country. If they offer what you want and you are accepted, they may be the right choice and will likely be the most portable credential.

There are many excellent programs that are essentially regional in their scope and reputation. Within the region, the program is well-known, the faculty and alumni networks are robust, and the market is dominated by those graduates. Unfortunately, it may be difficult to transfer that credibility and network to another part of the country. Nevertheless, your professional opportunities will be far wider if you are willing (and able) to relocate for a good job. You will need to be realistic about the portability of any program you consider, as well as your personal circumstances. If you anticipate living in a particular region for several years after graduate school, look closely at the programs in that region.

Who is on the faculty?

Your graduate school experience will depend, in large part, on the composition and experience of the faculty. Program faculties tend to be dominated either by practitioners, hired as adjunct faculty, or full-time academics.

Practitioners may still be working in museums and have great, relevant work experience but less teaching experience. And their day jobs may limit their availability to students. Adjunct faculty are less likely to be able to provide guidance on navigating the university, but they are far more likely to have active professional networks available to their students.

Academic programs have different advantages. Faculty members are generally skilled teachers, with experience in the classroom and in advising students on their academic development. They are more likely to be pursuing current research, either

in museum studies or related academic fields, and keep up with the work of others in their field. Some may augment their teaching with consulting, but in general their practical experience is more limited.

In either case, look critically at faculty members' experience and current work, either in interviews or by reviewing their credentials (which should be available on the program website or on LinkedIn). Are they actively involved in museum work as staff, consultants, volunteers or board members? What professional meetings do they attend? What articles or books have they published?

How can you find out more?

You should develop a plan for researching and evaluating programs that includes in-person, telephone, or email interviews. Develop your list of contacts by working your network of co-workers and colleagues. Have your questions prepared in advance with the right set of questions for each contact. You might ask experienced managers in your field what they look for when they hire people. Ask professionals their impressions of colleagues who went to particular programs and about the reputation of those programs and faculty. Ask recent graduates about their experience.

Remember that the options available to museum professionals and the expectations of museum workers have changed dramatically. The specifics of the graduate experience of more senior colleagues may not be the most relevant questions to ask them.

What will it cost and how will you finance it?

In a quick survey of some prominent graduate programs, it was difficult to find and then calculate the cost of tuition, perhaps because the number is often staggeringly large and therefore discouraging. When you look at programs, ask about the total cost of completing the degree (including the cost of living in the community, if you'll be moving). Public universities may be more affordable, particularly if you qualify for in-state tuition. Some schools have tuition-remission programs for staff; it may be feasible to look for an administrative job at a university and work on your degree part-time. Unless you have savings, help from family, or you qualify for scholarships, you will find yourself paying off loans at a museum professional's salary for many years.

What other options are available?

There are more and more ways to go to graduate school. You do not have to quit your job, move to a new place, and devote two years to the effort. The trend in higher education is towards "low residency" options that allow students to combine graduate school with work or other pursuits. There are part-time, evening programs, particularly in larger cities. There are executive-education format programs that meet on weekends or in slightly longer blocks of time throughout the year. There are distance-learning programs, and programs that combine formats. If you have a good job you enjoy and like where you live, I would think twice about disrupting that for graduate school. If you can keep working

and/or go part-time, you may be able to complete your degree with less debt.

A graduate degree may not even be appropriate to your situation or career goals, particularly if you already have a graduate degree in another field or significant work experience. Consider mid-career intensive programs, skill-based workshops, certificate programs, and even single courses. Career changers may just need a few courses to help them develop a better sense of museums. For those who have good museum experience, look beyond museum courses to nonprofit management, "green" design, new media, or social enterprises. If you are new to a city, consider programs that introduce emerging leaders to the community and its resources.

One word of advice: among the proliferation of programs there are some ventures with shallow roots. Some add a veneer of applied studies to traditional academic programs in art, history, anthropology, etc. to make their departments more appealing to students who want a backup to an academic career. Others are crafted by university administrators who look at the courses offered by their continuing education programs and find new ways to repackage them. Over time, some of these enterprises do develop deeper roots: they attract fine adjunct faculty who teach relevant courses and build networks of alumni.

But in their early years, they are often too thin to offer a substantial education.

Mentally assemble your course of study: are there sufficient courses, taught by faculty you can learn from, available each year? Good networking, asking about the reputation of the program and faculty, are even more essential.

Is grad school enough?

Although one of my graduate school professors observed that "icebergs whiz by museums," our field is changing and will continue to change as our communities and their expectations change. What you learn in graduate school will only take you so far. Use it as an opportunity to develop new skills, perspectives, and networks. But continue to nurture all of that through ongoing professional development throughout your career. Make time to read professional journals even when you're not completing course assignments. Find low-cost workshops and other professional development opportunities to fill in gaps or update your skills. Apply for conference scholarships and submit proposals for sessions. Museums are grounded in the principle of lifelong learning; active museum professionals live that value personally!

Career Path: Grad School Changed My Life

Phyllis Hecht, director of the online Museum Studies program, Johns Hopkins University

Graduate school changed my life. A simple but true statement for me, and one that others, I'm sure, share with me. My graduate school faculty, advisors, courses, and activities broadened my knowledge and gave me new skills and confidence. I entered grad school—the Museum Education Program at The George Washington University—ten years or so after attaining undergraduate degrees in journalism and art history from the University of Maryland. I had already worked at a variety of jobs, from designer/producer of multi-projector slideshows at a recording studio to editor at a newsletter company to graphic designer/project manager at the National Gallery of Art in Washington, D.C. I loved my museum position and was passionate about communicating exhibition, education, and press information through the design of words and images, and I was fortunate to be able to take a leave of absence from my job while I went back to school.

My decision to go to graduate school stemmed from my desire to build on my journalism background, embrace my art history roots, and increase my knowledge of object-based learning and communication. My master's degree program fulfilled these expectations and more. It paved the way to new colleagues, skills, and opportunities, as I armed myself with a toolkit that included learning theory, interpretation methods, evaluation techniques, and teaching skills.

After completing my degree, I continued in my position at the National Gallery with new understandings of the importance of the role of the museum as educator. My studies, however, did not end with graduate school. I would soon dive into the new skills required for the Internet revolution and for the expanded role technology would play in the museum. I jumped at the opportunity to work on the development team for the Gallery's website and took on the position of art director and later manager. My undergraduate and graduate degrees along with my work experiences became a solid foundation not only for working in a 21st-century museum, but also for the next steps of my career.

The Challenges of the 21st-Century Museum

These next steps involved teaching in the Communication program at Johns Hopkins University, writing about the future of technology in museums, and involvement in AAM's Standing Professional Committees (now Professional Networks). As an adjunct at Johns Hopkins, I met others there with the desire to focus on the issues and challenges of the 21st-century museum. Through a confluence of ideas and support, we created the online Museum Studies graduate program at Johns Hopkins University, which launched in 2008. As director of

the program I examine, along with my
colleagues, the challenges facing current
and future museum professionals and
recognize the need for museum-related
graduate programs to develop curricula
that focus on the issues of the 21st-century
museum—from audience expectations to
global perspectives, advocacy, accessibility,
best practices in media and technology,
and museums as agents of social change.
Graduate school is, of course, more than
an innovative curriculum, it is a time to
hone critical thinking and problem-solving
skills, tap into excellent mentors, and
become part of the professional commu-
nity. Today's access to social media and
web tools provides incredible opportunities
to keep current with the field and connect
with colleagues worldwide.

Many of us in the museum field have
had long winding roads to rewarding
careers. The many aspects of graduate
education can provide a foundation for the
next step on the road.

Chapter 4: Back to School: Museum Studies Programs During Tough Times

James Yasko, director of education, The Hermitage, Nashville, Tennessee

AS FINANCIAL HARD TIMES HAVE HIT the museum field, many professionals have turned to museum studies programs— some to continue their education, others to separate themselves from the crowd and some to defer existing student loan payments. According to *The Chronicle of Higher Education* (Sept. 14, 2010), from the fall of 2008 to the fall of 2009, graduate school applications rose by 8.3 percent. The museum field has been no exception to this trend. Gretchen Sorin, director of museum studies at the Cooperstown Graduate Program in Cooperstown, N.Y., can testify to this. "We've noticed a significant uptick in our overall number of applications in the past couple of years," she says, citing an iffy job market as a reason. "I think when the job market is bad, people tend to go to graduate school." Eileen Johnson, chair of the museum science program at Texas Tech University in Lubbock, agrees. The program has grown at such a rate that leaders are considering placing a cap on the number of students they accept each fall.

Advancing careers, competitive edge

While the shaky job market may drive the unemployed to the safe haven of graduate school, a number of gainfully employed museum professionals may also feel they need a graduate degree in order to advance in their current careers. At Bank Street College in New York, four different tracks ranging from museum education to exhibit development either prepare or refine students for their field. According to Leslie Bedford, director of the Leadership in Museum Education Program, many of the museum professionals-turned-students come to Bank Street because they feel like they have to have a master's degree to get anywhere now. "They are generally a pretty ambitious group," she says.

They're also a pretty loyal bunch. Stephen Light, a Cooperstown Graduate Program graduate, said his wide range of experiences in the program not only prepared him for a variety of jobs in the museum field, but also served as a

networking platform. "CGP opened doors for me because of its reputation in the museum field, and because of the large number of successful CGP alumni in museums across the country."

Katy Bunning, director of the Museum Studies by Distance Learning program at the University of Leicester in the United Kingdom, agrees that their 250 students share this desire for a competitive edge. "One of the main motivations for students applying to our master's programs is the desire to gain a recognized and respected qualification, which will put them ahead in the competition for jobs, or which might help to progress their career within a particular area or institution."

Growth of online programs

As its title suggests, the University of Leicester's program is available online—an emerging option for those considering graduate school. Students are flocking to the Internet to complete a degree or to pursue an advanced degree. Phyllis Hecht, director of the Master of Arts in Museum Studies program at Johns Hopkins University, says that even though the program only began in January 2008, it now has 350 students from 42 states and nine countries, representing a melting pot of backgrounds. "We have students with undergraduate degrees in art history, anthropology, history, economics, business administration, historic preservation, music, philosophy, and film and media arts," she says.

Loni Wellman, a May 2011 graduate of the Johns Hopkins program and now the educational program manager at the Children's Museum of Memphis, had a similar dilemma. "Like many people," she says, "I was concerned about the whole 'online' thing. There was—and still is—a certain stigma about online colleges and universities. I looked into options at the University of Memphis, which has a museum studies certificate in their public administration master's program. However, I just could not pull it off with my schedule." At the University of Oklahoma's College of Liberal Studies, which oversees the online museum studies program, Assistant Professor and Graduate Program Coordinator Julie Raadschelders points to a shared background among the 140 students. "The most common denominator is that almost all of our students are full-time working adults."

Flexibility isn't a sufficient selling point, though, for prospective students who must commit to two or more years of studying and thousands of dollars in debt. What's a good hook? Hecht says that students in the Johns Hopkins program "are looking for an innovative curriculum that will give them an edge when they are seeking promotion or job opportunities."

Online programs must also consider how they will compare to the traditional classroom experience. Bunning says that it's important not to just replicate the college experience: "Our distance learners have a profoundly different experience to those on our campus programs, in terms of both space and time, so we know we cannot simply replicate that experience— nor would we want to do so, [when] we can see the unique opportunities afforded by distance learning study, such as the possibilities of applying theories and ideas immediately within a working environment."

Developing online courses can also help a school improve its traditional classroom

programming. At Texas Tech, Johnson notes that the plethora of online options have "encouraged traditional programs, such as ours, to evaluate and strengthen the graduate programs, be more responsive to current issues while bolstering the basics and focus on recruitment efforts."

Bridging the gap

In an effort to bridge the gaps that might occur when people are not physically present together in a classroom, programs like Johns Hopkins have embraced enhanced technology and social media in an effort to keep students engaged with professors and fellow learners. "We post images and audio content to give the courses a 'human' feel," says Hecht. "We have a virtual museum café within the course management system so that students can meet each other outside of the classroom. It is a very lively environment where students meet virtually and plan local meet-ups in their areas. We also use tools such as Facebook, Twitter, LinkedIn and Flickr to build community."

Hopkins graduate Wellman found such communication methods to be extremely helpful. "I was worried about the lack of 'face-to-face' time with my professors and classmates," she says. "With technological advances like Skype and other social networking sites, this fear was put to rest." A group of JHU online grads and alumni, having never actually met each other, went to the AAM Annual Meeting in Houston last May. "The time was amazing," Wellman says. "Everyone just seemed to click. We went to dinner together, caught an Astros game, and went to sessions. It was like seeing old friends for the first time."

Saturation?

Such glowing reports spread the word about these types of programs and ultimately play a part in student recruitment. Cooperstown's Sorin says, "I'm quite amazed at the proliferation of museum studies programs out there. There seem to be new ones almost every year. I think having a variety of options for students is a good thing, and there are some terrific programs available for students with different interests." But she worries that the high volume of different programs could saturate the job market. "There are not positions for everyone who graduates with a museum studies degree or certificate," she says. The result is a perplexing cycle. The job market is bad, which leads to increased applications in various graduate programs, both onsite and online. Graduates then flood the job market. And those student loans have to be paid back regardless of whether you can find a job.

Diversity

Another concern is the relative lack of diversity among program applicants to museum studies programs. The *Chronicle of Higher Education* reported in 2009 that minority representation in U.S. graduate schools grew from 28.3 percent in 2008 to 29.1 percent in 2009. Yet Sorin warns that "until both museums and museum studies programs are more focused on looking like and being responsive to those [minority] communities, we will not attract as diverse a group of people as we would like to the profession." Bank Street has focused on this issue, offering scholarships from foundations and alumni to support minority

students. "Bank Street has always pushed diversity," says Bedford. "Having highly respected people like Claudine Brown [assistant secretary for education and accessibility] as one of our faculty advisors for ten years helped create an image of the program as a place where students as well as faculty of color were very welcome."

Gender diversity in the museum field is also a concern. AAM's Center for the Future of Museums wrote in a blog post, "More on the Future of Museum Studies" (Aug. 7, 2009), that the museum field is not only about 80 percent Caucasian, but also 80 percent female. The report states that this trend "creates two unhappy groups: museums as employers who want more diverse staff and complain they cannot attract ethnically/culturally diverse, qualified candidates, and museum studies graduates bearing large amounts of debt from student loans."

Impact

What is the impact of programs such as the Cooperstown Graduate Program, University of Oklahoma, Johns Hopkins and the University of Leicester? For the graduates (at least those who find or advance in a job), it can be life changing. Cooperstown graduate Light can identify numerous advantages from his higher education experience: a better understanding of why museums are important and how they work, a chance to study the latest developments in the field and connections with fellow graduates. "Alumni networks," he says, "provide excellent avenues for developing contacts with the very same professionals working on these cutting-edge practices."

Wellman of Hopkins draws similar conclusions about the impact of her online experience, but for a different reason: "While I'm still the educational program manager, I have been able to take on other opportunities at work. I have a more comprehensive view of how museums work, not just my own education corner of the museum. It has definitely given me job security, which is so important today."

(Originally published in Museum, *Jan/Feb 2012.)*

Career Path: Life Lessons: A Journey of Continuous Learning

Kimberly H. McCray, *doctorate candidate in education studies, Lesley University and former director of interpretation and education, Nantucket Historical Association*

I sat staring at the blank paper before me. The lesson of the day: Future tense. The assignment: Explain to Madame Sorrell—in a short essay in French—what my life would be like in ten years. I was 14 years old, without a crystal ball and on a 30-minute deadline. Being completely clueless about the lives of adults in their early 20s, I wrote an imaginative essay in which I envisioned myself as a world-class museum professional, living a life of luxury in my Smithsonian office. Strangely enough (and luxury aside), my idea was not that far off track. In 2002, at the age of 24, I was a museum educator at the Smithsonian Institution National Postal Museum.

My high school French essay was not the result of divine inspiration; nor was it a self-fulfilling prophecy. No one can completely predict the future, but one can be proactive about determining what lies ahead, especially when guided by a curious force—the love of learning. For me, the love of learning is a lifelong pursuit integrally connected to my professional growth and development. It is in this spirit that common professional development tools—such as volunteering, mentoring, informational interviews, graduate education and networking—have furthered and enriched my career.

I started volunteering as a teenager, including one summer at a fish culture station in Grand Isle, Vermont, that promotes the conservation and management of nearby Lake Champlain's fish habitat. My favorite part was showcasing the small area dedicated to orientation—in other words, the education area. It contained a three-dimensional map, a video explaining the process of fish cultivation, an interactive where you could "fish," a computer game highlighting the lake's food chain, and a large aquarium filled with a selection of native aquatic species. Though it was not a museum per se, my time at the station taught me how much I enjoyed interacting with people, answering questions, and making the experience accessible and meaningful to visitors.

After finishing my undergraduate studies at Saint Michael's College in Colchester, Vermont, I worked for two months at the U.S. Senate and then gained full-time employment as a public programs coordinator at the Smithsonian National Postal Museum in Washington, D.C. I also continued to volunteer with public programs at area museums, such as the large family festival and the *OurStory* program at the National Museum of American History. Along with being a great networking opportunity, volunteering kept me up-to-date with the field and my colleagues, exposed me to new program ideas, and gave me a benchmark from which to think about ideas of my own. In addition, it felt both natural

and rewarding to give back to the museum community while doing something I love.

Throughout my career, I have been lucky to have a host of coaches, teachers, professors, undergraduate and graduate advisors, work supervisors and museum colleagues who served and continue to serve as my mentors. These people are my cheerleaders, but they also assist in developing an accurate perception of reality: they help weigh the good and the bad and create a balanced, more rounded view. For example, I know that whenever I need an honest opinion or to gain perspective on a situation, I can call up David T. Z. Mindich, a professor (and my mentor and friend) whom I met my first semester of college. He always knows the provoking, reflective questions to ask that stimulate my critical thinking and reveal items I overlooked.

Informational interviews are another great way to gain insight. By conversing with professionals you know and don't know about their experience in the field or even something as simple as why they entered the profession in the first place, you expose yourself to new perspectives. People love talking about their story, especially when they have an interested audience. Most people enjoy sharing job knowledge with others and will happily meet with you to discuss their experience.

Sometimes it even leads to a job offer. After graduation, I interviewed with Sen. Patrick Leahy's office in Burlington, Vermont, because I was curious to learn more about his office and line of work. A few weeks later when two positions opened up in Vermont and Washington, D.C., they remembered me and offered me the position in Washington.

Interviews can be impromptu as well. When I received a phone call with news that I had not been selected for a position at the Smithsonian National Postal Museum, I politely asked the woman who had interviewed me, Esther J. Washington, head of education, if she could offer me some feedback. Not only did she take the time to share this information, Esther mentioned that no one had ever asked her to do so before. Then, she asked me for feedback on her performance as an interviewer. We had a dynamic conversation. When the position suddenly became vacant again a month later, Esther thought of me and offered me the job. This initiated an incredible working relationship between us for the six years I worked at the museum. Esther took a risk on me, taught me the ins and outs of museum education, and remains a great mentor and a dear friend.

With technology and the growing numbers of networking groups, it is easier than ever to connect with fellow museum professionals. I am a member of several professional groups and associations including AAM, AAM Emerging Museum Professionals (EMP), AAM Committee on Education Professional Network (EdCom), the Museum Education Roundtable, the Greater Boston Museum Educators' Roundtable, and the New England Association of Museums (NEMA). A colleague of mine also introduced me to LinkedIn, an online networking site for professionals.

I also have found it is possible to pursue academic interests and work at the same time. I earned my master of arts from Georgetown University in 2004 while working at the Smithsonian National Postal

Museum. I worked for nearly five years as director of interpretation and education at the Nantucket Historical Association while a doctoral student in Lesley University's educational studies program.

The beauty of pursuing graduate education while working full-time is that you can apply theory directly to practice. As part of my studies at Lesley University, I evaluated one of the Nantucket Historical Association's public programs, the "Food for Thought" lecture series. I learned the proper methodology of qualitative evaluation, as well as valuable information for planning the program's future. Graduate education also provides connections to the professional community you may not make otherwise. I am incredibly fortunate to be working under the direction of George E. Hein and have met fellow doctoral students and program alumni who are also active in the museum field.

Balancing work and school can be a challenge. It takes discipline, dedication and a little bit of sleep deprivation, but it allows for simultaneous intellectual and professional growth. On a practical note, it is also an asset to earn an income while shelling out tuition.

There is no wrong way to accomplish professional development. The important part is investing yourself in learning—pursuing what you are passionate about while seeking engaging methods of accomplishing your goals. Be creative! Whether it is spending time in the community, reading and reflecting, visiting museums, talking with others, experimenting or just seeking out experiences that inspire you, every moment is an opportunity for growth.

When you develop and freely communicate your thoughts and ideas with others, you never know where the conversation will lead!

(Originally published as a Web Exclusive article on the AAM website.)

Chapter 5: Powering Up Your Personal Brand

Greg Stevens

"You exemplify the best of your generation—connecting the dots, building creativity everywhere, reaching out with welcome, kindness, humor and beyond boundaries."

"Thank you for taking time from a busy professional life to stay connected and provide inspiring leadership."

TAKE A LOOK AT A PERSON'S LINKEDIN profile and you might find quotes like these from colleagues. From these lines and without knowing the person, how would you characterize her professionally? At a glance, you might get the impression of a creative, connected, hard-working, dedicated, thoughtful museum person. Conversely, it might seem to you like the person is "tooting her own horn." But in fact, by publicly sharing a few things colleagues have written to and about you, you can communicate your "personal brand." It's your colleagues "tooting your horn" for you.

Conduct an online search for "personal branding" and you'll find roughly 58,000 entries, including half a dozen books, several articles, and more than a few career

websites and blogs addressing the topic. The concept was born in the mid-1990s in a *Fast Company* article by Tom Peters, "The Brand Called You," in which he suggests that everyone has the opportunity to stand out and that everyone has the chance to have a remarkable career. David McNally and Karl Speak, in *Be Your Own Brand* (San Francisco: Berrett-Koehler, 2002) tell us that your personal brand is who you are and what you believe in and the ways you demonstrate it.

In this chapter, we'll briefly explore the concept and practice of personal branding, how you must communicate "you" to others in valuable, relevant, and consistent ways throughout your career, and how relationship-building is at the core of your success.

Personal branding and marketing principles

You can take different approaches to personal branding and choose from many models. The one I like best and promote in the workshops I facilitate for museum colleagues is based in part on principles

borrowed from the world of marketing and in part on sage advice given to me by a mentor several years ago during a bumpy period in my career.

In the personal branding workshops I lead, I begin by asking participants "what is a 'commercial brand'?" The various groups usually arrive at a fairly consistent set of answers: "something familiar," "something you like," "a product you can rely on," "something comfortable, something that fits" or "you know what you're getting." All true. A commercial brand is what businesses tell their actual and potential customers; what consumers like, trust, remember, or value about a product or service; and the emotional bridge between the two. It's the reason we'll pay $4.50 for a *grande latte* at a bustling coffeehouse that one can find on nearly any street corner in any city (and feel confident that the coffee will always taste *just right*). It's the reason we're drawn to a well-known retail chain that targets consumers interested in products that are well-designed and affordable sold in stores that you can count on to be laid out pretty much the same, regardless of location. It's the reason that even in a weak economy, you can find the smartphone or related product you just have to have at a crowded but strangely accessible mall store that is as cleanly designed and user-friendly as the products being sold. Some marketing texts emphasize the Five P's of product, placement, promotion, price, and people as the magic formula. Similar marketing principles focus on the Four Rights: delivering the right message to the right audience at the right time and in the right way.

How do these principles and practices translate into personal branding? For starters the concepts are the same, only in this case the business is you and the consumer is anyone with whom you come in contact. This can be your family, friends, partner, or spouse, but for the purpose of this chapter we'll focus on your professional connections, including your student cohort, professors, co-workers, colleagues, or supervisor. For all these relationships, your personal brand is a two-way street. On one side, it's how you communicate your strengths, skills and passions in a distinctive, relevant and consistent way; on the other side, it's how others perceive you. Ultimately, it's about the relationship between you and what people come to like, trust, remember, or value about you and how you continue to learn about yourself and others, growing and strengthening relationships along the way.

Distinctive, relevant, consistent

Being distinctive is knowing what you believe in and committing to taking action on those beliefs. It demonstrates and projects your understanding of the needs of others and wanting to meet those needs. In what ways, under what professional circumstances, do you demonstrate what you believe in? In what ways do you try to better understand the needs of others and make efforts to meet those needs?

Relevance is nothing short of having something that people need, want, expect, trust, like, remember, and value. What do you have to offer (your colleagues, your institution, your community, the field) that is relevant to the work you'd like to do in museums and that people value? We all have relevance in some way, somehow.

Being consistent is simply about

dependability of behavior and building trust by being trustworthy. Patrick Lencioni, in *The Five Dysfunctions of a Team* (San Francisco: Jossey-Bass, 2002), offers a leadership fable and a model for team effectiveness that has at its foundation the critical element of trust. Without it, teams are rendered dysfunctional. In what ways are you trustworthy and dependable in your work in your department, your team, your institution?

As you move through your museum career, this combination of distinctiveness, relevance, and consistency is essential for your success. Leadership coach and museum colleague John Durel frequently talks about "love" when describing the foundational relationship between a museum and its audience. For Durel, the strongest emotional connection ("love") equals the strongest and longest-lasting staying power. The same holds true for the professional relationships we each build throughout our careers. Each interaction builds history, familiarity, trust, and strength. Ask anyone who has been in the museum field for a few years. Relationships matter.

Self-reflection

Many years ago when I was struggling to find a museum job, a colleague, who has since grown to be a trusted mentor and friend sat me down and helped me uncover things about myself I guess I'd always known, but didn't yet know how to articulate. She asked me three deceptively simple questions:

1. What are you *good* at?
2. What are you *passionate* about?
3. What does this have to do with the *work you want to do in museums?*

I had to think for a few minutes before answering the first question, stumbling and straining to overcome my tendency to "beat myself up" and focus on my weaknesses rather than my strengths. I offered my answer up hopefully.

"Well ... I'm very creative ... I think I'm a good teacher ... I'm good at coming up with ideas and putting stuff together ... and making things happen that never existed before." My colleague smiled, nodded in approval and made me write it down.

I went on to the second question with guarded enthusiasm, encouraged by my colleague, even though I had little idea at the time what passion had to do with anything related to finding a museum job.

"Let's see ... I love art ... I love theatre ... I love being on stage ... I'm passionate about helping people learn ... and ... well, I'm passionate about coming up with ideas and putting stuff together and making things happen that never existed before." From the look on my mentor's face, I got the "right" answer. I smiled inside, feeling fairly empowered. I felt clever that what I'm good at and what I'm passionate about are pretty much the same things. She made me write it down.

Now for the third question. I struggled a bit. How do I combine what I'm good at and passionate about and communicate it to people who might have a job for me doing what I want to do in museums?

"Well, it seems like I need to work in a place where I can express my creativity ... come up with new ideas ... try stuff out ... teach or help people learn, and, well ... be on stage." (Did I mention I was president of the Drama Club in high school?) I was on to something! I wrote it down.

The payoff

My first part-time museum job was as museum teacher at the National Building Museum (*"... help people learn ... putting stuff together ... be on stage"*); my first museum internship and full-time museum job was at the Smithsonian National Air and Space Museum, developing Discovery Cart curriculum and teaching in galleries with multigenerational audiences (*"... creativity ... new ideas ... try stuff out ... help people learn ... be on stage"*). Do you see a pattern?

Years later I arranged an informational interview with the director of a local children's museum. My real goal was to get her feedback on my resumé, which she offered. After that first meeting, she asked me to come back again with a portfolio of my work. When we met again, I brought my portfolio full of theatre designs and elementary school student art projects and exhibitions from a decade of teaching art and designing theatre at a performing and visual arts school in San Diego. In talking her through my portfolio, and without a hint of looking for a job I confidently let her know what I was good at, what I was passionate about, and what I wanted to do for museum work. On the spot, she created and offered me the position of creative director. True story.

A similar true tale happened later in my career when I was recruited for and offered a job on the spot at the National Museum of the U.S. Army. I had gone to the interview applying for a mid-level educator position; at the end of the interview (with portfolio in hand) I was offered a higher-level and higher-paying position as project manager for education. The best part of the story: Wendy Luke, the human resources specialist who recruited me for that job and recommended my hire has since grown into one of the most thoughtful colleagues and mentors I have had the pleasure of knowing. She was my only choice when it came to looking for a co-editor for this book.

Flash forward several years. During my interview for my current job at AAM, I practiced my "personal branding" once again. My soon-to-be supervisor asked me to tell him a little about myself. This time, clearly positioning myself for a job, I confidently shared what I was good at, what I was passionate about and what I wanted to do for work, reinforced with specific examples of how my skills and passions have played out in my previous positions.

I have the added advantage of having a strong network of colleagues who vouched for what I was saying about myself when it came time for reference checks and colleague phone calls from my future boss. I now have a fabulous job where I have the great fortune of helping museum colleagues learn; where I get to plan, produce, and evaluate new programs constantly; and yes, I even get to be "on stage" enough to make my inner thespian happy.

Practically Speaking: Take Action!

Greg Stevens

If you're exploring your personal brand, here are a few tips:

1. Ask and answer these questions:
 a. What are you *good* at?
 b. What are you *passionate* about?
 c. What does this have to do with the *work you want to do in museums?*

Of all the sage advice I've gotten from colleagues and mentors in my career, this has been the simplest and most effective tool for me and I use it in nearly all the career workshops I facilitate when self-reflection is on the menu. Try it. You'll like it. Share it with someone.

2. Ask and answer these questions:
 a. How are you *distinctive* in what you have to offer?
 b. In what ways do you demonstrate *relevance*?
 c. In what ways are you *consistent*, dependable and trustworthy?

3. Do a self-assessment. Try a simple, no-cost, online version of a personality assessment (based on Jung's theory of psychological types and Myers-Briggs personality research). You can find variations of these online. It's a great way for you and others to learn about what energizes and motivates you.

4. Do an online 360° assessment. One tool I've found helpful is William Arruda's Reach 360° (http://www.reachcc.com) where you can access a personal branding tool that allows you to explore your own attributes and get anonymous feedback from your colleagues, helping you better understand how others perceive and value you.

5. Ask, listen, act. Ask a trusted and trustworthy friend or colleague to give you constructive feedback about you, your strengths, your growth opportunities, your behavior, your attitude. Celebrate what you know is good, and be willing to listen carefully and take action on whatever you can do to build on your strengths and improve how you are perceived by colleagues.

6. Spread your gifts. One of the best ways to communicate your personal brand is to share what you're good at and passionate about with the museum field in whatever ways you feel comfortable (or even stretch yourself beyond your comfort zone). Try crafting a personal summary statement for your resumé. Practice your "elevator speech" for the next museum professionals networking event, focusing on you, not your job title or position. Join AAM if you haven't already! Submit and present a session for the next AAM annual meeting. Write an article for submission to *Museum* magazine or your museum newsletter. Get involved. Join a committee. Contribute a chapter or a career path story to a museum career book or blog.

Career Path: From Guard to Great

Patrick McMahon, director of exhibitions and design, Museum of Fine Arts, Boston

As director, exhibitions and design, for the Museum of Fine Arts, Boston, I manage the department responsible for how the public encounters the museum's collections. We produce our own exhibitions (about 20 per year) and gallery renovations for over 200,000 square feet of gallery space. We also plan five to eight touring shows for other museums—including a sister museum in Nagoya, Japan. The designers handle the 3-D and graphic design for the galleries in-house and the pace is frantic at times. After 20 years of museum work I am completely at home in this environment—but my career path has been an unlikely one.

I graduated in 1991 during a terrible economy. With no prospects for work related to my history degree, and no funds for graduate school, I delivered dry cleaning. I also paid cold-calls at any museums and historic sites I could think of, whether or not they were hiring. Some months after being turned away from the Isabella Stewart Gardner Museum, I got a call from them about openings in the security department and I was hired as a part time gallery guard. I worked every shift I could get my hands on. I also trained in the command center and as a watch desk guard to work overnight shifts when the museum was closed. I used my time between evening patrols to study the collection.

Gallery guards were assigned a different gallery every day and we stayed there. I could spend a shift really looking—and

listening to the docents and teachers as they came through. The installations did not change, and I learned them. I could locate almost anything from just a partial description. When the assistant curator discovered that I could do this, she asked me to help identify objects based on the vague descriptions in Isabella Gardner's original receipts. Her goal was to clarify the provenance of the collection by matching up the receipts in the archives to what could be seen in the galleries. I had fun with this and used my down time between night patrols to keep it moving. Eventually I was offered a part-time position as a curatorial assistant and I continued doing night watch shifts to pay my rent. The staff was tiny and when the assistant curator left her job, I was the only one who knew how to do it.

I worked hard to fill her shoes, and the museum soon stopped looking for a new assistant curator. I got the position but I didn't get that title because I lacked the credentials. They titled me the registrar and I set out to figure out exactly what a registrar was. I joined the professional registrar's networks and frequently called over to the MFA with questions about how things were done (like insurance and arranging for loans to and from exhibitions). The registrar's office is a great place to discover museum work. You are exposed to the whole range of operations in a museum. Many registrars were (plenty still are) boot-straps-type professionals who grew into their positions

just as I had—and keen to help others in their field.

My position also included assisting the archivist to help scholars with their research, and I developed a strong network of curators and historians, especially with the curators of American art at the MFA. Eventually our chief curator left (the archivist was also absent) and I ran the curatorial department for a year while they searched for replacements. I never went back to school. I loved the work and I couldn't see leaving to pursue a degree (and an expense which I could not afford) to compete for a job that I already had.

In 1999 when the MFA restructured, they created a position, Curatorial Planning and Project Manager, within each new curatorial department. It was designed to take the administrative labor off the desks of the curators themselves. My colleagues in the Art of the Americas department invited me to apply and I got the job in December of that year. With it, I was involved in the planning for the galleries in the new Art of the Americas wing, not to mention the administration of a newly merged department that had lots of different ways of doing things. My overall responsibility was helping standardize practices across the museum with the other Curatorial Planning and Project Managers so we could roll out an electronic collections database, standardized paperwork, etc. It was a great time to be there and a big growth opportunity, taking what I'd been doing on a micro scale and applying it in a macro environment. In 2006 I was promoted to my current position.

I always tell people who think they are interested in museum work to *volunteer*. First learn what the business is like before chasing an advanced degree (and advanced debt). Do whatever else you have to do for money. As a volunteer, make yourself indispensable—no task should be beneath you. Put in the time, pay your dues, meet as many people as you can, and develop a network. Then use it. Always ask questions and learn from the people you meet. Take a long view, and be useful.

Chapter 6: The Eight Networking Competencies

Anne Baber and **Lynne Waymon,** *partners, Contacts Count*

"NETWORKING" IS A TERM OFTEN heard in academic and professional circles, an activity or goal encouraged by our colleagues and mentors as essential to our career success. In graduate school, our advisors told us to network; in our job searches, members of our cohort told us to network. But as often as not, and depending on your personality type and comfort with meeting new people, networking can be a daunting, even frightening proposition. Even more so if you don't understand the basic nature of networking. In truth, networking is nothing more than connecting with people and building relationships on many planes. But it all starts with a contact.

Everyone has contacts. But not everyone has contacts that count. In this chapter, we'll explore eight networking competencies with the goal of helping you be better prepared to make great connections. And remember: you don't network just for yourself. You network for your team, your department, and your institution as you listen for good ideas and recent trends, as

you gather museum intelligence, and as you build alliances. Networking is not just a career skill, it's a professional competency built on your personal brand. Most established museum professionals embrace networking as essential to doing their jobs well, fostering excellence in their institutions, and contributing to the wellbeing of the field.

1. Capitalize on Your Style

Many people have challenges with networking that keep them from doing it well—or at all. Some say, "I'm shy." Some say, "I'm an introvert." Some are from cultures that discourage taking credit for accomplishments. Some come from diverse groups that still experience invisible but real barriers. Some think "keeping their nose to the grindstone" is the way to succeed. Some are "newbies"—Millennials or new hires in the non-profit world who are uncertain about workplace protocols. Some are operating under misconceptions that make networking seem unappealing. If you are one of

these reluctant networkers, you can learn to appreciate how your personality and mindset affect your ability to build relationships. Decide to adopt a positive attitude toward this essential workplace competency.

Some people think networking is about *talking* and *taking*. In our training programs, we help people redefine networking as teaching others about themselves and learning about other people. Then their reluctance disappears. When you realize the benefits—for your own career and your organization's success—you are ready to begin learning specific strategies and skills that make you feel even more confident and comfortable as you connect.

2. Take a Strategic Approach

Few people take a strategic approach to networking. Most have only the vaguest idea *why* they are networking (unless they're job hunters!). They know it's smart to network; they are much less sure why they're spending their time and money—or their organization's—and what exactly they are trying to accomplish at any one time. Our research shows that only about 20% answer "Yes!" when asked, "Do you have the network you need?" It's a rare person who puts together a comprehensive networking project with a clearly defined goal in mind.

How about you? What's your networking goal? Do you want to get a job? Get on board quickly? Get the job done? Get behind organizational initiatives? Get the audience? Get visible in your museum? Get a project up and running? Get known in your field? Get ahead? Get more out of conferences and meetings? Having answers to these and other self-reflective questions will help you craft your networking strategy.

Often people attend networking events without any idea of what they are trying to find or what they have to contribute. So decide what's on your networking agenda every day. What do you have to *give* (tips, shortcuts, trends, ideas, enthusiasm)? What do you want to *get*, find, solve, understand better, learn more about, connect with, brainstorm about, be ready for, be more aware of? You will be amazed at how goal-setting and planning can lead to networking success at one networking event or over one year, or several.

3. Envision the Ideal Network

Everybody has four networks: your work colleagues, your museum workplace, colleagues in the field, and your personal network of family and friends. Each of these networks comes with its benefits, challenges, and opportunities to help you grow personally and professionally. To visualize your networks, think of a box divided into four sections. Label each quadrant:

- **WorkNet**—these are people you interact with in your job.
- **OrgNet**—these are people in your organization outside of your job.
- **ProNet**—these are other professionals outside your own organization.
- **LifeNet**—these are your family and friends.

Identify and evaluate various relationships in your four networks, sort your contacts into those "Nets" then decide whose help you might need and whom you might help. Then plan "next-step conversations" with each of these contacts. Envisioning your network this way will help you achieve a high-functioning and balanced network—one that is even more valuable to your success and well-being.

4. Develop Relationships

Grow relationships through six stages of trust-building, and know the appropriate things to do and say at each of these stages.

- **Accidents** are people you meet at random and will never run into again. For example, you might meet and chat with someone standing in a line at the annual meeting; you may or may not ever see this person again unless you make the effort. To build that relationship, you'll have to reach out because you have no regular way to see each other.
- **Acquaintances** are people you meet though others; you could find them again through those mutual acquaintances. For example, a co-worker at your museum has invited you to join her for lunch with a colleague from another museum, and you have a rich conversation with that person. Your co-worker provides the link to that acquaintance.
- **Associates** belong to a group you belong to. Because you have the group in common, you have a good chance to see each other repeatedly and build a relationship. For example, you are a member of the AAM Media & Technology Professional Network and you attend the MUSE technology awards at each AAM Annual Meeting.
- **Actives** are people with whom you are actively exchanging information. For example, you are one of four presenters in the upcoming AAM webinar on collections storage, meeting by phone and online throughout the planning process. These exchanges give you the chance to experience and learn about each other's character and competence.
- **Advocates** are people who believe in your character and competence and who will stick their necks out for you and pass your name along. For example, someone you know well and have worked with recommends you for a position that has yet to be announced at a museum you want to work for.
- **Allies** form your innermost circle, people you turn to for advice, and commiserate and celebrate with. For example, your trusted allies will be there when you are grappling with important career decisions, like leaving a job or managing after a layoff.

Valuable relationships develop only if *trust* is established. People decide if you are *trustworthy*—and if they want to have more of a relationship with you—only if they become satisfied that you are a person of character and competence. As you and your contacts teach each other about these two essential traits, your relationship becomes more useful.

5. Increase Social Acumen

Become comfortable, confident, and professional as you master these relationship rituals. Contacts Count research indicates that 97% of people have trouble remembering names. Teaching your name and making it memorable and learning someone else's name are key skills. Come up with a tip to help people remember your name, and ask your contact how to remember theirs. Knowing when to exchange business cards for maximum effect, understanding how to join groups of people who are already talking, and ending conversations with the future in mind are all essential skills.

6. Showcase Expertise

Use examples and stories to teach your contacts about your expertise, experience, talents, and interests. When someone says, "What do you do?" give one sentence telling what you want your contact to remember about you (one skill or talent), not just your job title. Then add a vivid example to show how you saved the day, solved the problem, or served the visitor, customer, or co-worker. You want your expertise to stick in the minds of your contacts so they can connect you with the right opportunities.

Stories stick. Tell stories when people ask, "What's new?" or when there's a lull in the conversation. Use our 5-S Formula to write out several stories until this story structure becomes a habit. Here's the Formula:

- **Segue:** A transition that signals you have something to say.
 Example: *"I got more than I expected from the AAM Annual Meeting last week."*
- **Situation:** Who/What/When/Where. Briefly set the stage.
 Example: *"I found a session that was perfect for me—one on how to create garden-based programs for the children's museum by partnering with community resources. I was excited about bringing this information back to my director."*
- **SNAFU:** (Military slang for Situation Normal, All Fouled Up). Outline the problem.
 Example: *"Even though I have a minor in horticulture, I had no idea where to begin. I knew I needed help in how to identify and work with a team of community leaders to help me plan the project. I worried that a conference session wouldn't answer all my questions."*
- **Solution:** Tell what you did to turn things around or solve the problem.
 Example: *"So I decided to introduce myself to the speaker after the session. I asked if I could take her to lunch that day to talk about my ideas for the new community garden at our children's museum. She said her plane was leaving soon, but offered to mentor me long distance! We've already had our first phone meeting, and she connected me with some other people who might help!"*
- **Significance:** Comment on the impact and outcome.
 Example: *"Now I know just how to begin, and I'm sure our program will make the museum's green and community initiatives more visible."*

7. Assess Opportunities

What are the best networking arenas for you? Look at your goals. It doesn't make sense to join a networking group whose members are all small business people if your goal is to connect with people in the arts. Take time to decide if a specific group meets your needs. Check out its website, read its newsletter or attend a meeting or two as a guest. Once you decide to join, put at least three-quarters of its events on your calendar. You won't reap any benefits if you don't attend—and participate. Plan your involvement so that you get what you want out of the group.

Also, know when to discontinue your membership in a group. Look back each year. What have you gained? If you can't justify your time and your dues, opt out. And remember that networking isn't limited to groups outside your organization. Seek out and plan how to take advantage of

(or create your own!) internal networking opportunities.

8. Deliver Value

Make your networking affect the bottom line and contribute to your organization's networking culture. To capitalize on your networking efforts:

- *Ask good questions* and listen generously. These two skills are key as you develop relationships that pay off.
- *Be alert for opportunities* to connect your contacts and to provide access to resources, talent, and opportunities.
- *Up your conference ROI* by bringing back business intelligence and new contacts.
- *Encourage and support a networking culture* throughout your organization. Model good networking practices and mentor others.

Some Conversation Starters

1. Catch me up on what you've been doing.
2. What are you excited about these days?
3. What's a typical day like for you?
4. What's the most challenging trend you see in museum work these days?
5. What are you hoping to learn more about in the next few months?
6. Is there any information or resource you're looking for that I might be able to help with?

Practically Speaking: Networking and Relationships

Greg Stevens

In my spring semester of graduate school, I was searching in vain for a job, alongside hundreds of other museum grad students across the country. Admittedly, "searching" in my case amounted to not much more than applying for any and every museum education-related job that I saw posted—sometimes jobs I knew I would never accept in cities, towns and states where I knew I would never choose to live. In response to my misguided predicament, a classmate of mine earnestly said to me, "You need to *network*!" I remember responding to my classmate with something like (and here's the punchline): "I don't have time to *network*—I need to find a job!"

At that time, I confess I had no concept of "networking" (or strategic job searching, for that matter) other than it must be some important skill set or activity that somehow others knew about and had mastered but I didn't and hadn't. It was many months before it dawned on me that networking is nothing more—and certainly nothing less—important than building relationships, and that I had actually been *networking* my whole career.

I've since been told I'm a master networker, so I must have picked up some tips along the way. Over the past several years, I've had the great fortune to collaborate and build relationships with a remarkable array of colleagues from many backgrounds, working in many functional roles, from museums of all sizes and disciplines and from all over the globe. In fact, my co-editor on this book, Wendy Luke, is a perfect example of someone who started out as an Acquaintance and has since grown into one of my staunchest Allies. Networking (in the truest sense of that word) is what got me my job at AAM.

From my vantage point, networking involves the project teams I work on with colleagues at AAM; external planning teams I work with to produce seminars, workshops and webinars; the colleagues I can call on or email to lead a specific career, management or leadership development topic at the AAM annual meeting; or the new colleagues I meet over coffee, lunch or a glass of wine, introduced by a mutual colleague with similar thoughts about why and how museums matter. On a much more personal level, networking is about the relationships I have built and continue to build with people I can trust (like Wendy) to give me sage career advice when I need it; people who know they can come to me for advice or just a shoulder to lean on; and the comfort that comes from knowing that even if I don't always see eye-to-eye with a trusted friend or colleague, I can rely on them to "have my back" and vice versa.

Chapter 7: Polishing Your Resumé

Nik Honeysett, head of administration, J. Paul Getty Trust; *Katherine McNamee,* assistant director for human resources, American Association of Museums; and *Greg Stevens*

Your Resumé and You

At a basic level, this chapter is about how you can effectively communicate your work experience, skills, strengths, accomplishments and education through your resumé. But we anticipate that you will emerge from reading it knowing or reflecting more about yourself, what you've achieved and what you hope to achieve in your career. We'll explore the basic mechanics of a resumé, what you should or shouldn't include, when and why you need to "let go" of past experience, and the relationship between the resumé and cover letter (for more about cover letters, see Chapter 8). We'll emphasize why and how your resumé must demonstrate the quantifiable impact you've had in your professional experience. Our goal is to help you look objectively at your experience and sell yourself powerfully, persuasively, and with polish. The ultimate goal of a well-crafted resumé is to get you an interview.

Before we go any further, we'd like to acknowledge there is no one right way to craft your resumé. There are many styles

and formats you might use and endless resources available in print and online. While there are other types, we'll be focusing on chronological resumés (experience listed in reverse chronology), typical for entry-level and mid-career professionals. What we've written here works for us; use what works best for you.

Reality Checks

Now let's do a handful of reality checks.

- Reality Check 1: your resumé is likely to be one of hundreds received for any job posting. All the more reason for you to make your resumé the one to notice.
- Reality Check 2: your resumé might be looked at by a real human being or by an automated program searching for keywords that align with the position description.
- Reality Check 3: if a live person looks at your resumé, it may or may not be the hiring manager or supervisor of the position for which you've applied.
- Reality Check 4: whether your resumé is one page or two (and there is

considerable debate these days about which is "right"), you can count on busy professionals spending about thirty seconds (yes, seconds) scanning your resumé to see if you are a match; this and your cover letter may be their first and last impression of you.

- ■ Reality Check 5: if your resumé has typographical or formatting errors, doesn't fit the specifics of the requested format, or doesn't match the position description, your resumé may end up being discarded.

The Resumé Process

The key point about applying for a job is that you are entering a process, which does not start and stop with you sending your resumé off into the abyss. The process is generally the same for all types and sizes of museums—the larger the institution, the more complex the process. In any case, the process starts with a job posting and hopefully ends with a salary negotiation. A successful resumé and cover letter will match the job posting, so begin your process by underlining the verbs in posting and seeing if they match your skills and how you are describing yourself; if the posting says "manages" and "leads," make sure your resumé says the same thing.

Because this is a process, make sure you follow all the instructions in a posting—they are there for a reason. If instructions ask for salary history (and there are plenty of opinions about this question), include it in your cover letter or address why not. If instructions require specific skills or qualifications that you don't possess, explain in your cover letter how you'll compensate, and be sure your resumé highlights the specific skills and qualifications you do possess.

For a hiring manager, reviewing resumés is a process of elimination: how can I remove this resume and cover letter from my pile? This means that resumés with typos or those that are difficult to read (too wordy, vague, poorly formatted) will be the first to go in the "no" pile. Resumés that do not address the skills needed to do the job or follow the directions specified in the job posting will be eliminated next. This is a relatively simple task, because approximately one-quarter of cover letters have some form of typographical or grammatical mistake. Simple mistakes will eliminate you from the "yes" pile. From the hiring manager's perspective, if you can't take the time to get this very basic, very important task right, it does not bode well for your performance as an employee, particularly if the job requires attention to detail, as most jobs do. Another 25% can be eliminated because of ineligibility based on lack of skill and experience, so be sure you qualify for the job.

Many larger institutions use an applicant tracking system (basically a program that requires you to conform to a template for submitting information online), with the consequence that a hiring manager may never actually see your well-designed resumé, just a sanitized, form-filled version of it. Furthermore, they may never actually know that you have applied because these systems can be configured to filter out an applicant based on required qualifications. These applicants are sidelined and rarely viewed. Therefore the content of your resumé and cover letter are paramount.

To put this all in practical perspective, a general rule of thumb for hiring managers generating a short list of applicants to consider is 10% of the submission total. So for a submission pool of 200 applicants, 100 resumés have already made

their way to the "circular file" because of typos, bad grammar and lack of qualifications. This leaves only 20 out of 200 as ROIs—Resumés of Interest. Depending on the position, there may be a group of people who have a role in the hire (human resources staff, hiring manager, department supervisor, museum director, et al.); if that's the case, the 20 ROIs will be forwarded to this group and a final list will be generated—5% is normal, but more likely it will be a number based purely on being manageable. The bottom line: only five out of 200 applicants will ever have their resumés reviewed for serious consideration, let alone be asked to an interview.

Format

As we mentioned, we're focusing on chronological resumés (experience listed in reverse chronology), typical for entry-level and mid-career professionals. The basic outline of your resumé will vary depending on several factors, including:

- How long you've been in the field
- The type of job for which you are applying
- The kinds and amount of professional experience you have
- Your level of education, and
- Other relevant information (awards/recognition, additional skills, volunteer/intern positions, publications/presentations, or hobbies/special interests, etc.)

There is considerable debate about how many pages a resumé should be, citing one or two maximum (as we do here). As online job submissions become more prevalent, this is less of an issue, but in reality forcing it to one page is more about forcing

brevity than any standard length requirement. A well-written and concise two-page resumé can be easier to consume than a badly written one-pager. The important thing is to create a resumé that is an effective tool to be used by your next employer, no matter how many pages.

When formatting your resumé, your safest bet is to start with the basics: white space is important. Try a one-inch margin, .75 at a minimum; use a clean, simple font, not less than 11 pt.; and take advantage of the header space if you need it. Avoid fussy formatting or design. Keep it simple.

Contact Information

Your resumé should start with basic information: name, address, phone number, email address, and link to any professional online profile you might have. Don't include your Social Security number unless specifically asked for it, and don't include any personal information like age, gender, race, etc. Be careful about listing a personal email address that includes a username like "sexygurlnSF@gmail.com" for example. Also, don't use your work email address unless you're comfortable with people contacting you at work. As for online profiles, hiring managers will look you up online whether or not you include a link, so be sure your online profile has plenty of filters in place and that it is scrubbed clean (e.g. no pictures of you drunk at a party with your friends, nothing sexually suggestive, no politically charged comments, no racial or religious epithets, no homophobic remarks, etc.). It may be a free country, but you never know when a potential hiring manager or future boss will take a glance at you online and make a judgment on the spot.

Summary Statement or Objective?

A summary/objective statement is important for several reasons: it frames the whole resumé and sets the expectation for the reader of what she is going to encounter in the resumé. More importantly, if you make it through the cut, it creates the "elevator speech" for the individual (i.e. you get to define how members of the interview group will describe you to one another). Lastly, it has the added benefit of serving as the basis for your own "elevator speech" as you develop your networking skills.

Generally, objective statements alone are no longer used for resumés. You and 200 other people have the same objective: to get the interview. Nevertheless, many people still include objective statements that are poorly conceived and do more harm than good. Here's a (real) example of an objective statement. Take a moment to consider why this may not be a good statement.

- **Creative, conceptual, and passionate,** *with the ability to visualize possibilities and think "outside the box"*
- **Organized, methodical, and assertive,** *from process to product*
- **Industrious, tenacious, and collaborative,** *with a focus on teamwork and the "extra mile"*

What's wrong here? The problem with this vague, emotive example (as nice as the person might be) is that it doesn't really tell the reader anything about what this person has done or what they can/will do in the job for which he or she has applied. While the individual may be creative,

organized and collaborative (all good traits for an employee), the hiring manager is left knowing next to nothing that might make her want to read on. In addition, the jargon is a contrived distraction. "Outside the box" and "extra mile" are among the most frequently overused and outdated phrases used in objective statements.

Here's another bad example:

Goal-oriented professional and life-long learner advocate with expertise in planning and implementing multi-part projects. Motivated self-starter with strong visual-spatial intelligence, exceptional oral, written, and interpersonal communication skills, and proven record of ability in cross-sector collaboration. Passionate about museums!

The problems with this example are many, starting with "buzzwords" that are a "buzzkill." "Goal-oriented," "life-long learner," and "motivated self-starter" are a few of the phrases you should steer clear of (what is a "life-long learner advocate," anyway? What exactly is "cross-sector collaboration"?). It may be true that you are goal-oriented and self-motivated, but you should demonstrate these attributes through specific examples of your work in the body of your resumé, not tell the reader about your personal characteristics. In this example, "multi-part projects" is redundant—most projects are comprised of multiple parts—and the reader still doesn't have a clue about what kinds of projects the applicant has planned or implemented. But the most egregious part of this objective statement is the most over-used and meaningless phrase of all: "exceptional oral, written, and interpersonal communication skills." If you have anything that resembles this phrase on your resumé, delete it now.

It's simply a matter of objectivity vs. subjectivity: who says you possess these skills? You? Your former employer? True or not, you don't demonstrate these skills by saying they are so.

Conversely, try including a short, concise summary statement describing what you do/have done in your career, for whom you have done it, and some hint of your success/impact. Here's where you can weave in a brief objective statement, as long as it is specific and to the point. Your concise summary statement might read something like this:

Education and professional development specialist offering 25 years of demonstrated expertise in successfully developing, implementing, managing and evaluating outcome-based projects and programs for museums and other cultural institutions.

Why does this example work? In short, it tells the reader what kind of professional the applicant is and for how long he has been doing this work; that the individual understands the importance of basing project and program development on sound outcomes throughout the process; and where this work has been done.

Work Experience

The main body of your resumé is your work experience listed in reverse chronology. For each job entry, include your job title, the full name of the organization, city, state, and length of time employed. There is no one right way to list this information, but remember this is a tool for your next employer. Right-aligning the dates, for example, will allow the reader to quickly ascertain how your experience is distributed across your various positions. Our recommendation is as follows:

- *Job title (use the actual job title)*
- *Organization (use the actual and full name)*
- *City, state*
- *Length of employment (be specific to month and year)*

For example:

Assistant Director, Professional Development
American Association of Museums
Washington, D.C.
July 2007–Current (4 years)

Depending on your job level and the museum, there are times when it may benefit you to put the institution's name first. For example, if you were an intern in the education department at the Smithsonian National Air and Space Museum, you might want to put the institution's name first. Be sure to be consistent in formatting for all job entries.

Job Description and Accomplishments

Next, we suggest you include a very brief summary of your job tasks/description, followed by specific accomplishments. Your resumé is not meant to be a full transcription of your position description. Your list of significant accomplishments can be in either narrative or bullet form (keep number of bullets to a minimum–three is good, five maximum); either way, the information must be concise and to the point (tip: try deleting articles where possible— "the," "a," "an," if only to save valuable character space).

Be sure to use powerful (and varied) verbs to lead off each bullet or phrase. Action words like "Managed," "Supervised," "Developed," "Implemented, "Coordinated" are effective because they demonstrate your role in the work. Verbs like "Helped," "Contributed," and "Assisted" are weak, because they deflect attention away from your primary accomplishments.

Demonstrating Impact

One of the areas that most people fail to address in a resumé is demonstrating specific and measurable impact. Regardless of the level or type of work you've done, every job includes tasks or assignments with an end goal or deliverable. Your goal here is to demonstrate to the hiring manager and your future boss that you can do the job and make a difference in the organization. Therefore, be sure to emphasize quantifiable impact whenever possible— how many exhibitions designed, how many visitors attended programs, how many staff supervised, how much money raised through grants, etc. How you communicate your information is critical. Be specific.

Take a look at these examples and see which demonstrates quantifiable impact more effectively. Both examples contain the same basic information.

Arts Program Director
Naples Arts Academy
Los Angeles, CA
1995–2000 (5 years)
- *Created and taught visual arts units, student exhibitions and marketing materials using cross-cultural competencies*
- *Guided arts educators; worked with volunteers; trained teachers*

- *Helped manage partnership program with community organizations*

This first example reads more like a job description and says very little about the impact of these activities. In contrast,

Arts Program Director
Naples Arts Academy
Los Angeles, CA
1995–2000 (5 years)

Developed and co-managed interdisciplinary arts program for K-6 magnet school in multi-ethnic community serving 425 students; collaboratively planned program goals, strategies and assessment.
- *Conceived and taught 125 thematic visual arts units; realized 20 student exhibitions; produced marketing materials reaching 10,000+ people per year*
- *Supervised 3 arts educators; managed volunteer corps of 200+; facilitated arts training for 27 classroom teachers; conducted district-wide workshops in largest elementary school district in California*
- *Managed community support program, Partners in Education; built sustainable relationships with cultural, academic and corporate partners region-wide for financial and in-kind support*

This example contains much more detail—detail that communicates specific information about the scope of the work and the impact the work had on the stakeholders (in this case, students, teachers, community and the school district).

Education

Where you list your education typically depends on where you are in your career. Emerging professionals with little/no work experience will generally list education at the top of the resumé; more experienced professionals at the bottom. Be explicit about degree(s), school, and graduation date (use "anticipated" if you're still in school). It's okay to use the acronym for your degree if you wish. For example:

- **MAT, Museum Education**
 August 2001
 The George Washington University, Washington, D.C.
- **BA, Theatre Design, Applied Arts and Sciences**
 May 2000
 San Diego State University

You may be wondering about including your grade point average (GPA). There is no "right" answer, but generally (there may be some exceptions related to research or academic positions), once you're out in the workforce a few years, no one is paying attention to grades.

Awards, Honors, Recognition

Honors and awards are good to include in your resumé. They convey accomplishment and distinction, possibly setting you apart from another applicant. If you have them, include them, but be honest. If you don't have room, save it for the cover letter, curriculum vitae (CV) or your interview when/if asked. Here's an example:

- *Superior Performance Award 2005*
 SUPRA Corp. (contractor for National Museum of the U.S. Army)
- *Director's Award of Excellence 2003*
 Smithsonian National Air and Space Museum
- *Classified Employee of the Year 1998*
 Kellogg Performing & Visual Arts School
- *Arts Education Achievement Award 1997*
 California Center for the Arts, Escondido

Additional Information

Include on your resumé any skills you possess that are related to the position for which you are applying. Professionals in today's workforce are generally assumed to have basic proficiency in technology-related skills (e.g. Microsoft Office suite), but you should include additional skills as relevant, like database management, project management, or languages (proficient).

Additionally, if you have published a book or an article or delivered presentations, include them on your resumé, but only if you have room. You should also list any professional affiliations, volunteer positions or (relevant) hobbies. Be judicious and conservative with what you choose to include. When in doubt, avoid listing any political, religious or potentially controversial activities unless they are directly related to the position for which you are applying.

References

Don't write "references available on request." Like objective statements, indicating or listing references is no longer customary practice for a resumé. First, it takes up valuable space on your resumé.

Second, they will ask and you should have references ready. Note: be sure you have confirmed people on your reference list, and let them know in advance that you are applying for a job so they're not caught off guard by a random email or phone call from a hiring manager.

Letting Go

Your resumé is a snapshot of you professionally, not a comprehensive accounting of everything you've ever done, every job you've ever had. As you go through your career, the focus of your resumé will change repeatedly. The question to ask yourself is, "(when) does it make sense to customize?" There are times when you may want to tailor your resumé to address specific requirements of a position. If narrowing the focus of your resumé allows you to better present your skills, then you should do it. But be aware there are potential pitfalls to customization. Doing so might imply second-guessing what the institution or interviewer is looking for. Leaving off some seemingly unrelated skill or experience might be a mistake, particularly as institutions look to cross-train or stretch employee's contributions outside the job description. Furthermore, there is a high risk of confusion if you are applying for multiple jobs. Interviews have been conducted where the interviewee has clearly tailored their resumé and become confused about what they should be discussing for this job. You never want to give any negative impressions in an interview. Include all work experience, just lessen the descriptive comments as you go back in time. As you do, some work history will be highlighted, some de-emphasized in

the current version. It's also important to keep all past versions of your resumé filed away for future reference—you never know when you'll need to pull something out of storage.

Keeping Current

Your resumé is metadata about your career. It is an at-a-glance reflection of you and your professional accomplishments. You should consider it a work in progress; whether or not you are currently searching for a job, update it yearly to adjust dates or add significant accomplishments. Plan and make time to update it when you have a performance review or on the anniversary of your hire date. Your resumé is a reference tool for your next employer. A great resumé is simple to use and easy to understand. Make it work!

Do's and Don'ts

Do:

1. Follow submission instructions
2. Make it one page; two page, maximum
3. Make it neat, conservative, use visually easy format
4. Include a summary statement
5. Be honest
6. Be specific, quantify achievements
7. Use good grammar
8. Include dates of employment, account for any gaps
9. Proof, proof, proof
10. Take copy to the interview on quality paper

Don't:

1. Apply for jobs for which you're not qualified
2. Have typos or grammatical errors
3. Use fancy, fussy formatting
4. Use complex format, fancy words
5. Use jargon, buzz phrases
6. Include personal, private information
7. Inflate your role
8. Falsify information
9. List references
10. Forget to proof, proof, proof

Practically Speaking: Give Your Resumé a Strong Start

Wendy Luke

One way of maximizing the positive impact of your achievements and experience and capturing a reader's attention is to create a Summary of Experience or a Profile. It will be a short paragraph (two or three sentences at most) or list, and will appear directly under your name and address. It's likely to be the first thing the employer will read. It succinctly communicates your "brand." You can use a wide array of formats, some of which are illustrated in the examples below. For example,

SUMMARY – Fundraising Professional
Professional with over eight years experience in fundraising, including capital campaigns, planned giving, major gift solicitation, volunteer recruitment and program start-up, design and administration. Certified Fund Raising Executive (CFRE).

Or use a list format:

Human Resources Executive Skills
- *Start-Up HR Development*
- *Training & Development*
- *Leadership Development*
- *Compensation & Benefits Design*
- *Policy Design & Administration*
- *Employee Relations & Conflict Resolution*
- *Corrective Action/Progressive Discipline*
- *Diversity Programming*

Here's another version (be sure to omit examples not relevant to a museum job or examples that make your experience appear fractured).

Summary of Qualifications – Director of Exhibitions
1. *Wide range of exhibition development experience, including incorporating interactive design and program elements into art and history exhibitions*

2. *Grant writing and fundraising experience totaling over a quarter of a million dollars, including minority outreach and corporate sponsorship*

3. *Extensive outreach and public programming experience, with a particular focus on cultural diversity and intergenerational programs*

4. *Responsible for budget development and management of over $200,000 annually*

5. *Skilled in developing a variety of visitor experiences and educational products, including electronic field trips, interactive websites, educational curricula, tours, and exhibition guides*

6. *Applied experience in museum evaluation design and implementation*

7. *Demonstrated leadership skills including supervision, teamwork, and volunteer relations*

If you know the precise job for which you are applying, you may want to tailor your summary to match. For example,

Profile – Collections Management
Provide comprehensive advice and project management relating to a full range of collection management and exhibition activities, including traveling exhibitions, collection policies, cataloguing, information management, and inventory control.

Chapter 8: Do I Really Need a Cover Letter? (Yes, You Do)

Wendy Luke

WE'VE ALL HEARD ABOUT PEOPLE WHO find jobs just by posting a resumé on Monster.com, or someone contacted directly by recruiters, courted by employers, or lured by unsolicited promises of signing bonuses.

But let's face it. You are not LeBron James, and museums are not the NBA. You're not even an associate director at the Met unexpectedly nominated by a major donor for an even better position at the Getty. You are a dedicated museum professional who has networked, capitalized on opportunities to learn, and done a great job in the intern, volunteer, and paid positions you've held. Unfortunately, your resumé looks a lot like the resumés of dozens of other museum professionals. Especially as the job market has tightened in the last few years, a strong resumé and cover letter can significantly strengthen your candidacy.

To maximize the impact of your resumé, never underestimate the power of a compelling cover letter that captures the attention of a hiring manager. Many managers moan and groan over staff that can't write. When you send a well-written cover letter, you let your potential employer know that you stand out from the pack because you have demonstrated a skill valued by the hiring manager.

"But I'm a conservation professional...an organizer ... a do-er," you say. "I work with my hands ... with people ... with numbers. My resumé says it all."

You still need to write compelling, tailored cover letters. Your career advancement depends on it. Here are some guidelines to help you get started:

1. There is no such thing as a generic cover letter. If you want to turn off a hiring manager quickly, send a cover letter that could have been sent to anyone for any job at any museum. A good cover letter addresses, in detail, the specific job for which you are applying. It must describe the skills you bring to this job, the experiences you've had that will make you a success, and how you will contribute to the institution.

Just as important is demonstrating that you are in sync with the specific organization's vision and goals. Refer to your visits to the museum, if you've made any, or to

people you've met who work there. Just referring to those visits or people is not enough, however. You strengthen your position when you reference something you saw that connects with the job for which you're applying. Recount a conversation with a museum employee that piqued your interest. Recall a talk you heard at a conference that helped you gain insight into the museum's future.

If you don't have direct experience with the institution, comb its website. Google the top staff members and read articles they've written. Reference their work. Your letter must convey not merely that you want this job but that you want to work in this specific organization with these specific people for specific reasons.

2. Don't expect your future boss to "read between the lines." In some cases, the connections between your background and the job may be obvious, but don't assume too much. Five years in public outreach programs do not necessarily qualify you to direct those programs. Enumerate times you've performed director-level tasks, made director-level proposals, or substituted for your director at internal or external meetings.

This is also a chance to elaborate on elements of your resumé. Describe your thinking behind the project that led to an award your resumé mentions. Talk about the ways you ensured its success.

3. Brevity is a virtue. Three or four paragraphs should be enough.

This translates to one but not more than two pages. Here's a general rule of thumb:

First paragraph:
- Why you are writing.
- For what position.

- Where or how you learned about the position—for instance, where it was advertised.

Second and third paragraphs:
- Highlight your skills and your specific relevant experience.
- Why you and your skills are a good fit for this organization.
- Why you are seeking this particular job at this particular time.

Final paragraph:
- Describe specifically how and when you will follow up.
- Offer to supply work samples. Enumerate any that specifically pertain to the job.
- Refer to your professional website if you have one.
- Thank the reader for considering your application.

4. Use a formal writing style. Do not use a breezy text message or email style and don't use abbreviations you might use in less formal communications. Use a formal business-letter format. Always avoid slang and use humor judiciously. If you don't know the name of the hiring manager, "Dear Hiring Manager" is an optional salutation for "Dear Sir or Madam."

A formal writing style does not mean that you should use the passive voice or make your sentences very long. To the contrary, use an active voice ("I accomplished this" or "My accomplishments include" rather than "This was accomplished"). Short sentences are easier to read and help the hiring manager better grasp what you are saying.

If your word processing program has a grammar checker, set it to a formal style and consider its suggestions carefully. While it is not a perfect measure of style, it

can alert you to phrases you may need to double check. Similarly, use your "reading ease index" tool, if you have one, to make sure your grade level does not stray above 11; if it does, you probably need to shorten some sentences.

5. Minimize use of "I." Granted, the cover letter is about you. But it's also about the institution you want to work for, the people you've been involved with professionally in the past, and the community the institution serves. If all your sentences focus on what "I" did or what "I" want, you need to rethink your approach. You can totally discredit your strong statements about being a team player by repetitively using "I."

6. Proofread carefully. Candidates have been known to lose interview opportunities because their resumés or cover letters contained typos or grammatical errors. And the spell check in your word processing program is not enough. It cannot catch words you've misspelled but that are words in their own right, as anyone who has ever omitted the "l" in "public" knows.

Even experienced writers have trouble proofreading their own work within two or three days of writing it. We see what we "know" we wrote—that is, what we intended to write. Since you won't have the luxury of waiting two or three days before you send in your application, you must have a trusted friend, spouse, or parent who spells well read both your cover letter and your resumé.

7. Make sure your materials don't get lost. While you'll write the cover letter as if it were being sent on paper, the usual form of transmission today is as an email attachment. Make it easy for hiring managers to find your material in a long list of saved

attachments by titling your cover letter file "Last Name, First Name Cover Letter," (e.g. "Luke, Wendy Cover Letter") just as you title your resumé file "Last Name, First Name Resumé."

If responding by email, state the job for which you are applying, and note that your cover letter and resumé are attached. If the organization requires your salary history and a list of references, be sure to send them as attachments with your initial email.

8. Follow up. You've indicated in your cover letter that you will call the hiring office on a particular date. Do it. Ask if there are additional materials or references you might send. Inquire about setting up an interview. You may get the brush-off. But failure to follow up could give the hiring manager a reason to believe you lack interest in the job or that your ability to follow through on commitments is poor.

Other Words of Wisdom

Part of your strategic job search should be identifying museums where you might like to work, in addition to responding to job postings. If you limit yourself to responding only to job postings, you might not ever find out about the substantial number of jobs that never get posted. Many positions in the museum field are filled through networking, recommendations from colleagues, and individuals who effectively market themselves. Cover letters are especially important when you are targeting an organization you would really like to work for even though they don't have any openings. In this type of cover letter, you are informing the director or a department head about why your skills and experience would be of value to the institution. You

need to be clear about the role you might play in the organization and you must demonstrate that you understand the organization's mission, audience, programs, etc.

When Not To Send A Cover Letter

In reviewing documents sent in response to federal jobs, only the resumé is reviewed. Cover letters are not read so you can save the time and effort of writing a cover letter for this position and focus all your energies on the resumé to ensure it closely matches all of the requirements detailed in the job posting.

Reminder

Your cover letter and your resumé are reflections of who you are and what you have done. They are your advertising tools and promote your brand. Make yourself memorable.

Practically Speaking: Sample Job Posting and Cover Letter

Here is a sample position description and cover letter that might help guide you in crafting cover letters.

Job Posting

Executive Assistant to the Director, Action Museum

Do you have the business and social skills to interact by phone, email, correspondence and in person with a dynamic Board of Trustees, top museum, business, government, and community leaders and a dedicated, highly professional and hard-working staff? Are you passionately aligned with the Action Museum (AM) mission? Do you prefer a daily routine that is typically fast-paced and non-routine, enjoy working with people with a can-do attitude, and thrive on supporting a hard-working, creative Director who travels extensively, a senior management team with heavy meeting schedules, and a Board of Trustees that is committed to AM's cause? Are you especially proud of your sound judgment and discretion, the quality of your work, and your organizational skills? Do you want to engage your business acumen, intellect, and dedication each and every day? If the answer to all these questions is yes, you may want to join AM as the Executive Assistant to the Director.

You will have a minimum of five years administrative experience in support of senior level executives including knowledge of preparing complex board and high-level committee packages and comprehensive board and committee minutes. In addition, you will be proficient in advanced MS Office Suite applications.

Cover Letter

January 31, 2012

Director of Human Resources
Action Museum
Museum Drive
Washington, DC

Dear Museum Administrator:

The position of executive assistant to the director of the Action Museum (AM) advertised on the Museum's website excites me because my experience aligns with the position's requirements and my passion aligns with the AM. My resumé is attached for your consideration.

My museum support experience is varied and extensive, gathered over seven years of performing all general office duties. I am experienced in protocol for an executive office, and would be able to represent AM with professionalism, courtesy and tact. I am energized by providing exceptional customer service, follow up and follow through with my supervisor, museum colleagues, the board, donors, and the public. My previous positions have required me to communicate effectively in writing, including composing correspondence, writing reports, and responding to requests and inquiries; maintain calendars, coordinate meetings, process invoices and reimbursements, arrange travel, and manage logistics for events. Additionally, I have performed research, assisted with preparing/editing documents such as grant applications and assisted with preparing manuscripts for submission to journals. On the office management side, I have been responsible for office purchases and have monitored departmental accounts. I have advanced proficiency in Microsoft Office 2007, downloading and manipulating data, creating and maintaining databases and spreadsheets, and using industry-specific programs.

My broad understanding of museum operations combined with my strong executive assistant skills would be of value to AM. My museum background began as an intern at the Art Museum, located on the campus of the university where I received my art history degree. I interned at this museum during college and worked in a number of departments including exhibitions, curatorial, communications and public relations and development. These assignments afforded me extensive interaction with the public, museum professionals, donors and the Board. After earning my degree, I worked in the development office of my university, concentrating on alumni giving and then at the City Science Center as executive assistant to the executive director.

I am both a museum professional and a professional executive assistant. You will find me organized, self-motivated and able to work on multiple projects simultaneously and independently. Knowing several AM staff and holding them in high regard, including Jane Jones and John Smith, it would be an honor for me to become an enthusiastic AM team member. As requested, my salary requirement is in the mid-upper $40s. Thank you for considering my application. I will follow up with you at the end of next week to answer any questions you may have.

Sincerely,
(Signature)
Typed name

Attachment

Chapter 9: Applying for Federal Jobs (or the Smithsonian)

Maggie Limehouse, personnel manager, Smithsonian National Museum of American History; and **Erika Mack-Dillaber,** assistant personnel manager, Smithsonian National Museum of American History

APPLYING FOR A FEDERAL POSITION CAN be daunting. The process is complex and the competition stiff. Nevertheless, the rewards of federal service are well worth the time and effort. There are federal museum careers in organizations such as the Smithsonian Institution, National Gallery of Art, the presidential libraries, military museums and the National Park Service. Although not a federal agency, the Smithsonian Institution has a substantial federal workforce: about 70% of our employees are federal civil servants. This chapter is a basic introduction to federal employment and a "how-to" on the application process. Since people are often interested in Smithsonian jobs, we have added a brief discussion about the other Smithsonian employment system known as trust (the National Gallery of Art also has comparable non-federal positions), as well as a short note about Smithsonian internships.

A Brief Look at the Basics of Federal Employment

Federal jobs are limited to citizens and nationals of the United States. Only United States citizens and nationals are "eligible" to apply for federal positions. By law, employment in the federal government requires fair and open competition. A person who competes successfully for a permanent federal position becomes part of the competitive service. He or she is sometimes described as having "competitive status" or simply "status." References to the "competitive service" or people with "status" mean employment after competition. There are slight differences in the application for various federal museum jobs. Although all post positions on USAJobs (https://help.usajobs.gov, the federal government's online clearinghouse for employment), be alert for some differences in applications processes.

Please keep in mind that there are exceptions to law that are created by other

laws. For example, Veterans' Preference gives extra points to those who have served in the military; students and persons with disabilities can be hired directly (i.e., without competition) to temporary positions that may become permanent.

Round One

Federal law requires selection for employment based on the applicant's merit, i.e., the experience and/or education of the applicant as compared to the job requirements. Often referred to as "basic qualifications," these requirements are formally described as "one year of specialized experience" equivalent to the next lower grade level in the federal service. An applicant must show specialized experience in order to advance to the second round of competition. Think of the first round as competing against the basic qualifications to obtain a passing score of 70 (of 100). In other words, you have met the "basic qualifications."

Specialized experience is usually—but not always—described specifically. For example, "in an electronic environment, performing duties such as processing museum acquisitions, deaccessions, and disposals; assigning museum registration numbers; documenting legal title to museum objects; and advising on museum accessions processing requirements."

Round Two

In the second round, the basic qualifications are supplemented by questions developed to judge the level of attainment of the *knowledge, skill or ability* (known as KSAs) or competencies being examined. For example, there might be a question about the independence of processing

acquisitions. The questions combined with the specialized experience make up the whole of the qualifications for the particular job. Each question has a value assigned to each choice of answer; the total points for all answers represent a score on a scale from 70 (see basic qualifications above) to 100. The scores (and therefore the applicants) are ranked in order. Think of the second round as competing against the other candidates. The top candidates are referred to the hiring manager.

Trust Employment at the Smithsonian (and also comparable non-federal positions at the National Gallery of Art)

The 30% non-federal part of the Smithsonian workforce is called trust (i.e., private sector) employment. The key difference is the source of funding. Trust positions are not funded by the federal government but by gifts, special project funds, grants or other sources such as the museum shops and cafes.

Trust positions may be "indefinite" (permanent) or temporary. The temporary positions are usually tied to specific projects and limited funding. Trust positions may be announced through USAJobs or may be advertised in journals, list serves, college/university career offices, or by other means. Temporary trust positions may be filled without competition through direct appointment of a qualified and known person, such as an intern. Some indefinite trust positions are also filled directly.

Internships

One way to position yourself for a federal job is through an internship. The Smithsonian internship programs allow diverse groups of people with innumerable interests, strengths, and goals to encounter an educational environment where they can work with and learn from professionals and scholars. Interns range in age, interests and educational status; most are in some stage of their educational process but some may be exploring career change. An internship is an excellent way to gain experience and build your resumé. Most Smithsonian internships are unpaid but some offer stipends. Paid or unpaid, a Smithsonian internship gives you an invaluable hands-on experience and can sometimes lead to employment in the Smithsonian. Go to http://www.si.edu/Interns for more information about internships across the Smithsonian.

You shouldn't be discouraged from applying to a federal position unless it is based on informed knowledge of the qualifications or you are not eligible to apply (e.g., the position is open only to "status" candidates and you do not have status). We encourage you to apply to any job for which you are qualified and interested, even if it is open for only a few days. You won't be hired if you don't apply.

How to Apply for a Federal Position

Most federal positions are advertised through USAJobs (https://help.usajobs.gov).

BEFORE you submit the application by the deadline, prepare yourself.

- Go to http://www.usajobs.gov/
- Set up your account (upper right hand "Sign In or Create an Account")
- Go to http://www.usajobs.gov/ResourceCenter/Index/Interactive/TenTips#icc for valuable resumé writing advice.
- Upload your resumé(s) to the USAJobs format.
- Look at the Help/FAQs part of the site.
- Study job announcements. Some terms and acronyms will be unfamiliar. If you don't know what it means, it probably does not apply, but you can find definitions at https://help.usajobs.gov/index.php/Main_Page

NOW you are ready to apply.
- READ INSTRUCTIONS CAREFULLY ON EACH ANNOUNCEMENT.
- Plan on up to five hours or more for your first application.
- Aim for an early application submission; sometimes there is an early review or cutoff after X number of applications (the announcement should state this) or you run into system problems.
- Most federal agencies and the Smithsonian use automated systems for the first review. This means you will be answering questions that are:
 - Multiple choice
 - Multiple choice/multiple answer
 - Yes/no
 - Any combination of the above
- However, some agencies and some Smithsonian jobs use questions requiring a narrative response for the first review.
- Use key words that relate specifically to the announcement and the KSAs (see above in Basics of Federal Employment)

in your narrative response and be certain they are supported by your job experience and/or education as documented in your resumé.

- There may be a second round of questions sent to those who pass the first round; those questions also usually require a narrative response.
- Your answers are compared to your resumé, which must support the answers or the application may be disqualified.
- Remember to edit for spelling, typos and grammar.
- Be honest but not too modest.
- Supplemental Documents; if you don't know what the document is, it probably does not apply to you unless you are a military veteran, or a current or former federal employee. Commonly requested documents are: DD-214 (military discharge), SF-50 (federal notification of personnel action), transcripts (you may use unofficial transcripts in the initial application but may be asked for official transcripts at a later point).
- Submit—be sure to hit the FINISH (or for some jobs hit the SEND) button to actually submit your application and to FAX or upload any required documents.
- The system will acknowledge that the application was received.

NEXT STEPS?

- It varies among agencies, although all are striving to keep applicants informed throughout the process.
- For Smithsonian positions, you will receive a brief email acknowledging receipt of the application, followed later by an email advising whether you have met the basic qualifications (i.e.,

one year of specialized experience as described in the announcement).

- If you do not meet the basic qualifications, you will not be considered further.
- Next, an email will be sent advising whether you have been referred to the hiring manager (aka selecting official). If you have not been referred, you will not be considered further.

INVITED for an interview?

- If you are not invited for an interview, it is unlikely that you will be considered further.
- There may be an interview panel, typically consisting of the hiring manager and others with whom you would be working. A panel gives more than one perspective of applicants and—if done well—gives applicants a more rounded picture of the job.
- At the end of the interview the hiring manager should let you know what happens next and when. If not, ask.

If you are offered a federal position, the one-year probationary period is the final step of the hiring process—your opportunity to cement your employment. Because probation is part of the hiring decision, take note that you can be separated (i.e. fired) from the federal service at any point during the first year if you fail to meet performance or conduct expectations.

Chapter 10: Working in a Small Museum

Janice Klein, EightSixSix Consulting

OF THE MORE THAN 17,000 MUSEUMS IN the United States, it is estimated that about three-quarters are considered small. Small museums cover the full range of collections and administrative types. They range from the wide variety of objects and records of local importance found in historic houses and county-owned history museums to university art museums with encyclopedic survey collections to "general" museums with natural history, art, and science holdings

What is a "Small" Museum?

While there are many definitions for "small" in the museum world—usually having to do with budget or staff size—one of my favorites is what I call the "plunger" definition, coined by Pat Miller, small museum advocate extraordinaire: "If you've ever had to deal with your plumbing first-hand, you work in a small museum."

Of course, there are more formal definitions, like the one used by the Small Museum Committee of the American Association for State and Local History: "A small museum's characteristics are varied, but they typically have an annual budget of less than $250,000, operate with a small staff with multiple responsibilities, and employ volunteers to perform key staff functions. Other characteristics such as the physical size of the museum, collections size and scope, etc., may further classify a museum as small."

In general, working in a small museum means wearing multiple hats, often at the same time. In my ten years as the director of a small museum, I was responsible not only for administrative and fundraising activities, but also for collections management, exhibition development and installation, membership, PR and marketing, security, and purchasing everything the museum used, ranging from toilet paper to craft supplies to items to sell in the shop. Minor maintenance (like changing light bulbs, shoveling snow and, yes, using a plunger) was also part of the job.

Coping, juggling

One way I learned to cope with the large list of responsibilities was by shutting off one part of the job while performing another. For example, as "head of membership," I regularly had to send out invitations

to the preview of exhibits that I, as "exhibit designer and installer," had not yet finished. One of my volunteers will never forget the day I told her that although I seemed to be standing quietly in the middle of the gallery, the "conservator" was having a furious argument with the "curator," and we had both locked the "registrar" in the closet.

A good way to explain what happens in a small museum is to describe all the very different things done during a "typical day." As Marjorie Schwarzer views it, "juggling only begins to describe a director's day. Juggling, at least, has a predictable rhythm. A day in the life of a museum director is multifarious, its predictability apparent only to a mathematician or expert gambler." ("Turnover at the Top: Are Directors Burning Out?" *Museum News,* May/June 2002.)

Here are a few of the relevant numbers to set the scene: the museum I directed had a permanent staff of two (myself and a curator of education), one part-time staff (who assisted with collections and exhibits), and numerous volunteers with a wide variety of skills. Our annual visitation was about 10,000, half of which were kids on school trips. We had five permanent galleries and a changing exhibit gallery, where we mounted two temporary shows each year. And a budget of a little over $200,000.

A day in the life

My day usually began with checking with the curator of education that there were no immediate emergencies in her areas of responsibility: front desk volunteers, programs, and school tours. In fact on the day I am describing, there was. Because of some snafu, we had over 70 school kids visiting the museum at one time. The result

was a way-too-big group of bright, active kids, with less than stellar parent supervisors, and only one docent. Dividing the group in half, one group touring with the docent, while the other viewed the temporary exhibit with the parents *almost* worked, but ultimately we had to shift the kids to the Craft Room, where I spent the rest of my morning cutting yarn.

I met with my board president at lunch, something we tried to do on a weekly basis, to talk about how to move forward with board development and fundraising, as well as our upcoming Spring Benefit. While I was director, the museum went through a transition from being owned by a college to a separate independent organization. In addition to all the legal procedures that I had to master, I was also heavily involved in helping the new board members understand what governance and fundraising is all about. Teaching the legal requirements of running a non-profit, not to mention museum standards, is often the responsibility of the director, since the board members of a small museum commonly have little previous board experience. It is always helpful to remember that museums are educational institutions, and it's not just the general public that we're educating.

I also talked with a reporter from the local university newspaper who said she was surprised at how much she enjoyed her visit to the museum, as well as editors from two other magazines that wanted to include us in their publications and "could I just send them a list of kids programs for the summer and next fall." Since that was outside of our usual three-month planning window, I had to sit down with the curator of education and do them *now*.

Then there was the visitor with a piece she brought in for "someone" to identify. I

showed her examples of objects on display around the museum, not only of what she had, but how she had confused it with something else, and also spent a little bit of time explaining how she could care for and mount her object.

In between all this, I also worked on a donation of over 5,000 books for the Library, wrote exhibit labels, and researched the grant that was due the following week.

Challenges, benefits

From this abbreviated "day in the life" account, it is obvious that there are a great many challenges in working in a small museum. The limited resources of time, money, and manpower need to be faced not only with a broad knowledge base, but also with creativity, patience, and good people skills. Or, as a perhaps not-altogether humorous job description from the Small Museum Group listserv summed it up: "When not working at the museum, [the director] can fill in as an archangel."

What, then, are the benefits? For me, the answer has to do with the museum's underlying purpose. Museums are no longer the 19th-century "cabinets of curiosities," but instead places of education and, hopefully, wonder. To paraphrase Stephen Weil, today's museums' focus is less about objects and more for people.

My own background is heavily object-oriented. I was an archaeologist before I was a museum professional and archaeology is *all* objects and context. The intimacy and immediacy of a small museum, where the visitors are literally at my office doorstep taught me that it is the individual experience that matters most. A colleague, when asked in a museum studies class what the most important thing

in a museum was, answered "the person who walks in the door," whether a visitor, researcher, volunteer or staff member. Working at a small museum allows every staff member to participate fully with that person.

When I worked at a much larger museum I was, in many ways, shut off from the public. My job as registrar brought me into contact with a great many people—researchers, donors, students, volunteers, and staff from almost all of the museum's departments, from development to education to exhibits to PR. But as at many other larger institutions, it was possible to go to work each day and never interact with the visitors in the galleries.

Impact

At a small museum, because of the size and multiple responsibilities, everything I did had an immediate impact. Listening to visitors helped me understand that a new arrangement of the cases in the changing gallery would make the storyline clearer. So I moved the cases. A teacher from a local elementary school asked if there was "something we could do" with the drawings made by her students of subjects relevant to the museum's mission. Within three weeks we were able to mount an exhibit with labels written by the students, paired with a more detailed text from me. A formal member's opening and publicity photographs of each student with their work sent to the local papers helped these young artists understand that they too could be part of the museum world.

A community place, a community of practice

No matter what its subject matter, a small museum is almost always also a community place. At the small museum I directed, a group of children would regularly stop in on their way home from the elementary school down the street to see what was in the Craft Room, to use the toilets, to get a drink of cold water, or call their parents to make play dates or be picked up. That these families saw us as a safe haven in their neighborhood, a part of their community, may have been as important a part of our work as teaching our "subject." The five- and six-year olds who learned life skills, like sitting quietly, taking turns, and helping each other, is another example of one of the many non-academic experiences to be gained from a museum visit.

The "immediacy" that comes from working in a small museum also provides benefits to the staff and volunteers. All museums are wonderful places for personal learning and growth, but in a smaller institution, the opportunities are generally more varied and the responsibilities greater. Volunteers and interns can develop and implement entire programs, undertake the day-to-day running of the shop, or, as is often the case with small museum board members, provide the museum's accounting or legal expertise.

And, of course, we can also use working at a museum as a more peaceful place to escape from other concerns, just like the visitor getting out of the rain, or for very personal needs, like one of my volunteers, a recent immigrant from Czechoslovakia, who found working at our front desk an excellent way to practice her English.

Finally, even the desire to make a difference and experience that warm and fuzzy feeling from "doing good" can be more personally felt in a small museum. I still have the card that came from an eight-year-old boy telling me that the enclosed (relatively small) contribution came from his job mowing lawns, but that he wanted the museum to have it, since he enjoyed his visits so much. Priceless.

Practically Speaking: Careers in College and University Museums

Linda Downs, executive director, College Art Association; and *David Robertson*, retired director, Mary and Leigh Block Museum of Art at Northwestern University

Academic museums and galleries offer an intellectually stimulating work environment with an emphasis on teaching, research, and interdisciplinary projects that integrate collections of original materials across the curriculum.

Academic museums exist in most cultures, but are particularly prevalent in the United States, with over 1,250 of the nation's estimated 17,000-plus museums located on college and university campuses. Originally founded to house collections of

study materials assembled by the professoriate working in a variety of fields, the oldest campus museums date from the early 19th century and are found on the eastern seaboard at Yale, Bowdoin, Dickinson, Harvard, and Princeton. They are the offspring of European, chiefly British, academic museums in gathering, studying, and displaying objects of art, cultural heritage, natural history, anthropology, history, and science, with the goal of stimulating research, testing new ideas, and—like their parent institutions of higher learning—adding to the knowledge of the known world.

As recognized institutions of high professional standing (over 15% are accredited by the American Association of Museums), academic museums are involved in exhibition development, research, teaching, publishing, and conservation. As museums based at research institutions, they often explore—via exhibition and publication—cutting-edge and even controversial topics in order to expand knowledge and test cultural truisms. Faculty and students frequently collaborate on collection and exhibition research, publications, and educational programs. Museum catalogues are peer-reviewed and respected criteria for judging research productivity for faculty promotion and tenure. In smaller towns and cities, academic museums serve as surrogate civic museums for the entire population.

Professional positions at academic museums mirror those at other museums and include administrators, curators, public program coordinators, exhibition designers, registrars, public relations managers, and security staff. Museum directors and curators often hold academic appointments in their field of study. The staff size is usually small, allowing for staff members to participate in a variety of activities. Academic museums rely on the university's development office, human resources, and legal department to assist, and professional advancement is more often achieved by moving through the ranks at more than one museum.

Academic museums are principally administered under the college or university senior academic officer (provost or dean), who in turn reports to the institution's president and board of trustees or regents. In addition, most campus museums have independent advisory boards consisting of interested university trustees, academics, alumni, corporate leaders, philanthropists, and collectors who have a keen interest in supporting the museum through their knowledge and financial contributions.

Education is central to the role of academic museums. Students learn via for-credit and paid internships, faculty- and curator-led exhibition projects, and even work-study jobs. The professional organization for academic museums is the Association of Academic Museums and Galleries (www.aamg-us.org), which helps lead a national Task Force for College and University Museums and Collections in partnership with other professional organizations.

Chapter 11: Acing the Interview

Katherine McNamee and **Greg Stevens**

WE'VE ALL BEEN THERE AT ONE POINT or another—excited at the prospect of the perfect position in the institution of our dreams on the eve of a job interview. Along with the excitement and anticipation, we may also feel a sense of dread at the thought of the interview itself. If you have not experienced the highs and lows of interviewing just yet, consider that one day soon you'll join the ranks of thousands of museum colleagues who share this universal experience. If you've been in the field for a while, you might consider changing jobs (thus interviewing) as a necessary step to career advancement; for younger colleagues just starting out, you can expect to have multiple jobs and multiple careers in your lifetime (therefore multiple interviews). You may be one of the many museum professionals looking for jobs in today's hard-hit economy and a museum field oversaturated with job seekers.

Against this backdrop, we'll explore some of what you need to know and do before, during, and after the interview to communicate your knowledge, skills, and talents effectively. In the process, you'll gain some insight into overcoming typical interview challenges so you can feel more confident in your next interview.

Preparing for the Interview

First, let's acknowledge the myths and fears often conjured up by just the word, "interview." Many people think of interviewing as a stressful and high-pressure situation, something akin to an interrogation. That fear of being "tested" or having to "perform" is common for many of us. We all want to show our best side and hide our flaws. For some, getting peppered with questions with little time to think out a response can be intimidating. Others struggle with making small talk or talking, let alone boasting about their accomplishments.

The good news is that if you've been asked to come in for an interview, someone in the hiring process must have seen something in your resumé or skill set that made him or her think you might be qualified to do the job, and they are inviting you in to help confirm or refute it. You should feel good about having made it to this stage! Although you may still be competing with a large pool of other qualified candidates,

being selected for an interview gives you a golden opportunity to influence an employer's assessment of your skills.

With that in mind, now is the time to consider your primary goals in the interview: to communicate your talents and qualifications in a clear and relevant manner; and gather information that will help you determine if the position and organization are a right fit for you. In many institutions, behavioral interviews are used to help the interviewer discover how you have acted in various work-related situations. This process is based on the premise that your past behavior generally will predict your future behavior. Interviewers are looking for information that can be summed up in the following categories:

- Knowledge (what you *know*): technical or professional information needed to perform the job, including what you know about the museum.
- Experience (what you *have done*): education and work achievements needed to perform the job; specifically, what experience do you bring to *this* job?
- Competency (what you *can do*): behaviors demonstrated while doing a job; not just *what* you do, but *how* you do it.
- Personal attribute/motivation (who you *are*): factors that lead to job satisfaction, success or failure; this includes how you might fit into the organizational culture

One model that interviewers use in a behavioral interview is known as STAR (Situation/Task, Action, Results). In a STAR-based question, an interviewer may ask you to describe a specific *situation or task* you were given in a past job; what *actions* you took to address the situation; and the *results*

(impact/effect) of your actions.

Are you prepared to answer with specificity and clarity by using several examples from your past professional, academic, internship, or volunteer experience? The advantages of anticipating and preparing for STAR-based questions in an interview are multi-fold: STAR is a practical tool that can help you in crafting your resumé and cover letter. It can help you in answering specific questions during an interview. And later (once you're hired!), employing the STAR model can help you during your performance review/evaluation period.

Additionally, taking several hours to address the following tips will help you prepare for your interview and give you added confidence.

Take an inventory of your transferable skills. Brainstorm first to get them all down on a master list, which you will refer to later. For example, if you previously worked in retail and you're looking to become a registrar, what skills do you have that are applicable? If you were a theatre stage manager, what skills do you posses that would make you an ideal docent or volunteer coordinator? If you performed multiple functions in your job at a small historic site, what qualifies you to become the next exhibitions manager at a large history museum? Determine which skills are most relevant to *this particular job.*

Learn all you can about the position and organization. Visit the museum's website, read the annual report or strategic plan, look up the museum's Tax Form 990 on GuideStar (www2.guidestar.org), a nonprofit reporting organization. Visit exhibitions or programs if possible, learn about who comes to the museum, ask colleagues who might have more information. Find out if there is parking or nearby public

transportation and consider your commute. Call on your inner detective to help you prepare to make observations during the interview about the workplace culture, staff member interactions, communication styles, and other nuances not readily apparent on the surface.

Practice answering common interview questions. Online job boards provide many examples of common interview questions. Pick a few and practice role-playing your answers with a friend or a colleague, possibly using the STAR model. Everyone should be able to talk about his or her passions, strengths, growth opportunities, significant accomplishments, and career goals. If you are shy about role-playing, start by writing your answers down. Then practice saying them in a mirror. Do you sound convincing, sincere, believable, enthusiastic, confident? Can you tie these attributes to your work as a museum professional? Can you communicate these attributes in a brief but engaging way that demonstrates specific outcomes?

Prepare your "toolkit." Come to the interview with three copies of your resumé, letters of recommendation, awards, copies of presentations or writing samples, a portfolio, etc. You may or may not be asked to share any of this material, but have it ready.

Plan to dress for success. Without exception, plan to dress professionally and neatly, head-to-toe. Pay special attention to hair, nails, facial hair, shoes, jewelry, etc. When in doubt, opt for conservative.

Once you have given some attention to these details, you can take your preparations to the next level by considering how you can be fully present and engaged during the interview. Successful interviews are a balance of input (*listening*) and output (*speaking*). How will you engage in

both to your advantage? If you tend to rely on intuition in processing information, how will you utilize this along with factual observations to arrive at conclusions? Does being an introvert or an extrovert make different parts of the interview easier or more challenging? For example, are you:

Quiet Carlos (almost never says a word)?
Balanced Betty (listens and speaks)?
Chatty Cathy (once she starts, she doesn't stop)?

Are you uncomfortable being the center of attention or making introductions and shaking hands? Or perhaps you connect with others easily and sometimes go on tangents or tell stories when answering questions. Are you literal or more figurative in your communication style? How does this influence how you come across to others? Becoming aware of your personality and communication style can reveal how others may interpret your behavior and help you make the best impression.

Most of all, consider the interview process from both sides. The employer's goal is to learn more about your talents and qualifications and to determine if you have the right skills to successfully perform the job and fit in the organization. It is a chance for you to clarify career goals, strengths, and areas of improvement, and an opportunity to practice communicating these skills. Understanding each other's roles and needs makes you a better listener and therefore a better presenter during an interview.

During the Interview

It's show time! Hopefully, your preparations will give you a boost of confidence as you arrive for the interview. While it only takes 30 seconds to make a first impression, don't forget that any impression you make on an

employer can be undone (for better or for worse) during the course of the interview. You still need to keep an open mind, make no assumptions, and put yourself in the employers' shoes.

One aspect of the interview process is asking questions of interviewers, which can be very intimidating for many people. Asking questions in the interview is a significant opportunity for you to assess organizational fit and to reiterate your interest and confidence in your ability to do the job. For example, you may want to ask:

1. *Tell me about the top two or three priorities for this job.* Even if you've read the job description, you can use the response to determine important job functions and to communicate any relevant skills.

2. *Tell me about the organizational culture/ climate.* This can help you determine your fit in the museum.

3. *What results would you like me to produce in the first three, six, and twelve months?* This gets right to the employer's needs and how you can meet those needs.

4. *What can you tell me about your work style?* This will help you better assess if this job and this boss are right for you.

5. *Is there anything else I can tell you about me?* A good question toward the end of the interview gives you one more shot at demonstrating your skills, accomplishments and attributes.

After the Interview

You've made it through an arduous process that takes planning, determination, intense self-reflection, a lot of time, energy and resilience. Whether the interview went well or not, hopefully you've picked up some insights that you can put to use in the future. Shortly after the interview, it's always a good idea to jot down your impressions of what went well and what you can improve upon. Be honest with yourself.

Additionally, make sure you send a thank-you note. An email is fine but a *handwritten note* demonstrates extra effort and usually makes a good impression. Also, respect the decision process. Ask when it is appropriate to follow up and do so *once-* not multiple times.

If offered the job, take time to make the right decision, but be prompt in respond-ing to the employer. If you are *not* offered the job, it's okay to feel disappointed. You invested a lot of time and energy into the job search effort and it can feel like a real setback to be turned down. Remember that sometimes the hiring process is a numbers game. There are often hundreds of quali-fied applicants vying for one position, and just because someone else was selected this time, doesn't mean that you won't be the *most qualified next time.*

Stand out from the pack. Write a thank-you note expressing your disappointment about not being selected and acknowl-edging the positive interviewing process. Express interest in wanting to work for the museum in the future. When a hire hasn't worked out, candidates who have written thank-you notes after the hiring decision was made are frequently called in for an additional interview. Why not increase the probability that you will be considered as a candidate to be recalled?

Lastly, think of one positive insight to take away from the experience and *move on.* Continue to be professional (even in the face of disappointment) because you never know when your paths may cross again, especially in the museum field.

Practicum: STAR Activity

Greg Stevens

STAR

Situation Task

Action Results

The Activity: Spend five minutes writing a brief STAR for yourself—one each for several situations in your past work. Remember, in a STAR-based question, an interviewer may ask you to describe a specific situation or task you were given in a past job; what actions you took to address the situation; and the results (impact/effect) of your actions.

1. For each STAR, imagine one specific situation or circumstance (in a job, internship or academically).
2. On a piece of paper, for each STAR write down in a brief, first-person narrative paragraph:
 • The situation or task you were faced with
 • The action(s) you took to accomplish the task; and
 • The results of your action(s), both on your job directly and on the team, program, department, or institution.
3. Create several STARS, rehearse them, and have them in your mind, ready to go when you're in an interview.

Example:

"I used to work at the museum shop. Every morning before the store opened, I had a checklist of prep work I needed to accomplish—restocking, clean up, sign changes, etc. I would prioritize my work based on what would have the greatest positive impact on visitors, do that work first, and then follow up with the rest of my list. The store was always ready to go at 11 a.m., which was important at our museum because the store is the first thing people see when they come in."

In this example, the first sentence is the situation or task (prep work before the store opened), the second sentence is the action taken (work prioritized and accomplished), and the third sentence is the results of that action (store is open on time and looking good for visitors).

This example also carries more implications for the museum than the actions taken to get things ready for store opening. The fact that the store is the first thing that visitors see when they come to the museum says that this is the first impression made on visitors; these impressions are lasting impressions that may influence how much time visitors spend in the museum and the store—which has an impact on the museum's bottom line. This is the type of STAR you want to be!

Practically Speaking: Interviewing and Negotiating

Nik Honeysett

The interviewing process can vary by institutional policy or practice, preference of the hiring manager, or the type of job being advertised. Throughout your museum career, you may be interviewed on the telephone, in person with a hiring manager or in a panel format, or a combination of all three. Of the many things you need to do in advance of any interview is to brush up your image. In whatever ways people can learn more about you, your job is to make sure all information is current, accurate, and representative of you at your best. As you prepare for your initial interview, for example, you should assume that your social network presence (e.g. your Facebook Wall) has been reviewed. Do yourself a favor in advance by setting filters and cleaning your online presence.

The process relating to the first interview is one of elimination—they are still looking for reasons to cut you from the list—so make sure you are well prepared. Do some background research, make a list of questions, have your resumé and cover letter handy, be somewhere where you won't be disturbed. Note: do not schedule it during your lunch break on a mobile phone—a bad connection will create a bad impression of you. Re-read the posting, as this is your one source of information about the job and it is often a thinly-veiled critique of the previous person in that position—all their negative qualities will be accentuated.

In any interview, someone from the HR department will be a professional interviewer—they interview all the time. Other museum staff are not; as supervisors or department heads, they may hire for a position once every few years and they may likely be as anxious about it as you; this is your opportunity to make them feel comfortable. An HR interview will consist of *pro forma* questions about you (e.g. successes, failures, best trait, worst trait, etc.). By complement, an interview with a curator, for example, will likely be about content, collections you have worked with, publications you may have contributed to, and lectures you have given.

For convenience, hiring managers may often want a telephone interview first. Obviously this is a good sign, but you may need to prepare differently for a phone interview, depending on who will be calling you. Telephone interviews afford the interviewer an easy out, an easy way to say "thanks but no thanks," so your goal with a telephone interview is to make the interviewer want to meet you. When you are invited to an in-person interview, the paradigm has shifted in your favor; there is no easy out and the process has switched from reasons to eliminate you to reasons to hire you.

If you make it to a telephone interview, the hiring manager thinks you have the credentials to do the job. If you make it to the in-person interview following a telephone interview, it means the hiring manager thinks you have the ability to do

the job. The in-person interview is really about whether you are going to fit in.

Interviewing is time-consuming for all concerned, even more so if it is with a group of interviewers, so don't waste their time. It's okay to be nervous or apprehensive, but don't panic. Your goal is to make them visualize you in the job—which you can do by demonstrating the three C's: Competence, Commitment, and Chemistry. I recommend reading *Blink* by Malcolm Gladwell (New York: Little, Brown and Company, 2005). In it, Gladwell suggests whether we like it or not, we all make initial judgments or perceptions on people and things; it's hard not to do and it's hard to change that initial perception. The interview process is one of creating a succession of successful initial impressions of yourself: your cover letter, your resumé, the telephone interview and the interview. *Blink* provides an insight into how and why we think without thinking and create those initial judgments and perceptions—in the blink of an eye.

Consider the process that you are now in. Since the institution is bringing in a number of candidates over a period of time, you need to make an impression and make sure that impression lasts until a decision is made, regardless of whether you are the first or last interviewee. Aside from an excellent performance, ensure that each interviewer receives an *aide memoire* from you—something that at the end of the interview goes into a folder, and is then pulled out when decision time comes. It could be a version of your resumé printed on high-quality stock paper, or a sample of your work. Your goal is to avoid an empty folder at decision-making time. Following the interview, a prompt thank-you card still works more effectively than an email because it goes into that all-important folder.

If everything went according to plan, you'll get a call with an offer; if you get a call with a rejection, always be gracious and polite, because there may be other positions in the future.

With a job offer comes the salary offer, which may have already been discussed during the interview. Depending on the institution's process, addressing salary may happen in a number of ways. The hiring manager may or may not have the authority to negotiate salary. The position may be unionized, in which case the salary is set and you have no opportunity to negotiate; alternately it may be in a grade structure, in which case there are some policies surrounding how much the institution can offer you. Don't be afraid to negotiate, recognizing that salary may not be the only thing to consider and discuss, like benefits, schedule, days off, professional development opportunities, conference trips, etc.

When negotiating salary, you need to have a relevant explanation about why you're asking for a particular amount (sorry, kids and mortgage don't count because they are not the institution's responsibility). For example, you might face a longer or more costly commute, or the position involves more scope and responsibility than your current/previous job; these types of work-related issues should be your focus. How different is this and what reasonable increase does that demand?

An indication that the salary negotiation

is over will come with something akin to the phrase "our last and final offer." This is your cue to accept and discuss a starting date. Two weeks' notice to your current employer is standard, but there may be reasons why you give longer or shorter notice. Never give notice until you have a written offer in hand, one that details the offer and requires your signature. An email offer is close, but is unlikely to stand up as a contract of employment. Sign it, keep a copy, give notice, and try and have a few days between jobs to clear your head and prepare for your next adventure.

Chapter 12: Internships as Stepping Stones

Sandra Abbott *Curator of Collections & Outreach, Center for Art, Design and Visual Culture, University of Maryland, Baltimore County; with* **Greg Stevens**

INTERNSHIPS PLAY A SIGNIFICANT ROLE in the career development of museum professionals looking for skills development, an overview of museum work in a specific discipline, or increased knowledge of and exposure to the field at large. From the institutional perspective, interns provide valuable points of view, knowledge, skills and service to museums, assisting with a wide range of activities.

Interns can be students for whom internships are a requirement (or independent study); recent graduates looking for an opportunity to transition into entry-level work; or professionals coming to museums from another field. In recent years, internships have become increasingly competitive, resulting in fewer paid internships available, more people looking for them, and more museums with staffing reductions and plenty of work to be done but lacking resources to pay staff.

Compounding this dilemma is the increase in the number of museum professional training programs (and students graduating from them), most of which

include internships as part of student graduation requirements. Against this reality, how you approach the process of researching, landing, and performing during an internship is an important part of your career development strategy. This becomes more significant if you have an eye toward turning your internship into a job, as many interns have done.

First Steps Toward an Internship

The smartest way to turn an internship into a job begins *before* you land the internship. Your first step should be to determine what you want out of an internship (beyond fulfilling graduation requirements). Are you looking to work with visitors in public programs, or are you more interested in museum management and operations? Are you interested in working behind the scenes in collections care, or would you like to expand your design skills by interning on an exhibitions design team? Knowing what you want to learn and experience in

an internship is paramount to internship success.

The next step is a two-part, self-reflective one: identify the strengths and passions you bring to an internship; then reflect on your growth opportunities (see Chapter 5 for more on this topic). What do you have to offer the museum as an intern and what does the museum have to offer you?

Third, do some research on what internship opportunities exist across the field that most closely match your interests, skills, and areas for career growth. As you do so, shop museums for internships carefully, as you would for a full-time, permanent position. Read newsletters, blogs, and articles in museum publications regularly to learn which institutions are the strongest fiscally, have high visibility in the museum community, or have announced plans for new exhibitions or programs. For example, you may want to keep an eye out for which institutions are expanding or have just received a large grant or endowment. They will be the most likely to offer employment opportunities in a slow economy.

Next, reach out, connect, network and listen to anyone and everyone who may help you secure an internship that meets your needs—from speaking with alumni of your museum studies program to conducting informational interviews with professionals in the field (see Chapters 2 and 6 for more on these topics). By the time you are actively seeking an internship (in anticipation of museum employment), ideally you are already networking via regional or national professional organizations or committees, like AAM Emerging Museum Professionals groups (AAM EMPs). Many organizations offer reduced membership fees to students and scholarships to conferences to offset costs. Take advantage of these opportunities and take the time to ask questions about the institutions of those you meet. This way, you will learn about the best opportunities from the true insiders.

While the prospect of interning in a museum of any size can be intimidating, you should keep in mind that most professionals who manage interns are used to receiving inquiries, and expect to field questions from prospective interns. If there are no organizational opportunities in your area, create your own. Contact museum professionals for informational interviews before you apply for internships. But do your homework first. Read the museum's website thoroughly. You'll want to be familiar with their deadlines and their basic operations and mission. The professionals you contact will appreciate your better-informed questions, which won't waste their time.

Be a good consumer of your own internship. Shop around, don't sell yourself short, and keep your eyes and mind open to opportunities that may be somewhat hidden. Sometimes your internship might not perfectly match your needs or expectations, but the learning opportunity is just as significant.

The Internship Agreement

Always start an internship with a written agreement. If the museum does not have one (most do), construct your own. It doesn't have to be fancy or notarized, but it needs to state the basic conditions of the internship. At the minimum, it should include a starting date, any compensation or stipend (if you are lucky enough), a job description with specific activities, and an assessment component. Don't forget to include an end date on your internship agreement.

One mistake interns make is continuing endlessly without establishing a definitive end date. Sometimes it makes sense to continue on past an internship end date in order to participate in a special project a new intern would not be ready for, for instance. In this case a new agreement might be helpful so that you don't get caught in the internship indefinitely.

Your internship agreement should include a special project or portfolio opportunity—something you can own as "your contribution" at the end of your internship. Depending on your background, some examples of this might be designing a special webpage, writing all the labels for one gallery, cataloging a small collection, installing an exhibition, or organizing an important component of the annual fundraiser ball.

Before finalizing this agreement, work with your intern supervisor to negotiate your ideal learning outcomes that match the projects and needs of the institution. While "guaranteed job offer" would not be appropriate, there are other ways to steer your outcome in that direction. Some employers allow employees to have the first shot at internally listed jobs before they are advertised. If this is the case, try to get access to this benefit and get it in writing on your agreement.

During Your Internship

It's simple: do outstanding work. Dress for success, in accordance with the established (and observed) dress code of the museum. Show up on time, make your workspace comfortable, and go out of your way to meet others on staff. Check in regularly with your supervisor and don't be afraid to ask for regular feedback. Stay focused on your assigned work, give a little extra when possible, and do it all with low-maintenance attitude and behavior. Enjoy yourself, but remember that an internship is a job in itself, and as a stepping-stone toward employment is tantamount to an extended job interview. This is your chance to shine. Impress them with your standout work ethic, your knowledge of cutting-edge scholarship or technical advances in your field, and your ability to learn fast in order to execute the job with little to no supervision.

Post-Internship Employment

If there is a job opening when your internship ends, your internship supervisor may have some influence on the decision-making to hire you. Your best approach is simple throughout your internship: impress everyone with whom you come in contact. Your good attitude, excellent performance, and ambition will carry you far. If you are one of the fortunate interns who manage to successfully turn an internship into a job, don't let it go to your head. Stay humble, listen, and continue to learn. Consider mentoring new interns while it's fresh for you.

If you find yourself moving on after your internship, arrange for strongly worded, meaningful statements of support, and get them in hand *before* your exit interview. Be ready to draft one if needed, but from the start, try to prepare your immediate supervisor *and* the big boss to write these for you. (See "The Internship Agreement.") Your recommendation-writers will appreciate it if you provide them with an electronic summary of your activities and a candid self-evaluation as a headstart. Always follow up with correspondence

immediately afterwards, thanking them for the opportunities and reiterating what your contributions were. If a hiring opportunity arises after your departure, this will leave an impression worthy of a callback. Checking in occasionally and appropriately is a great way to keep your brand on their radar. Try sending cordial holiday greetings or touching base at annual professional conferences to casually stay in touch without making a pest of yourself. Online social networking is great way to keep them abreast of your ongoing accomplishments and movements as well. This will help to bridge internship-based relationships into life long mentorships, which could lead to employment outcomes at any point in your career. At some point, perhaps the tables will be turned, and you will be the one to whom they are looking for an employment opportunity!

Practically Speaking: Turning Your Internship into a Job

Michael Balderrama

If you ever find yourself near the end of a museum internship saying to yourself, "I really wish I could stick around and take this to the next level," you may have already missed crucial opportunities to make that dream a reality. Turning an internship into a job isn't rocket science, but it requires attention to detail, ambition and inward reflection. That "career seed" needs to be present from day one. You want to be there; you want to prove yourself competent and capable—that comes with the territory of everyday intern work. Still, it goes beyond getting the job done. There's the added element of marketing your uniqueness as an indispensible asset to the organization.

I cannot stress enough: *advocate for yourself*. Find ways of communicating your value to the institution, back it up with your measurable successes in the work you do, and identify colleagues who can validate how important you are. This approach is extremely valuable for pushing a job agenda in the organization while building your technical know-how and exercising your networking skills. If you're lucky, you'll have a supervisor willing to share his/her enhanced responsibilities with you, as well as project ownership. Your supervisor may have a history of mentoring interns inside the organization, as well as supporting a strong professional network throughout the field. Greg Stevens, my intern supervisor in the professional development program at AAM, offered me the opportunity to build my project management skills and networking opportunities by assigning me a lead producer role for a multi-day, multi-part online conference, featuring subject matter experts from across the field. In addition, I co-moderated the program

for an audience of hundreds of museum colleagues, giving me added visibility. In my case, this internship turned into a job. But even if an internship does not lead directly to employment, you will have established a long-lasting relationship with exponential career benefits.

Practice summarizing how your intern work ties to your career ambitions—craft a polished, 60 seconds-or-less elevator speech. If you can, push yourself to collaborate with as many people across the institution as possible. For one, it exposes you to a large number of other career avenues, should job opportunities open up in other departments. It also helps you build on different experiential learning sectors: now more than ever, museums are turning to those "jack-of-all-trades" individuals to help in cross-departmental daily operations. Ultimately, it positions your name (and you!) to become synonymous with the organization—if threat of your absence is palpable, there may be an inclination to keep you around.

Still, the difficulty with a process like this is the time and investment it takes to maintain it. My own job opportunity at AAM matured out of two consecutive internships, numerous projects and long hours, on top of working on my Masters degree at Georgetown University. Nevertheless, I took it upon myself to treat these internships as full-time, 9-5 employment, even when they weren't. Never let an internship guideline—whether from the institution or from your school—restrict you; use it as a springboard to push yourself to exceed those expectations.

There's an Ancient Greek saying—*know thyself*—that I like to use when talking about the "limbo" stage between internship and job. Take the time to ask yourself some difficult but important questions: What are those connective threads running through everything I've done up until this point? How have they fed into my passion for museums? Who in the organization is in my corner? Have I opened my talents up and exposed my genuine interest and confidence in being a permanent part of this institution? Answering these with confidence can put you in the essential mindset to tackle an internship in a way that can position you for a job.

Chapter 13: Helping Hands: Volunteering in Museums

Amy Rogers Nazarov, freelance writer, Washington, D.C.; with **Greg Stevens**

AS MUSEUMS HAVE SOLDIERED ON through the recession, their dependence on volunteers—in steady supply during good economic times, downright heavy in turbulent ones—has grown. Organizations say they are asking more of their unpaid workers—urging a greater time commitment and soliciting specific skills.

An unexpected silver lining to the recession was that many museums could be choosy, with some institutions thinking hard about new ways to put a glut of willing volunteers to work, while other museums were simply out of space to accommodate more. Inboxes containing applications for volunteer positions are still overflowing at many institutions.

But why do people volunteer and why should you? According to Ellen Hirzy in *Transforming Museum Volunteering* (Washington, D.C.: American Association of Museum Volunteers, 2007), museums, like many institutions in the non-profit sector, have a strong tradition of volunteering that benefits both individuals and institutions. Volunteers donate their time for a variety of personal and

professional reasons: interest in the work of the museum, a social outlet, a place-holder for permanent (paid) work, career advancement, community service, and/or lifelong learning. What are your (honest) reasons for wanting to volunteer at a museum? Answering this question will help you determine what type of museum and department you'd like to volunteer in, and if you should consider volunteering at all.

Not only has the number of people seeking volunteer opportunities in museums steadily ticked upward, but the qualifications of these prospective volunteers—from their advanced academic degrees to relevant work experience—are ever more impressive. On the one hand, more skilled people serving as volunteers means museums can launch long-postponed projects that require specialized knowledge, such as building a database, repairing cabinetry, or making use of the Internet's vast marketing potential. But they can also fill the gaps left by their own budget shortfalls. More than ever, skills to perform specific tasks are being sought by volunteer coordinators. What are the unique skills, passions and

interests you bring to a potential volunteer position at a museum? (See Chapter 5 on personal branding to help you in this area.) By knowing and communicating your passions and skills, you are helping the volunteer manager at a museum make better decisions about your potential "fit" within the institution. Not surprisingly, a good "fit" is likely to result in a good volunteer experience, whether short- or long-term.

If you're considering volunteering, you may be like many of today's volunteers who expect a fast-paced, well-managed, clearly defined social learning environment that provides an opportunity to share expertise, build skills for career growth or give back to the community or the museum field. When considering a volunteer position, do your homework. Learn more about the institution generally, its collections, programs and exhibitions more specifically, and most importantly, the structure of the volunteer program in place. Here's a few questions you'll want to keep in mind as you research volunteer options:

- Is there specific and meaningful work for volunteers, work that interests you and matches your skills and personality? Are you interested in working with the public? With collections? Both?
- Do volunteers at the institution have an active role in reaching new audiences/ communities, or embracing new ideas and approaches to specific types of museum work?
- Do you know someone who volunteers at the institution who can give you some "insider tips" about the volunteer work there?
- Is there a formal orientation and ongoing training component to the volunteer program? In what ways are volunteers recognized or appreciated at the institution? What are opportunities for learning or advancing, either as a volunteer or perhaps a paid employee?
- What can you take away from the volunteer experience that will build your knowledge (and your resumé)?
- What can you offer as a volunteer that supports the mission of the institution?

There's an important caveat for you to remember when considering volunteering at a museum: depending on your situation, your volunteer tenure may last only as long as your job search or capacity to juggle some combination of work, school and family life, and museums can't always recoup the value of time spent training you. When unpaid staff members go, the investment of time and training made in them is gone, too. Those charged with bringing volunteers onboard have always asked questions designed to determine why someone wants to volunteer and whether there is a fit, but in the past few years, they encountered another level of employment-related reasons: the pain and frustration of being let go from a paid job, or struggling to find a different one. With this complex reality in mind, you should be as thoughtful about seeking out a volunteer position as you would a paid position. The same rules apply: commit, do great work, follow the rules, make your work and your museum shine!

(Parts of this chapter were excerpted from the article, "Helping Hands," published in Museum *July/Aug 2010.)*

Practically Speaking: Why Volunteer?

Wendy Luke

There are many reasons to volunteer at a museum. Consider some of these reasons that might apply to you and use your answers to guide your decision-making criteria:

- ▓ You're thinking about a museum career and want some first-hand exposure to museum operations.
- ▓ You want to give back to your community.
- ▓ You think you might want to work in that museum and you want to:
 - • Learn its culture
 - • Learn more about the collection

- • Work with visitors
- • Become known and respected by the staff
- ▓ You're between jobs and want a potential place holder on your resumé.
- ▓ You have lost a museum job and want to stay connected.
- ▓ You want to expand your network.
- ▓ You want to make connections to obtain informational interviews.
- ▓ You have a full-time job and want the satisfaction that can come from volunteering.

Career Path: Amy in Wonderland

Amy Duke, Kemper Museum of Contemporary Art

A family trip to Chicago when I was six sparked my love affair with museums. I remember feeling like Alice in Wonderland, shrinking within the Field Museum's grand hall and beside its dinosaurs, and growing before the Museum of Science and Industry's miniature Fairy Castle, giving me the impression that museums were rabbit holes full of mystery and majesty.

Ten years later, at 16, I made a pilgrimage alone to the Museum of Fine Arts, Houston. Despite regular visits to history and science museums, this was my first

to an art museum. I ambled through the galleries until I came to William Adolphe Bouguereau's 1869 painting, *The Elder Sister,* and my eyes locked on the subject's eyes as if I was looking in a mirror. Her features and expression bore an uncanny resemblance to mine as a child (or so I thought at the time), and as an elder sister myself, I forged a curious bond with this painting.

Wanting to share her, I returned with my mom, and in a sudden role reversal, I became the one facilitating the museum experience. From this moment I knew art

and education would be central forces in my life, but figuring out how parallels Alice's discoveries about herself and her encounters with various challenges and quite a colorful cast of characters.

My formative and transformative experiences prompted my studies in art history, and in my last year at the University of Texas at Austin, a workshop on careers in the arts introduced me to the museum field. I haven't always been intentional in my course, but now, mapping the relationships between the positions I've held in museums and the professional development tools I've employed along the way—including volunteering, networking, participating in professional organizations, and tracking transferable skills gained along detours—reveals the myriad ways these tools kickstarted and continue to steer my museum career.

As a student, a flyer on a department bulletin board was the first breadcrumb that led me to a (paid!) internship at Austin's Umlauf Sculpture Garden and Museum where I led touch tours and clay-sculpting workshops for visually impaired and under-served youth. The extensive training offered insight into how museums teach from objects, and helped me increase my capacity for connecting with visitors whose backgrounds and abilities were markedly different from my own.

Upon graduation, I was fortunate to find employment as a personal assistant for the owner of a contemporary art gallery in Houston. The year-long experience taught me, among other things, that I was not destined to work in a commercial art gallery. Without knowing what path I

wanted to pursue, I found value in ruling out this one.

Admittedly, I credit my seventh grade history fair project for what happened next. When I learned that the newly opened Holocaust Museum Houston was seeking a special exhibitions coordinator, I turned to the two survivors I interviewed for my project on the subject; in the intervening years, they had founded the museum. My personal relationships compensated for my limited professional experience and the museum leadership considered my potential as much as my accomplishments. In a young museum with a small staff, I was encouraged to think big and take certain risks. In time, my accomplishments were in balance with my potential and I had gained curatorial, interpretation, and registration experience.

Love eventually led me to leave Houston and land in Kansas City without a job, network of peers, or knowledge of the local cultural arts community. Volunteering at area arts organizations helped me build those resources, and six months later, the Kemper Museum of Contemporary Art took a chance on me as interim registrar. It wasn't the *position* I had hoped for, but the *place* was ideal, and sometimes that trumps other considerations. Eventually the "interim" was dropped and additional responsibilities, position titles, and support staff were added. I found a generous mentor in my director (who entered the field as a registrar) and received invaluable professional development support from the museum to regularly attend (and occasionally present at) national and regional conferences.

Though I enjoyed my intimacy with objects, after eight years, I was missing an intimacy with the public. In recent years, I contemplated graduate school, but these economically austere times have kept me from committing—and then an unexpected opportunity arose to move into a *position* I desired in a *place* I love. Reflecting on the arc of my career to date, I have always worked in mid-sized museums, where, regardless of my official position, I have approached my daily work equally as an educator, fund- and friend-raiser, steward of collections, and more. Putting this philosophy into practice is how I define and demonstrate my potential. It worked again and I now proudly manage the Kemper Museum's adult programs and volunteers. I'll find my way back to school eventually. In the meantime, I'm enjoying navigating this new rabbit hole and providing opportunities for our visitors to shift their perspective and forge connections with art and one another.

PART TWO: ON THE JOB

¿A dónde sera que llevan
para que así las crucemos,
como un corridor de gracia,
que muda la marcha en veulo?

Where can the roads be leading
that we go through them thus,
as passages of grace,
that turn walking into flight?

—**Gabriela Mistral,** Chilean poet (1889-1957), from "Alamedas"
in *Poema de Chile* (1967, published posthumously)

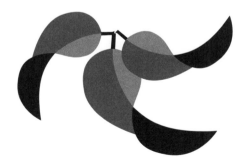

Chapter 14: From Student to Staff Member

Lin Nelson-Mayson, director, Goldstein Museum of Design, University of Minnesota

"Through the University of Minnesota's museum studies program, the class learned about museums' unique challenges, took field trips with collection tours, and discussed current topics with guest speakers from a wide range of museums. This hands-on style was also beneficial to my career. After fulfilling my internship, I was hired by the same museum to work on an exhibition that is touring the country!" —**Jenny Parker**, *University of Minnesota / Minnesota History Center*

Starting Out

The transition from student to staff member is a process of acclimatization to a new environment over time. Unless you are working for an academic museum, the academic calendar with its frantic rush to finals week no longer affects your work timing. Generally, any new job will take about a year to fully understand the annual work plan and program timing.

Combining your classroom knowledge and learning on the job is a challenging opportunity to make a productive

contribution to the museum field. Make the most of the life-long learning environment of the museum and the professional field. Ask questions and look for ways to lead, take risks, and collaborate.

A Checklist for New Employees

Before the First Day

- **Thank the Committee!** Start off your relationship with your new museum by acknowledging your new supervisor's confidence in you as a new employee.
- **Explore the museum's website:** Understand its relationship to the community through current and upcoming activities. What are its programs, who are its supporters, what policies (ADA, tours, etc.) does it state, how does it use social media?
- **Ask your new supervisor or HR person about expectations:** Appropriate apparel, lunch options, workday start/stop times, work week days, personal tools or equipment needs (will a computer be provided or will

you need to bring a personal laptop?), location of office/work space.

- **Parking and transportation:** Review transportation options. If you will be using public transportation, understand the schedule and fees. If you need parking for a personal vehicle, identify available parking and contract terms.

First Day

- **Move in:** Locate your new office/work space and other staff-related spaces that you will use on a daily basis. If you need to sign or clock in, meet security personnel.
- **Meet your supervisor and co-workers:** Get to know the people you will be working with and join them for lunch. Try to learn the names of four co-workers by the end of the day.
- **Go over your new employee checklist:** Your supervisor may have a version of this checklist that includes a review of your job duties and performance evaluation schedule. Review the checklist with your supervisor and complete other paperwork as needed.
- **Fill out employment forms:** I-9, W-4 form, etc. The museum's human resources professional will help with this.
- **Obtain employee identification and email account:** Internet ID, departmental ID (if applicable), etc.
- **Sign up for direct deposit (if available):** This will enable your paycheck to be deposited directly to your bank account.
- **Tour work area and building:** Get to know your museum well. This includes the public areas (galleries, classrooms, emergency exits, restrooms, parking),

behind-the-scenes areas (collection storage, mail room, break room), and more.

First Week

- **Review training and development plan:** Talk to your supervisor about what training you will need and be sure you get it scheduled on your calendar.
- **Partner up with a mentor or buddy:** Talk with your supervisor to see if there is a mentor or buddy program in your museum. If not, ask if there are a few people your supervisor would suggest that you get to know. Make a point of introducing yourself to those people this first week and see if you can meet them for coffee or a walking break at some point.
- **Obtain important contact information:** Ask your supervisor for a list of the most commonly occurring questions in your office and make sure you have contact information for the people who can help you with these questions.
- **Take a tour:** Explore the facilities and grounds so that you are familiar with the museum's resources and people.

Two-Three Months

- **Probationary review:** Although annual performance reviews are the norm, many organizations also schedule a probationary review for new employees sometime between 60 days and six months. Ask your supervisor what the timing is for this and request this as an evaluation of your early performance. This will help you perform better in your job sooner.

■ **Become involved with professional organizations:** Most states have a state museum association, many of which have opportunities for EMPs to network and become involved in the museum community. Other relevant organizations may include regional museum associations, discipline-specific associations, and national museum organizations. Ask your supervisor and co-workers about the organizations to which they belong and why.

Practically Speaking: Museum Professionals Continuum Chart

Wendy C. Blackwell, director of education, National Children's Museum; and Wendy Luke

As you develop your museum professional career, you will expand the depth and scope of your knowledge and increase the impact you have on the operations of your institution. You can use the chart in a number of ways, including what skills and experience you need to gain in order to move up in your institution, and to assist you in selecting the jobs you might want to take or not take. The chart might help you put your career and career steps in perspective.

Description	Emerging Museum Professional	Mid-Level Museum Professional	Executive Museum Professional
Duration	First 5 years	5-10 years on the job One or more positions	10 or more years Has held multiple positions
Knowledge level	Basic knowledge	Seasoned knowledge	Expert knowledge
Perspective	Departmental	Overview knowledge of the organization; in-depth departmental knowledge	In-depth knowledge of the organization and the industry
Budget	None	Creates and/or manages the budget for a specific program/department	Creates the budget for the organization
Operational Knowledge	Tactical	Tactical and strategic	Strategic
Staffing/direct reports	None or interns	Interns, docents, curators, educators, programmers, support staff	Oversees senior-level professionals
Management	Performs or manages tasks and/or projects	Manages programs/ projects and/or department	Manages the organization
Board contact	None	Contributes to board reports or presentations; some contact	Extensive contact
Mentoring	Is mentored	Is mentored and mentors	Mentors

(Chart originally published in Museum, Nov/Dec 2011.)

Chapter 15: The Value of 21st Century Skills

Marsha L. Semmel, *director for strategic partnerships, Institute of Museum and Library Service, Washington, D.C.*

THE DYNAMIC TIME IN WHICH WE LIVE affords our museums the opportunity to strengthen their positions as life-changing, transformative learning organizations. To do so will require a pan-institutional approach that re-examines our missions, visions, and our own organizational cultures in the light of today's learning environment. As museum leaders, we will need to practice the 21st-century skills that we preach, including forging new and innovative partnerships that break down the silos that too often have divided "formal" and "informal" learning, "experts" and audiences, and even different museums. Museums have always inspired learners' imaginations, curiosity, and interests— essential 21st-century skills attributes. Today, we have more ways than ever to continue to play this role.

The world of learning is changing. The combination of a global knowledge economy, the proliferation of digital technologies, and enhanced expectations about the availability of information means that learners of all ages need to master

new skills, are creating new and hitherto unforeseen learning networks, and can access and produce knowledge resources anytime and anywhere. In their book, *That Used to Be Us: How America Fell Behind in the World It Invented and How We Can Come Back* (New York: Farrar, Strauss, and Giroux, 2011), Thomas L. Friedman and Michael Mandelbaum write that in today's world, "one of the most important life skills will be the ability and desire to be a lifelong learner." Students, throughout their working lives, will need to be prepared "to understand a book that has not yet been written, to master a job that has not been created, [and] to conceive a product that does not yet exist."

What does this mean for museum professionals? In my view, it means that the rich resources of museums—of any type of museum—in collections, spaces, programs, staff, and volunteers, need to be harnessed and intentionally repurposed to meet the learning needs of our many audiences. In addition to the core content of art, history, and science, we need to promote the four

"C's" of 21st-century skills: *critical thinking, creativity, collaboration, and communication.* We need to acknowledge and celebrate (and probably re-think) our longstanding role in fostering civic, historical, visual, scientific, and technology literacy. In addition, we are well positioned to promote such increasingly relevant themes as global awareness, and health, financial, and environmental literacy. Importantly, we need to build bridges between our powerful (and still largely tangible) collections and the digital tools and content that are essential to the new learning environment.

In order to do this successfully, we need to re-imagine our museums for this digital age. How are we contributing to knowledge, mastery, and understanding in today's dynamic participatory culture? How are we addressing changing definitions of access and inclusion to engage individuals with special needs and interests? How are we solidifying our place as essential and trusted community anchor organizations that meet our populations' needs? How should we measure success and define our impact? The Institute of Museum and Library Services' 2009 publication, *Museums, Libraries and 21st Century Skills,* and related online resources at www. imls.gov provide a framework and some suggestions for engaging museum staff and boards in this vital conversation.

This piece was written in Ms. Semmel's personal capacity. The views expressed are her own and do not necessarily represent the views of the Institute of Museum and Library Services or the United States Government.

Practically Speaking: Top Ten Job Skills

Katherine McNamee and **Greg Stevens**

In 2009, the Institute of Museum and Library Services (IMLS) released a report, *Museums, Libraries and 21st Century Skills* as a culmination of a year-long process which began with the creation of a Task Force and vetting sessions with leading thinkers in the field who identified such 21st-century skills as information, communications and technology literacy, critical thinking, problem solving, civic literacy and global awareness as the answers to the question, "What sorts of skills are needed to support productive participation in the new 21st-century workforce?" Included in the report was an overview of current and approaching realities:

- Workers will have multiple jobs in their lifetime
- Workers will need to master multiple fields
- Competition is global
- Creativity, interactivity, technical skills, and the non-routine are essential components of work
- Self directed learning is critical
- Organizational cultures are increasingly multidirectional, meaning employees will need to manage from all sides (up, down, and across).

A few years before the IMLS report, author Dan Pink argued in his book *A Whole New Mind* (New York: Riverhead Books, 2006) that any task that can be automated will be taken over by technology and that skills such as design, storytelling, and teaching will be in demand.

More recently, Quintessential Careers, an online website for career advice (www. quintcareers.com) has listed the top ten job skills sought out by employers:

- Communication
- Analytical/research
- Computer/technical literacy
- Flexibility/adaptability
- Interpersonal Abilities
- Leadership/management skills
- Multicultural sensitivity/awareness
- Planning/organizing
- Problem solving/reasoning/creativity
- Teamwork

As a museum professional, how do you process and apply these various sets of information and data about the skills you need to succeed in the 21st-century workforce? What really matters is how this information applies to your career. What skills are needed if you want to design and teach educational programs in a science museum? What background and experience do you need to work as a registrar in an art museum? What skills are needed to be a director at a historic house museum?

One suggestion for answering these and related questions is to start by researching potential skills (or tools) to put in your own "toolkit." Ask people in the field what skill(s) they wish they had been taught in school that they later picked up "on the job." Read job descriptions for various museum positions and see if you can

determine what skills are needed for the work. Do any themes or patterns emerge? Become a "skill spotter." Doing so will help you craft your resume and your career narrative in a way that pinpoints the most relevant skills required.

What's in Your Toolkit?

Use the chart below to identify your job skills across ten dimensions.

1. Identify what skills you currently have in your toolkit in each dimension.

2. Then identify what skills you need to add to your toolkit in each dimension.

3. Articulate in what ways these skills relate to or impact your museum work.

4. Identify how you might go about gaining or improving the skills you need to succeed.

5. Take specific action on gaining or improving on your skills. Don't try to do it all at once; start small (see Chapter 28 Practically Speaking).

JOB SKILL	In My Tool Kit (Be Specific)	Add to My Tool Kit (Be Specific)	How Does this Relate to My Job/Work? (Be Specific)	How Can I Get/Improve This Skill? (Be Specific)
1. Communication				
2. Analytical/ Research Skills				
3. Computer/Tech Literacy				
4. Flexibility/ Adaptability				
5. Interpersonal Abilities				
6. Leadership/ Management				
7. Multicultural Awareness				
8. Planning/ Organizing				
9. Problem Solver				
10. Teamwork				

Chapter 16: We Can't Keep Our Mouths Shut

Colleen Dilenschneider, Millennial museum professional writing about the evolution of cultural nonprofit practices at "Know Your Own Bone" (colleendilen.com).

GENERATION Y. MILLENNIALS.
Generation "Me." The Obama Generation. However you identify yourself (or the 20-somethings working in your museum), one thing is for sure: we function differently from older generations in the workplace. Members of Generation Y (or Millennials, born roughly between 1980 and 1992) have a value set and method of communicating that are different from the generations that came before us. In fact, if you are a Traditionalist (born 1927–1945), a Baby Boomer (born 1946–1964), or even a member of Generation X (born 1965–1979), you may find that the behavior and priorities of members of the Millennial generation are directly at odds with your own workplace desires—or, at least, at direct odds with business as usual. If anything, the sheer size of Generation Y makes Millennials hard to ignore. By 2008, there were 77.6 million members of Generation Y, outnumbering the 74.1 million Baby Boomers.

So what do Millennials want from the museums that employ them, and why should institutions care? Studies have found that our generation has some tall orders that are likely to cause a bit of cross-generational clash. But while these starry-eyed, tech-savvy, entrepreneurial, cannot-keep-their-mouths-shut 20-somethings may have a thing or two to learn from older generations in the workplace, we bring with us a new way of thinking that can benefit any organization—and museums in particular—if given the chance.

Millennial employees want to be included in important conversations, regardless of their position within the institution. From a young age, members of "Generation Me" have been encouraged by elders to speak up and contribute—and we've been rewarded for our input. (On our Little League teams, everyone got a trophy, not just the MVP.) This egalitarian approach may perturb members of older generations who are accustomed to authoritative relationships within the workplace and value the hard work associated with moving up the organizational ladder that they climbed.

But they also bring transparency and accessibility to organizations, which will likely have a positive impact on the museum industry. The social media revolution is in full force, and many Millennials would not recognize a world without cell phones and the Internet. With increasing connectedness comes increasing information-share, and in the current market, incredible value is placed on brand transparency. Accessibility has always been an important aspect of museums' missions, but it is becoming increasingly critical as social technology, online engagement, and crowd-curated exhibits take hold of museum audiences. Most Millennials have communication and transparency hard-wired into their nature. And because we use these tools to communicate with friends and family, we often know how to utilize them with the sincerity that is required for building a strong brand.

Millennial employees value mission and mentorship over money, challenging traditional workplace motivators. That may not sound like a culture clash, but it certainly makes the priorities of Millennials a bit tricky to understand, particularly for goal-oriented Baby Boomers who are accustomed to utilizing monetary reward as a motivating force.

Working for an organization we believe in is often every bit as important to Millennials as the price tag on a starting salary. Because of our generation's desire to achieve and be recognized, mentorship is also an important aspect of the ideal Millennial work environment. Mentorship takes time, though, and time translates to money for older generations. Making time for the mentorship of Millennials is not always a high priority for busy professionals.

But these values also represent a natural alignment with your museum's public service goals. While adjusting to these "softer" workplace desires may require some effort within the museum, having energetic employees motivated by public service is sure to work in the organization's favor. Don't get me wrong: Millennials have more debt and student loans than any generation that came before them, so warm fuzzies aren't going to cut it if we cannot pay our bills. Those emotional rewards, however, motivate us and provide what studies have shown is often very high on our workplace wish list: personal fulfillment by making a positive social impact.

Millennials have a reputation for "overshare" and treating employees equally, even the CEO. Millennials are often regarded as an "oversharing" generation, seemingly tweeting about every meal and putting countless photos on Facebook for the world to see. Another habit contributing to our overshare reputation is the perhaps too casual way in which Millennials offer up input to leaders in the workplace. Millennials are a social bunch and, not surprisingly, surveys have shown that members of this generation prefer to work in groups and share information. Similarly, Generation Y has been found to value teamwork and organic workplace structures. Members of Generation X and Baby Boomers may find this particularly odd, as they've been found to generally prefer working independently and have championed workplace autonomy.

But overshare keeps upper-level management aware of industry trends, and collaboration increases opportunities for competitive advantages. With social technology bringing about almost constant changes in branding, marketing, and community engagement, Millennials

can be a key resource for institutions wrestling with the misconception that museums are organizations frozen in time. You might still cringe when a millennial offers unsolicited input to the department director, but it can help to share different points of view. Studies have found that organizational collaboration helps dodge management groupthink and, in general, makes organizations stronger.

So what's the value in taking note of the workplace desires of Generation Y? A simple response may be, "Because they are the future leaders of your museum, whether you like it or not." But that's not a particularly compelling answer. A better reason is that competitive organizations are becoming more transparent, public-service oriented, and horizontal in structure, with value placed on increased communication.

The evolution of these business practices reflects the values of Generation Y.

Can members of Generation Y be nuisances in the workplace? Maybe. Despite our reputation for over-confidence, we certainly have a lot to learn. But Millennials can also be invaluable members of your organization who help weave the fabric of a strong and strategically sound museum. Each of our respective generations marches to the beat of its own drummer. Though the Generation Y workplace beat is a bit more casual and dissonant than others, we still have the interests of the museum at heart and an aim to make a lasting difference in the communities we serve. And that's pretty cool, right?

(Originally published in Museum, *May/June 2011.)*

Practically Speaking: Generations at Work

Wendy Luke

If you are a Millennial and are early in your museum career, you will have a lot of interaction with Generation Y and Baby Boomers. Your institution's director is likely to be a Boomer. The following are some points to remember that should help you communicate effectively with a Boomer.

- Face-to-face communication is preferred.
- By phone is a close second.
- Email is third.

- Texting is last.

and

- Be sure to answer phone messages and emails promptly.
- When you write, write in whole sentences with words spelled out; abbreviations not wanted.
- Most bosses don't tweet.
- Don't expect your boss to use iPhone apps.

Each generation has a preference for the balance of work and life. It is not always easy for each generation to understand and/or appreciate the preferences of another generation.

Baby Boomers	Work/Life balance (Sequential)
Gen X	Life/Work balance (Sequential)
Millennials	Life/Work Blend (life and work intermingle throughout the work day)

Neil Howe has researched and written extensively on the generations. The following chart summarizes the positive qualities of each generation. As you interact with colleagues of different generations, you may find it helpful to seek out their positive characteristics.

Perceived Positive General Qualities

Millennials (Gen Y)	Generation X	Boomers
Confident	Independent Thinker	Strong work ethic
Sociable	Seeks creative challenges	Willing to take on responsibility
Ambitious	Open to new ideas	Demanding

(*Neil Howe and Reena Nadler,* Millennials in the Workplace, *Great Falls, VA: Life Course Associates, 2010.*)

Chapter 17: Writing Professionally, The Forgotten Skill

Carol Bossert, CB Services, LLC

WRITING IN TODAY'S WORLD IS MORE important than ever. With emails, blogs, list serves, tweets and text messaging, we can literally establish entire communities through our writing. In a way, we have become a nonverbal people. It is as if we have moved back in time to a previous century, one where we communicate chiefly through our letters and correspondence. What will future generations think when they read our emails or tweets? Is this a scary thought? With the stakes this high, it is imperative that we write well.

Business writing has a clear purpose and takes place within a business environment. We write to communicate information, resolve conflicts, persuade someone to our viewpoint, or teach. What is the difference between business writing and other types of writing? Your mother will forgive an email with a misspelled word or three exclamation points; she's just happy to hear from you. Your college roommate knows that the smiley face is just your playful side coming out. Readers of our professional writing, however, are neither our mothers nor our best friends. They are busy people who need written communication to be clear, clean, and direct. In essence, our professional colleagues ask, "What do you need? Why do you need it? When do you need it? What do I have to do?"

This chapter focuses on the types of business writing that most of us encounter routinely as museum professionals: emails, letters, and reports. This chapter provides tips and suggestions for creating clear, clean, and direct prose to communicate our thoughts effectively. It outlines the writing process from organizing, writing, and editing, and offers some tips on specific types of writing. Some of these tips might even help you communicate better with your mother.

Types of Professional Writing

Emails

How many emails do you get in a day? How many contain information that directly affects your work? Created as a way for scientists to collaborate on projects of national importance, email has become a primary means of communication for all

of us. We use email for everything. That's a problem.

Most institutions have rules that separate business email from personal email. It should be obvious that as a professional you should not use your business email for personal matters. However, many of us have professional colleagues who are also our friends. Email makes it easy to maintain friendships and good collegial relationships by quickly adding a few personal lines to the end of a note or forwarding an interesting article. The lines between professional and personal blur. We tend to chatter away informally to everyone, typing the way we talk without regard for how the reader must navigate through our words.

Our electronic communication skills are still evolving. Numerous websites provide tips on email etiquette. Like all rules, some will stick and some will not. Each organization seems to develop its own internal set of email do's and don'ts. So in addition to knowing the rules of your home organization, here are a few tips for business emails:

- Never use all capital letters in an email. Many people assume this convention means the writer is shouting or conveying anger. All-caps is also difficult to read.
- Write a clear subject line. This lets recipients quickly get an idea of what the email is about.
- Avoid using words like URGENT or ACTION in the subject line unless you know that the recipient responds to—and appreciates—these directives. Otherwise you sound pushy or impatient.
- Avoid creating long lists of cc recipients. Think carefully about who really needs to read and respond to the email.

- Avoid "me too" replies, especially if you are part of a long list of recipients. It may be necessary to let everyone on the list know you can make the meeting on the 15th, but once the date has been sent, you don't need to tell everyone that you're "looking forward to the meeting."
- Keep emails brief. Keep the body of the email short and to the point.
- If you find yourself writing an email that goes beyond two paragraphs, consider writing a letter instead and sending it as an email attachment.
- Apply the rules of good presentations to emails. Use standard fonts and point sizes. Save colors, scripted fonts and emoticons for personal emails, if you must use them at all.
- Always sign your email. Make sure that you have included a signature line that has your contact information and the name of your company or organization.
- Remember that emails are a harsh communication medium. Always begin an email with a simple salutation like "Hi" or "Dear Sue." Avoid beginning an email with the recipient's name alone. Use a closing as you would for a letter.
- Avoid writing wry or witty comments if the email is going to someone you don't know well, including anyone on the cc line.
- Remember that emails can be copied. Forwarded emails take on a life of their own. Never write anything in an email that you wouldn't want everyone to read. There is no such thing as a confidential email.

Letters

Business writing still involves letter writing even if the letter is delivered electronically.

A letter should include the date, the recipient's address, your address and a salutation. Keep the length of the letter to two pages. State in the first paragraph the purpose of the letter and what action you want the recipient to take.

- Do not begin the letter with "I am writing you..." or "The purpose of this letter is..." These statements are obvious and wordy.
- Use an appropriate salutation such as Dear Mr. Smith, or Dear Jeff.
- Avoid impersonal salutations such as Dear sir or To whom it may concern.

Reports

The first paragraph—or for longer works the first few paragraphs—will catch readers' attention and guide them in a logical way to the main idea—or purpose—of your writing. Like the large end of a funnel, the first paragraph pulls readers in and channels their thoughts, leading them to the last sentence of the first paragraph that expresses the main idea—the purpose—of the report.

The following paragraphs form the body of the report. Like building blocks, each paragraph uses examples and details to support the report's main idea.

The concluding paragraph, or paragraphs, reminds readers of the main idea and funnels them out of your writing, leaving them with a sense of satisfaction and a way to remember the main idea as they return to their busy lives.

The Writing Process

Whether you are composing an email or a multi-page report, all writing projects have three phases: organizing, writing, and editing.

Step 1: Organize

Good writing begins with good thinking. Before you put "pen to paper" it is important to know:

- **Why?**
 Are you writing to communicate information, persuade someone to do something, resolve a misunderstanding, or complain about an issue?
- **Who?**
 Who is your audience? What is their knowledge about the subject? What is their viewpoint? Does your audience understand the technical terms and jargon of your organization? Are you writing to museum members or to a potential donor?
- **(So) What?**
 What do you hope to achieve from your writing? Do you need to communicate the date, time and purpose of a meeting? Are you trying to persuade a potential donor to see the value in your museum's project? Is there a specific action that you want the reader to take?

WAYS TO ORGANIZE

The act of getting our thoughts out of our brains and onto paper is an essential part of the writing process. Sometimes our ideas flow in a logical order and writing the outline becomes as mechanical as writing a shopping list. But often our thoughts seem to tumble out without any apparent order.

There are many ways to organize your work, from dashing off a few notes on a yellow pad to developing a detailed outline on the computer. There are even specialized software programs that can turn raw thoughts into outlines. An outline organizes your writing. To start your outline, jot down the main points that you want to get across. Under each point write examples

that support the main point. Add details or facts under each example.

You can also begin by writing every thought or idea on its own sticky note or note card and then group like ideas together to create a visual outline.

Get into the habit of jotting down the main idea or purpose of your writing, even for emails or short letters.

Step 2: Write

If you have written a very detailed outline, chances are you have already written some good sentences. These sentences, particularly those that describe key points, become the subheadings of your document. With these key points in place you can begin to fill in examples and details that support the key points. At this stage, it is not important how nicely you're constructing the sentences, whether you use active or passive verbs, and how "dangly" your modifiers are. Get everything down on paper first. There will be time to edit later.

VOICE

A neutral voice that uses nouns and refers to everything in the third person (he, she, they, its) used to be the standard for professional writing. This is changing. Neutral language can result in stilted, formal prose that detracts from rather than promotes direct communication. Neutral voice can easily devolve into passive language and wordiness.

First person (I, we) and conversational tones (you, me) are becoming more acceptable in professional writing, especially in emails and letters. If you think that your writing seems dull and lifeless, try writing in first person. However, always be mindful of the style requirements of your organization and the expectations of your audience.

STYLE

Every organization has its own style. Many have a written style guide that describes how specific abbreviations are used and how certain punctuation rules—like the second serial comma—are followed. Make sure you follow your organization's accepted styles. If you are writing for yourself, use well-recognized style standards, such as those found in the *Chicago Manual of Style* and the *Associated Press Stylebook*.

GRAMMAR AND PUNCTUATION

Grammar and punctuation are the structure that holds writing together. Like traffic regulations, grammar rules keep us all moving along together without mishap or misunderstanding. Most readers will forgive a misplaced comma or lack of adherence to one of the more arcane rules of grammar, but misspelled words, lack of punctuation, or incorrect verb usage are major roadblocks, distracting readers from your ideas.

PRESENTATION IS IMPORTANT

In our busy business lives, most of us scan more than we read. We want to pick out key points and ideas quickly. Consider how you can make your writing easier for busy people to read. Take cues from newspapers and popular magazines: use subheadings, callouts, bullet points and illustrations to telegraph important points.

Use a standard font and a 10-12 point type size. Use black ink or dark color for the body copy. Double space between paragraphs and single space within paragraphs. Make sure that every document contains a title and date. Include page numbers for multi-page documents.

WRITER'S BLOCK

All writers get blocked. Words don't flow and writing a powerful sentence—any

sentence—feels impossible. Most of the time, writer's block is temporary. A walk around the block or a brief break will relieve the stress. Brain research shows that our brains need time to process and mull things over. Time spent in the garden or on the treadmill are times that our brains are actively processing our thoughts. "Sleeping on it" is a real method for overcoming writer's block. Putting the writing away and coming back to it in the morning can be like waving a magic wand: the words flow and the piece seems to write itself. But what if that magic doesn't happen?

GO BACK TO YOUR OUTLINE

Keep filling in the outline, adding details, reorganizing, and making complete sentences out of ideas or phrases. Eventually you will have all your points down and it is a matter of connecting the sentences. You can ease your way toward the editing step.

RAPID WRITE—WHAT CAN GO WRONG IN 10 MINUTES?

We've all been there; it is 5 p.m., the page is blank, and the report is due in the morning. You can't think of anything to say. One way to get over writer's block is to write through it. Set a ten-minute timer and write. Write anything that comes to your mind. Write that you don't know what to write about. Don't stop. Keep writing until the timer sounds. Reread what you've written. Most of it may be stream of consciousness, but something may stick out, a few words that spark an idea that you can develop further.

REMEMBER TO WRITE FIRST, EDIT SECOND

Premature editing kills writing flow. In our word-processing world it is easy to stop writing and begin editing. We start hitting

the delete key before we've even finished a sentence, let alone completed a thought. Resist the temptation to edit before you've finished writing.

Step 3: Editing

Take the time to review and edit everything you write. How many times have you hit the Send key and regretted sending the email?

Editing is more than a spell- and grammar-check. Editing makes sure that the writing is clear, clean and direct. Editing requires dispassionate pruning, removing what is extraneous, unhelpful and unnecessary. In this regard, professional writing is different from other types of writing. Let novelists paint scenes with words, build anticipation, and lead the reader on an intellectual romp. As writers of business prose, we need to make our points clearly, cleanly and directly.

- **Clear**

 Is the purpose of the writing clear? If the email is meant to communicate a date and time for a meeting, can the reader easily find this information? Can the reader discern what they need to do in response? In a longer document, do ideas progress in a logical sequence? Is the writing cluttered by questions that remain unanswered, or by too many details?

- **Clean**

 Is the document presented in an easy-to-read font and point size? Do subheadings, bullets, and call-outs make it easy to scan and find key points? Is the writing clean in terms of grammar and spelling?

- **Direct**

 Does the writing communicate your meaning? Have you written too much?

Have you repeated yourself? Have you removed excess wordiness, jargon, and overused phrases?

TIPS FOR EDITING YOUR OWN WORK

Read aloud. Your ear reacts to the awkward phrase or wandering sentence that your eye may not.

Let it rest. Putting the work aside for a day or two lets you forget what you were trying to say and read what you actually wrote.

Let someone else read it. Ask a colleague or friend to read your work and give you feedback about what was clear and what wasn't.

Edit a hard copy. Much has been written about whether there is a difference between editing on a screen versus a hard copy. While software programs are making it easier to edit online, there still are some errors that I can only recognize in a different format.

Color-coding. Use a color highlighter to identify all the nouns. Do you use the same noun repeatedly? Can you use synonyms to make the writing more interesting to read?

Use another color to highlight verbs. Are the verb tense correct? Do you use active verbs? Do you use the same verb repeatedly? Can you find different verbs, stronger verbs to communicate more effectively?

Use a third color for adjectives and adverbs. Have you used the same adjectives or adverbs repeatedly? Could you use a stronger verb or more precise noun to do the job of the modifier?

TIPS FOR EDITING OTHER PEOPLE'S WORK

Be gentle. When a writer comes to you with a piece to edit, she is entrusting you with her creative self. Imagine the writer coming to you with a baby bird cradled gently in her hands. As the editor you have the option to nurture this baby bird of creativity or squash it flat.

Being a gentle editor does not mean accepting poor writing. It means providing constructive advice in a way that encourages the writer.

- Be clear as to the type of editing advice you are giving. Make a distinction between the content of the piece and the mechanics.
- Find something to praise in the piece.
- This is a fine time for neutral voice. Instead of direct confrontation, offer insight from the reader's perspective. Rather than saying, "You need to rewrite the second paragraph on page four," try saying, "As a reader, I lost the thread of the argument on page four. What is it you are trying to communicate here?"
- Use blue or green color to make comments. Never use red. The editor's pencil is blue for a reason. Red makes us "see red."
- Keep up with changes to accepted grammar rules. Know what remains a hard and fast rule and what is open to interpretation. Work with the writer to find the best solution.

More Tips for Good Business Writing

The English language is a living language; acceptable grammar, punctuation, even spelling rules change over time. Some of the grammar rules you learned in 10th-grade English are no longer relevant. If you want to write well, take time to read about writing. Invest in one or two books about composition and take advantage of online resources. Answers to many of your grammar questions are just a click away. In the meantime, here are a few things to keep in mind.

Spelling

Spell every word correctly and use the correct word. Most software programs autocorrect or underline a misspelled word, but spell check software does not catch every spelling error. Spell check does not know the difference between *role* and *roll*.

Pronouns

Make sure that you have used pronouns properly. Make sure that the subject to which the pronouns refers is clear. For example:

Confusing
John will be helping Stan with the ceremony this year. Be sure to contact him for further information.

Better
John is helping Stan with the ceremony this year. Please contact them for further information.

Verb Use

Use the correct verb for the subject. Two subjects in a sentence require the plural verb form. For example:

Incorrect
The volunteers and staff talks on Tuesday.

Correct
The volunteers and staff talk on Tuesday.

Do Not Boldly Go

Do not split the infinitive. In grammar, the infinitive mode of the verb contains two words: to and the verb. "To go" is the infinitive form of go. In our oral language we often split the infinitive and it sounds natural to our ear. We say, "Hey, I'm going to *really* pick up the yard trash today."

Some grammarians are giving the split infinitive a pass, citing cases where the split aids clarity. But split the infinitives at your own risk. For many people, the split infinitive is one of the grammar rules they remember from high school, and they will react negatively to it—and to you—when they read it in your work. In business writing it pays to be conservative.

In most cases the split infinitive issue is avoidable with a different verb choice. For example:

Incorrect
We plan to boldly go forward with the campaign.

Correct
We plan to go boldly forward with the campaign.

Better
We plan to advance the campaign.

Modifiers

Adjectives, adverbs, and clauses modify or qualify the nouns or verbs in a sentence. A well-chosen modifier is powerful. Country music lyrics have great examples of effective use of modifiers; a single word can paint an entire picture or communicate a

nuanced feeling, but too many modifiers or misplacement of modifiers can bog down writing and lead to confusion. For example:

Confusing

Families are eligible for museum membership within the region.

Clear

Families within the region are eligible for museum membership.

Use Words Correctly

Know the meaning of the words you use and use them correctly. Improper use of a word and using complex words when simple ones will do are hallmarks of poor writing. "Irregardless" is not a word. "Regardless" is the word you want.

Run-on sentences

Sentences that go on and on without break are called run-on sentences. If you've written a sentence that takes up three or more lines, try breaking it apart. For example:

Run-on

Our program will begin with special events next Saturday running throughout the day.

Sentence

Our program will begin next Saturday. Special events will run throughout the day.

Wordiness

Make every word work for you. You can reduce wordiness by using action verbs and active language. For example:

Wordy

We anticipate that we will begin the campaign next April.

Better

We hope to begin the campaign next April.

Strong

We will begin the campaign in April.

Replace Passive Language with Active Verbs

Some technical professions such as science and medicine continue to use passive sentence structure in the belief that it maintains neutrality. Yet for most of us, active verbs and direct language strengthen writing. For example:

Passive

There is a need to decide upon a direction.

Active

We must decide upon a direction.

Wimpy Words

We use words such as *actually, seriously, really,* and *only* in oral language to emphasize a point, as in "I couldn't believe he actually said that." While these words have meaning in conversation, they rarely add clarity to our writing. They represent word clutter. Remove them and your writing will be trimmer, cleaner, and clearer to your readers.

Avoid jargon, slang and overused phrases

Every profession has jargon, words that are unique to a field of study. However, using jargon with general audiences makes writing pretentious, or worse, unimaginative. Avoid slang in business writing unless you are sure that it will be understood—and appreciated—by your readers.

Overused terms and phrases

Words and phrases go through cycles. Some become clichés, others are so overused that they become meaningless. See if you can write without using:

Cutting edge

Obviously

Near miss

Safe haven

Thinking outside the box

At the end of the day

For the most part

In general

For some reason

Including, but not limited to...

Punctuation

Consult a college-level grammar guide if you are unsure of or have forgotten how to use common punctuation marks. The *Associated Press Stylebook* can help you answer questions about capitalization.

Summary

Every business professional should know how to write well. Good business writing is clear, clean, and direct. Successful writing begins with clear thinking, so take the time to organize your thoughts before you begin to write. Know what you are trying to accomplish with your writing, and know who your readers are.

Writing involves more than the mechanics of putting words together into sentences. Be aware of how subheadings, bullet points and call-outs can make your writing easier for readers to follow. Don't skip the editing step, even on simple emails. Be sure that everything you write is spelled correctly and follows accepted grammar rules. Learning to write well takes practice, but is worth the effort.

Chapter 18: Using a Career Journal to Document Achievement

Elizabeth L. Maurer, *creative director, Re-Living History*

IT'S PERFORMANCE REVIEW TIME AND you're having trouble recalling the many accomplishments you've made throughout the past year. Or you're updating your resumé in preparation for a job application and you can only think of a few of the significant achievements you've made at your current job. What do you do?

In a competitive economic climate where there are more applicants than jobs, candidates who can demonstrate that they have the most relevant skills, knowledge, and abilities will have an edge in the job search. Those who wish to advance within their current organizations must be prepared to build a case to supervisors to receive promotions, raises, and new responsibilities. While there are a number of approaches you can use to track and review your accomplishments, this chapter will focus on keeping a career journal.

A career journal is a valuable tool to help you keep track of what you do every day and pay attention to your project goals, your processes, and your results. As you keep it up faithfully, you will find over time that you can recognize and quantify your achievements.

Career Journal Format

A career journal template can take many forms. Your journal template will be unique to you, and the possibilities are endless. You may choose to record information in a spiral notebook while others set up a database. An up-to-date, highly detailed LinkedIn profile is a form of a journal with the bonus of being searchable by recruiters. You might consider starting a blog set to non-public view, posting updates via email. There are several note-taking apps available for the iPad and iPhone, which could easily be adapted to capturing career information (a sample worksheet is provided with this article). Whatever format you choose, the important thing is to set aside time to update your journal. Regularly recording information and activities, including measures of success, ensures a higher level of accuracy. Trying to recapture information well after the event is difficult, and critical details may be overlooked, or supporting data may no longer be available.

Career Journal Function

A career journal fulfills several useful functions. At its most basic, it is the depository of the key facts and figures of your employment history. The essential elements of a career journal include:

- Employment. A section to track your work history: whom you worked for, your titles, dates of employment, names of managers, promotion record, compensation history, position descriptions, and performance reviews. This section, kept in electronic format, will be especially valuable whenever you need to provide your employment history, whether you're applying for a job or graduate school. You will be able to copy and paste this information readily into online application forms. This will save you time because you can immediately find the information you need and it will have already been proofread for accuracy.

- Projects and Responsibilities. A list of projects or ongoing tasks that include descriptions of your role, project goals, methodology used to meet goals, measurement metrics, and why the goal or task was important to the organization. Include here challenges and how they were met, existing skills you used and new skills you acquired, key personnel with contact information, and recognition or awards. Apply the same process to each project and team assignment you undertake. Being able to clearly describe how your process was effective demonstrates your competencies.

- Training. All training that was acquired and/or applied in a career context.

Link training to on-the-job tasks. For example, a photography class may have been taken outside of work, but photography skills were used on the job.

- Professional Activities. Record participation in conferences, publications, professional organizations, community organizations, and networks. Capture event dates, conference and publication titles, names and contact information for key people, description of your participation, and outcomes.

Ways to Use Your Journal

Your journal is an active document that encourages you to be self-reflective while also identifying areas of improvement.

Self-Advocate. Over the course of your career, you will be asked in job interviews and in your responses to performance appraisals to demonstrate your value as measured both by your accomplishments and your skill set. It is critical to maintain documentation if your job changes significantly over time. You may have assumed more responsibilities as you developed new interests or the organization launched new initiatives in which you were a key player. Show how your achievements have benefited the organization in order to advocate for a raise, promotion, or better job title. Your journal will provide the documentation that supports your bid for recognition.

Gap analysis. While making entries in your journal, reflect on where you are and where you need to go. Assess what resources are necessary in order to complete a project successfully. A career journal is helpful in revealing gaps in your skills and proficiency areas. Compare your skill set to the skills needed at the next

level in your organization or advertised in job announcements. Are there skills that you will need to acquire or improve in order to be promoted to or apply for another job? Also consider whether you will be able to acquire new skills within your current job or will need to seek outside training. Make it a priority to engage in self-directed learning to close your skill and experience gaps, and then log them in your journal. Use your journal experiences to let your boss know how you've helped your institution. Having this information will allow you to interview with increased confidence.

Reflect on and analyze successes and failures. As you review your journal, reflect on and analyze both your successes and failures. What worked, what could have been done differently, what variables could have been adjusted in order to get a different outcome? If you worked on a project that was not successful, the ability to analyze what went wrong and describe what you would do differently in the future may impress a supervisor or subsequent job interviewer with your ability to learn and grow from mistakes. Having a very clear idea of how you have performed on past projects, including your missteps as well as successes, helps you to better articulate your professional competencies.

Tracking Projects. A detailed journal will include entries for work projects, teams, and ongoing duties. Before starting a project (or when evaluating a past project), make sure that the project goals are defined and that you understand how the organization will evaluate competency in an on-going task or its criteria for success in a project. As you undertake work tasks, note your progress towards meeting goals. Periodically measure your work against the benchmark to determine whether you are meeting or exceeding goals.

Remember your network. Your journal is a handy way to keep track of your professional network. Capturing contact information for your professional network in one location will facilitate your future outreach to the colleagues you meet outside of your organization. Your role as a volunteer on a professional committee or as a conference presentation panelist is as valid in showing career progress as your paid employment. Achievements in professional and community organizations also demonstrate competencies and stature. Reserve a special section of your journal to record your outside activities. As with your job responsibilities, make sure that you define the goal, describe your process, and measure your success. Be sure to record the names and contact information for all the people you collaborate with on your outside activities. Having all this information in your journal can facilitate your future outreach to the colleagues you meet outside of your organization. These contacts can be valuable when you initiate a job search or when doing research on a project for your museum.

Chart your path. When actively used, a career journal becomes a powerful instrument used to analyze your career and chart your future career path. Log information about the challenges you have faced, the skills you have built, and how you have used those skills to solve specific problems. As you enter information, reflect upon those experiences and how they have contributed to your professional growth. Measure your skills and abilities against the benchmarks in your field to determine where you stand in relation to everybody

else. Your journal information can provide the basis for future decisions about your career path, such as whether to pursue additional training, seek new opportunities, or rise within your current organization. It is a tool that encourages the active self-management of your career.

To feel good. Periodically review your journal. You're likely to feel good about your accomplishments, including all the ones you have forgotten about.

Career Journal

Organization/Company _____

Address 1 _____

Address 2 _____

City, State, Zip _____

Main Phone _____

Web Address _____

Company/Organization Description (mission statement, etc.)

Job title _____

Department _____

Starting Date _____ Ending Date _____

Starting Salary _____ Ending Salary _____

Position Description

Full time/part time/volunteer_____ Hours per week_____

Supervisor Name/Title _____

Phone _____ E-mail _____

Other Reference Name _____

Phone _____ E-mail _____

Address _____

Notable Projects (Describe goals, how goals were met, and your role):

Specialized Training and/or Skills:

Professional Activities (Conference presentations, Publications, Professional Committees)

Practically Speaking: Year-Round Performance Management

Wendy Luke

Many employees and managers see performance evaluation as an annual—often dreaded—conversation that focuses on what went wrong over the past year. Organizations can change this de-motivating experience into a platform for success by turning performance evaluation into performance management.

Performance management involves a frequent, often informal look at where employees are and where they are going. It's a non-threatening approach to performance that emphasizes lessons learned and achievable goals for the next few weeks or months.

The Employee's Role

- Periodically review your position description and the goals you and your manager have set. Are you filling your responsibilities and making progress against your goals? What more do you need to do?
- Keep a file—electronic and/or paper—of projects you have completed, reports or letters you have written, task forces on which you volunteered, recognitions you've received from colleagues and visitors, and other examples of the quality and volume of your work. This file becomes a handy reference when you are preparing for your annual performance review.
- Volunteer to help colleagues and record what you've learned from those experiences.
- Volunteer for new assignments and discuss the reasons for volunteering with your manager. Ask for resources you need.
- Get a mentor to talk with you about areas in which you would like to improve and grow.
- After each major project or event, assess your contributions, what you have learned, whom you learned from and how you can use this information in your ongoing responsibilities.
- Ask trusted and valued colleagues for specific feedback as soon as possible after a meeting, presentation, or other event and assess what you can learn from the feedback.
- Make a point of talking with your manager at least once a quarter to get feedback on performance and progress.
- Think about the attributes of a great employee and be one.

The Manager's Role

Managers set the pace for year-round performance management.
- Check in periodically with each employee and listen to his/her assessment of performance against responsibilities and goals.

- At the end of each major event or project, ask project participants—in a group or individually—what went right, what went wrong and what the group might do better in the future. Ask each team member how the project contributed to the organization's goals as well as to their own personal goals and learning.
- To help an employee develop and grow, talk with the employee about the skills and knowledge she would like to gain or use on the next project. Suggest tasks that can help develop the employee's career. Have the employee think about what she finds challenging, rewarding, or interesting. Consider what the employee wants and how that meshes with the organization's goals.
- Encourage staff to participate in organization-wide initiatives.
- Observe your employees. What is each suggesting and producing? How do employees interact with others? Are employees filling their responsibilities or going beyond them? Provide frequent and specific feedback to your employee, as close as possible to the observable event.

Year-round performance management helps align each employee's performance with an organization's vision, needs, and requirements. It is a tool that helps both employees and organizations grow. And when it is done well, performance management contributes to employee satisfaction.

Chapter 19: Communicating with Your Boss

Gary Ford, *principal, GLFord Consulting*

HOW YOU COMMUNICATE WITH YOUR boss and how you manage that relationship is critical to your success and your institution, if for no other reason (and there are plenty) than just the sheer amount of time that we spend at work: 2,080 hours a year is the baseline number of hours annually for a typical full-time exempt employee. Many of us work more than that. Our relationship with our manager is probably the most important relationship we have as professionals. The reality is that we may spend more time with our bosses and our colleagues than we spend with our loved ones.

In this chapter, the goal is to help you foster better communication with your manager:

- Effectively align your own expectations with those of your boss
- Effectively present solutions or opportunities to your boss
- Apply best practices for respectfully disagreeing with your boss

The real focus here is on managing up, but if you're a manager you can use this information to build a better relationship with your employees.

Power Differential

One of the reasons why the boss/employee dynamic may be challenging is because of the power differential between you and your manager. Let's put it in broader context. When we become adults, most (not all) of our relationships are based on mutual enjoyment; we choose with whom we want to spend time. But your relationship with your boss is different.

What do you think is the number-one reason employees voluntarily leave their jobs? Is it more money? Better career opportunity? Easier commute? A poor relationship with a manager is the number one reason why people voluntarily leave their jobs. This loss turns out to be very costly for the employer when you calculate the expense of recruiting, interviewing, hiring, and onboarding a replacement employee. Conversely, in a poor economy, employees may not be *physically* leaving your museum, but they're *mentally* checking out if they have a poor relationship with their managers. So it's in the interest of your museum's leadership to pay attention to the relationships between you and your supervisor.

Owner's Manual

Building strong relationships is an ongoing process, not an event. We're all in the business of modifying and adapting over time. One way for you to conceptualize building that strong relationship with your manager is by creating an "owner's manual." Mutually creating an owner's manual for how you work together is a great start to engaging both you and your boss in a healthy relationship. Your owner's manual can be based on (at least) five questions and the answers you arrive at together. Sit down with your manager and examine what the answers might be to each of these questions.

1. **What is my manager's communication style?** Is your manager somebody who prefers reading reports or getting email updates from you rather than meeting face-to-face once a week for a status update?

2. **Is my manager a detail-oriented person or a big-picture person who just wants an overview?** How much detail does your boss want or have time for?

3. **Does my manager prefer to delegate tasks and have minimal involvement or is she hands-on?** Some managers excel at delegation; others feel the need to micromanage. Which is yours?

4. **What issues does my manager want to be brought immediately to his attention?** Don't let your boss be surprised by information, from you or others.

5. **What are my manager's important goals and objective?** It's critical to have a sense of the "big picture" vision that drives your manager, and by extension should be a driver for you.

How well can you answer these questions? If you're certain of all the answers for your current manager, then you're in a good position; more likely you know only some of the answers. In any case, the next time you have an opportunity for a one-on-one conversation with your supervisor, try to clarify the answers to these questions.

What if your manager flexes between two options? Try to understand what other circumstances exist that cause your manager to act as he does. Is there anything that your manager can share with you that will help you understand if and when he is a delegator or micromanager? When he is going to be a reader or a listener? There's rarely a cut-and-dried answer to most of these questions, but you won't know the answers until you ask.

Getting on the Same Page

In creating an owner's manual, your next step is getting on the same page with your manager. Doing this involves three critical areas.

Level of initiative. How much leg work do you need to do before involving your manager? How much do you involve your manager in how you work to produce results? For example, you're the lead on a project team and most things are going well, but a few team members are underperforming. What can you do to make things right before results are negatively impacted and before escalating the situation to your boss? You'll want to come up with a plan first.

Level of ownership. Think about levels of ownership in terms of follow-through. What's the level of ownership you have on a given project? It's critical to be on the same page with your boss about that. If

you are solely responsible for the work of the project, then it's essential for you to put in place and use whatever system, plan, or procedures necessary to keep your work on time, on budget, and to specifications (the definition of "project management").

Level of urgency. Level of urgency is your sensitivity to the timeliness of project planning, prioritization, and delivery. Are you responding with an appropriate level of urgency for any given project, based on the priorities you have established in advance with your supervisor? If your boss doesn't given you a deadline, ask about one. People can disappoint their bosses because of assumptions they make, or lack of information. Another point about urgency: it is easy to be distracted by side projects that may come your way, and it may be difficult to say "no" to yourself and others, even if these projects impede your ability to prioritize your work effectively.

Disagreeing

Another topic related to managing up is respectfully disagreeing. There are three best practices for respectfully disagreeing or sharing an opposing opinion with your boss. One is to link your ideas or your feedback to your organization's mission. The second best practice is to come to any disagreement with actionable suggestions, having thought it through rather than just simply raising objections. The third best practice is to explain how your ideas could help prevent potential pitfalls and overcome risks.

If you look at the first one, you might say, "I've heard you say increasing efficiency is important. We know we have to do more with less and I think unresolved conflict is costing us in the area of efficiency. Because

of the amount of hours that managers are being drawn into these interpersonal conflicts that employees should be able to solve themselves." You might then go on to talk about actionable suggestions. Perhaps, "There's a way that we can create a culture where conflict gets addressed and we can do simple skill-building and express our expectations." And last, explain how your ideas might help overcome pitfalls or overcome risks. Talk about what challenges the institution faces, with recent layoffs and cuts in budget, and how staff can't afford to have deadlines missed due to internal squabbles.

In a healthy boss-subordinate relationship, you will bring forth issues and concerns. Because of our general tendency to be risk-averse in our organizational culture, and because some organizations haven't fully embraced the importance of engaging in healthy conflict, we don't always talk about things that we might see as small issues, even though over time they can become bigger issues. We encourage you to have these conversations and be a fully contributing member of your institution.

(This chapter is based in part on the AAM Web conference, Straight Talk: Communicating with Your Staff, Your Teams, Your Boss, available online in the AAM Recorded Webinar Library.)

Practically Speaking: Levels of Initiative

Gary Ford

In a popular article in *Harvard Business Review*, "Who's Got the Monkey," (www.HBR.org, 1974, reprinted 1999) authors William Oncken, Jr. and Donald Wass share the idea of five levels of initiative, and how you as an employee need to make sure that you and your supervisor agree on what level of initiative is needed for different types of work. Use the levels of initiatives below as the foundation for a conversation with your boss.

1. Create a simple worksheet that has the five levels of initiative.
2. Fill it out for yourself first. Be honest with yourself about your level of initiative.
3. Then fill it out for yourself, considering what you think your supervisor would write down for you.
4. Meet with your supervisor and discuss it. Where is there agreement? Where is there disagreement? What do you think is the value of holding this conversation with your manager?

Five Levels of Initiative

Level One: You wait until you are told what to do and how to do it. This is the lowest level of initiative: not the best way to demonstrate to your boss that you are fully engaged and capable of doing the work.

Level Two: You inform your boss of the issue and ask what to do. Level two is also to recommend a course of action and to take the agreed-upon action. You demonstrate to your boss that you have enough expertise and sense to come up with a plan, so it's easier and less time-consuming for her to manage you.

Level Three: You act on your own but keep your boss informed. You don't want your manager to be blindsided or surprised by any work that you do, or any communication you have with internal or external stakeholders.

Level Four: You act on your own and then routinely report. Maybe it's a weekly status report or a monthly touch-base meeting, acknowledging to your boss where you are with a project, identifying issues and celebrating successes.

Level Five: You act on your own and don't need to report (highest level of initiative). The task is routine. You have complete expertise and control over the work you are doing and your manager doesn't need to be informed.

Chapter 20: Career Development as an Aspiring Museum Professional

Joseph Gonzales, *director, Museum Communication Masters Program at the University of the Arts, Philadelphia; and* *Nicole Krom*, *manager of visitor services and facility rentals at the Fleisher Art Memorial*

Five Observations

Many of us can agree that people in our field have a deep commitment to some aspect of museums' role in our society. That said, experience shows us that most of our colleagues have at one time or another faced challenges and frustrations in their careers. It is an almost inevitable reality for most of us. This can lead to bouts of career and life soul-searching. Common and recurring challenges identified by conversations with our peers can be summed up as five observations in the form of questions.

1. *I thought I'd be making more money by now. How long can I work at this pay rate?* (Museum Salaries Woes)
2. *I work hard and am totally committed. Will I ever get a promotion?* (Limited Advancement Opportunities in Your Current Workplace)
3. *I know I have to "pay my dues," but will the workload ever really be "35 hours a week"?* (Work-Life Imbalance)

4. *My prospects in the field seem limited. Did I make the right career choice?* (Competitive Job Market)
5. *Will a graduate degree help my prospects or should I continue gaining work experience?* (Education vs. Experience Question)

Museum Salary Woes

It never fails; salary issues always enter the discussion among emerging and mid-career colleagues. Many of us have developed a sense of humor about it as we've adapted our lives to fit the reality. For example, some do without extras and staples once taken for granted. Other young and not-so-young professionals opt for roommates, or take up residence with their parents to subsidize their salaries. Humor helps cope with the situation.

Unfortunately, low salaries are a reality in the museum field. Even during the boom economy salaries were low and have

remained stagnant. It is said that we are among the most trained and lowest paid professionals. Museum salaries do not seem to have kept pace with inflation and cost of living increases. Disparate wages are so endemic in the field some people have suggested reform or making a labor issue out of it. At the very least, it should be acknowledged and out in the open.

Why we have low salaries is complicated. History, economics, policy, gender bias, societal values, education, and philanthropic priorities all contribute to the conditions. Nonetheless, it is helpful to be honest about these realities and focus on things you can affect. Here are several recommendations we have found useful.

- Understand that museums, by and large nonprofits, are mission-driven and that the social benefit goals are generally seen to outstrip the priority for competitive salaries.
- Know that museums are appealing places to work; many people want to and are willing to work for museums. The demand for a meaningful, well-paying job in a museum is greater than the supply of those jobs.
- Know that your responsibilities will probably outgrow your salary. Make a case for a salary increase if this occurs. Keep a work journal to track your work and support your case (see Chapter 18). If increased compensation is not possible, request a change in your job title to reflect your added responsibilities. This will help your prospects when you look for your next job.
- Have an honest and open talk with your supervisor about your salary expectations and goals (see Chapter 19). Don't see this as creating an uncomfortable or contentious situation, but see it as an act of professionalism. Let him or her tell you whether a salary increase is or is not possible.
- Don't assume that nothing can be done. For example, you can try to negotiate fewer hours for the same pay, ask to work on a special project with high visibility, request professional development or training opportunities, or arrange some other desirable action. Leverage your value and assets to get something beneficial, even if it's not more money.
- Do your job market homework. Know your pay grade within your institution and across the field. Be familiar with key job sites and regularly review job postings and salary ranges. Speak with your human resources officer if you have one to better understand your institution's salary grade structure. Again, this is a professional request and one you are entitled to make.
- Review your organization's and comparable organizations' IRS Tax Form 990s to better understand the overall budget and the top five highest compensated employees. Under federal non-profit statute, these are publicly accessible. You can find most museums' 990s through GuideStar, a non-profit reporting organization (www2.guidestar.org).
- Compare salary ranges with close peers, professional contacts, and mentors to help you gauge your salary.
- Learn to better brand and promote yourself, and craft your resumé with a higher paying position as your goal (See Chapter 5). This can help you be more effective in making your case in your current position, or it can prepare

you for networking opportunities and future interviews.

- Take advantage of free or affordable professional development opportunities, such as professional branding, resumé clinics, and other skill-building sessions offered through professional and other non-profit arts and culture organizations.
- Use your professional tool kit to take on a side job, or engage in other entrepreneurial opportunities that can help confront the frustration, meet financial goals, and hone existing skills or develop new ones.

Limited Advancement Opportunities in Your Current Workplace

This challenge worsened in the poor economic climate. As a result, many museums implemented business sector management strategies: some combination of budget reductions, staff cutbacks, hiring freezes, consolidation, and restructuring. One result has been contraction or consolidation of middle- and upper-management jobs. In addition, people ahead of you have nowhere to move, leaving little room for upward mobility. Factor in that some of these seasoned employees are highly valued by the organization, have job security, have clear retirement and savings goals, are entrenched within operating systems, and sometimes have other forms of income. They may have little incentive to move on or up.

Just as with the salary issue, we recommend that you focus on the things you can impact, and continue to be highly effective and accountable.

- The learning at your current job may only partially prepare you for your next career move. A wonderful aspect of the museum field is the belief in life-long learning. Talk to your supervisor and see what professional development or educational opportunities she or he will support. Most conferences offer scholarships or stipends to attend, and some local and state agencies offer professional development funds on a competitive basis. Propose to your supervisor to at least cover your pay while you are attending.
- Given that many museums don't have adequate resources for staff professional development, seek out your own professional development and training opportunities, including conferences, symposia, residencies, fellowships, workshops, webinars, and recordings.
- Look to national museum organizations such as AAM for professional development, networking, and mentorship opportunities. Look to regional, state, and local museum and arts and cultural associations, councils, federations, and alliances for options.
- Network and network! There are smart and intentional ways to network (see Chapter 6). The best advice we have heard is to create a plan and goals for a networking event. Spell out the kind of information you are seeking, the contacts you'd like to make, and have your introduction and "elevator speech" ready to go.
- Social media such as LinkedIn, Facebook and Twitter have provided novel networking and promotional opportunities. Study how successful and respected professionals are using them, and choose the one that fits you.

Blogs and discussion groups are also ways to network, gather intelligence, and promote your experience.

- Find a mentor or career coach (see Chapter 31). You want to work with someone you respect and admire, and whose career you'd like to emulate. One thing we'd like to emphasize is that mentorship is a two-way street, so use your time with your mentor respectfully and professionally. In other words, the mentor-mentee process should be mutually beneficial, and not a "take-take" situation on your part. Look for ways to support your mentor in the process. Secondly, we are all very busy (as the Work-Life Imbalance section highlights), so use your mentor's counsel efficiently and wisely.
- Do not limit yourself to work that takes place within museums. Seek jobs outside of museums that relate to or support the work of museums or that frequently collaborate with museums. For example, look for jobs at foundations, arts and cultural centers, local, state and federal arts and cultural agencies, contractors and consulting firms that do exhibition-related work, evaluation and visitor studies, research, conservation, marketing and PR, etc. This kind of work can pay better than many museum jobs and could help you reach your museum dream job down the line.

Work-Life Imbalance

Let's face it: there is generally no shortage of work to get done in museums. Our field promotes excellence and integrity, both of which require a strong work ethic and high degree of accountability. Dedication and loyalty are also highly valued in our profession. These are all good things, but add to this that we sometimes have limited resources with which to accomplish our work, and the balance is often made up by hard work and extra hours. Again, these are shared realities, but there are actions we can take to help our circumstances.

- We know it's tough to say "no" to projects in the early stages of our career. We want the experience and the challenge. We have the expectation that this will lead to a bigger and better position. One of the problems is that this can establish a pattern of overwork and overextension in your own work behavior. Low salaries and long hours can lead to burnout and create a sense that you are underappreciated. Work shouldn't feel like a dungeon.
- Meet with your supervisor and let her know what is important to you professionally and personally, and that it is a priority for you to have time for both. Again, this is not an act of attrition, but a professional act of honesty and courtesy.
- Learn how to say "no thank you" respectfully to new projects if your plate is already full. Focus, excel, and improve upon that with which you are already charged.
- Prioritize and seek out the right opportunities that can lead to career growth and resumé-building. Be strategic about the projects you take on; own them and make them great.
- Actively make time for the things that are important to you or that bring you the greatest satisfaction. This will make you a more fulfilled person and a better employee.

■ Follow the adage, "work smarter, not harder." There are many books, web resources, and professional training resources available to help with time management and organization. Developing these skills takes time, patience, practice, and experience. It is an ongoing process but it will improve your workflow and empower you to create more time for you.

Competitive Job Market

In an already competitive museum job market, there are too many qualified candidates. Demand is typically greater than the supply of job openings.

■ We've said it before: network! Talk to your peers and professional contacts to see if they know what positions are open, and if they can make a phone call on your behalf to an employer. Keep your references updated and "in the loop!"

■ Make sure your resumé is in tip-top shape. Any small typo or grammar error could take you out of the running (see Chapter 7). Employers are looking for any and all reasons to narrow the amount of applications they receive. Use a second, third and fourth set of eyes and ask the opinion of people you respect professionally.

■ Volunteer for another organization whose mission you support (see Chapter 13). Whether it is on a board committee, one-time events, or an on-going basis, volunteering can be a meaningful social outlet and lead to new job and career opportunities. Work it! This also adds to your contacts and adds value to your resumé. To find volunteer opportunities in your area

visit www.volunteermatch.org or www.volunteerspot.com.

■ Make a list of the characteristics of your ideal work place. From there, create a list of the traits you consider non-negotiable. Use this as a basis for your job hunt and interview questions.

Education vs. Experience

Does an advanced degree offer something that experience does not? You will find in the museum field that there is no definitive answer to this long-debated question. Some executive directors have only bachelors' degrees; some tour guides have doctorates. The decision to obtain higher learning has to be one weighed carefully (see Chapter 3).

■ We've all been asked the question "where do you see yourself in five years?" If your goal is a senior-level position, consider obtaining an MBA. You will need to understand, create, and analyze financial information and master management principles if you desire to be in any executive or director position.

■ Do not go to graduate school for the sake of it, or to figure out what you want to do. It is too costly an investment and should be well thought out. It is also easy to meander through school. You should treat it as a professional investment and part of your strategy. Have a plan that can be a guidepost for you through school.

■ Master degrees in the museum field ideally help bypass the entry-level positions. Do your research for colleges and universities that offer museum programs, and weigh the pros and cons of obtaining a higher degree.

- You shouldn't have to sacrifice one over the other. If you decide a graduate degree is the way to go, do your research and choose a program that can provide you a balance of academic and workplace experience. Find one that aligns with your short- and long-range goals. You shouldn't have to completely extricate yourself from the field to get a degree to reach your goals. See it as a professional degree.

- Educate yourself about your student loans, preferably before you request them, but it's never too late. Some useful resources to look into: studentaid.ed.gov and the Public Service Loan Forgiveness (PSLF) program, http://www.wikihow.com/Pay-off-Student-Loans.

(This chapter is based on a Mentoring Roundtable discussion at the AAM Career Café at the AAM annual meeting.)

Career Path: Transferable Skills

Wendy C. Blackwell, *director of education, National Children's Museum, Washington, D.C.*

When I look back on my days on the railroad, I remember with great fondness my favorite things—the smell of Zaro's bagels at 4:00 a.m., the sunlight streaming in the huge glass hallways, the polished brass information booth, and the Kodak picture over the bank. I remember Robert DeNiro's film crews, Music under New York performers, and celebrities like Pearl Bailey, Felicia Rashad, and Diana Ross passing through under the hats, caps, and scarves. All those fond memories are wrapped in hundreds of thousands of passengers streaming through Grand Central Terminal at rush hour wanting the same things: to be on time and make a connection. My job was not to let anything related to Metro-North Commuter Railroad stand in their way. All of this at Grand Central Terminal in New York City.

Most of us remember our first job and the circumstances of growing up, professionally. The majestic Grand Central Terminal was my home and my witness. It offered unrelenting lessons about customer service, managing up and down, and real lifelong learning. At 27, I was General Station Master, living my dream. I was the newest hire when the superintendent decided that the railroad would have no more specialists. Instead, every manager would be trained in a wide array of competencies and be able to respond appropriately in any situation or emergency. I was the only woman, the youngest, so it was my initiation and punishment to go first. I went to New York's Fire School on Coney Island to be a fire brigade member, learn evacuation procedures, fire fighting, and rescues from subway and train. Then I went on to asbestos abatement training, chemical safety, and material safety regulations.

In fact, anything that went awry on my shift (with the exception of police activity) was my problem to fix. I had to learn how to be a fixer, a planner, and a strategic thinker. I even learned the art of negotiation at union hearings.

What the guys thought was punishment was really the greatest opportunity I could have ever imagined. After all, I had failed up! When I started on the railroad, I was a tower operator, the railroad's equivalent of an air traffic controller. I was "the worst tower operator ever born," according to my teachers. I didn't know east from west. I was miserable and ill equipped, directionally challenged, and a nervous wreck. After all, I had left my very sheltered paid internship at the U.S. Department of Transportation in Washington, D.C., for a chance on the "hard side," working for a transportation agency rather than a regulatory one.

On the first day of qualifying as a tower operator, I derailed the track equipment. I had moved to New York from Baltimore, found a great apartment, and refused to go back home a failure, mainly because I had taken the bold step of leaving graduate school at Morgan State University to join the railroad.

So I begged for an opportunity to prove that I wasn't as stupid as I appeared. After entering data in the payroll department, telephone operating in the communications department, a few weeks in human resources, and six months in the General Station Master's office, I found my niche. I explained to the superintendent that I understood how the railroad operated. I finally understood how each department and position was strategically connected to another. I promised to make a real contribution if given the chance; no assignment was too small or too big. What I learned in the General Station Master's office, I still use today. The railroad isn't terribly different from a children's museum.

Learn to deal with people. Learning to deal with people, especially angry ones, was the most rewarding lesson. Customer service on the railroad is the same in the museum. If you provide what you promised in the way you promised, for the price quoted at the time, with extreme quality and care, people will say good things about you and come back often. Mess up and the whole world will know, sometimes broadcast via the six o'clock news. Apologize when you screw up and most people will give you another chance. But only one!

Lost children and lost parents are the same—looking to be rescued and reunited. Handling other people's problems with grace makes you a hero. Be a hero for people whenever you can.

Recognizing the value of stakeholders is important. Know that everyone who enters your door is a stakeholder.

Leading teams, working collaboratively, and sharing resources are always gifts. Many times I made the mistake of thinking it is just easier to do something myself; in many ways it was. I had to learn, however, that I had missed an opportunity to learn from and with others. I know now that the process of collaboration can be as important as the project or product. Take time to lead and learn.

Follow the rules, policies, and observe corporate culture. The railroad is highly regulated to avoid dangerous accidents and

loss of life. When regulations are followed operations run like a fine-tuned machine. Be aware of the culture and rules, both spoken and practiced. Be willing to follow the rules, understand policies and model professional behaviors and attitudes.

In recent years, I have met many young people who are not interested in the formalities of organizational culture encountered in the workplace. Sometimes they dismiss the ways of doing business as "old-school" operations. Learn how to navigate within the culture of your workplace without breaking the rules first. Stepping outside of the box will be easier when you know, understand, and respect what is in place and why.

Generationally, people approach work differently. Supervising men who were 20 years my senior was always a tightrope walk. I had a lot to learn quickly to gain their respect and support. Being the "college girl," I often felt ill at ease among my male peers who came to the railroad as teenagers with their fathers. I had to learn the railroad culture, the unspoken family way of doing business, and the new way the railroad intended to do business. I learned to see myself as a conduit for change and the model for respect. The transition into my professional life was difficult and sometimes painful.

Some museum interns entering the field with fresh eyes have compared their experiences to being a guest on the popular television court show where the judge yells over the bench, "Stay in your lane!" I have felt their uneasiness and know firsthand the stomach-churning anxiety caused by stepping on someone's toes.

The different generational approaches unite and sometimes separate. My lessons at Grand Central take me back to the Management Assessment Program where I learned to stay in my lane and when not to yield. Overall, the best lesson was this: be a support to your supervisor and the people you supervise.

Playing a supportive role is a great way to manage up and down. I remember wanting to jump in the deep end and just get the work done, but playing a supportive role, asking my superintendent how I could support his goals, immediate priorities, and hot spots was the best approach. Relationships improved because everyone in my circle of interest and influence knew that I could be counted on and was willing to learn.

Twenty years later, the General Station Master became a teacher. She is now a museum educator some 250 miles away from the beautiful sunlight streaming into the glass hallways at the majestic Grand Central Terminal, seemingly a lifetime away from that derailed track equipment. I know now that lifelong learning really means committing your life to new experiences and a willingness to be changed by the commitment. I know that we must remain open to knowing, experiencing, and learning from each other.

PART THREE:
MANAGING AND LEADING

Success breeds support and commitment, which breeds
even greater success, which breeds more support
and commitment—round and around the flywheel goes.
People like to support winners!

—**Jim Collins**, in *Good to Great and the Social Sector* (2005)

Chapter 21: Managing from the Middle

Sheetal Prajapati, associate educator for teen and adult programs, Museum of Modern Art

FOR EMERGING AND MID-LEVEL professionals, management in the workplace can get tricky. Our positions may not always specify management skills as a requirement for the job. At the same time, we can be called upon to collaborate on projects with our supervisors and peers or take a supervisory role working with volunteers, contract employees, or interns. Your peers or supervisor may not recognize your role as a manager, but you may still be responsible for keeping them on task and moving a project forward. It is important to remember that by employing effective management strategies in these cases, your presence as leader, though less visible, remains critical.

Beginning with three characteristics all managers should develop, this chapter will break down practical methods and strategies for managing projects with staff at various levels—staff you supervise, your peers, and finally your supervisor. Keep in mind that every situation is different and it is up to you to decide what approach to apply to get the best results.

Three Key Characteristics for Effective Management

When managing staff across different levels of the museum hierarchy, these three characteristics will take you a long way.

Goal-Oriented Leadership

A key function of any managerial position is to ensure productivity. Keep your team focused and directed by providing achievable goals and benchmarks. This requires advanced planning and periodic assessments to provide a clear path for success while demonstrating your commitment to the project.

Flexibility

Flexibility is about managing your own expectations for the project, your team, and yourself. Effective managers strive to achieve a balance between providing structure and remaining flexible. Flexibility allows managers to adapt to change and respond effectively to any challenges or setbacks. This can mean changing strategies, adopting new ideas or suggestions, or

even adjusting tasks to better suit the skill set of your team.

Effective Communication

Communication among your team—at all levels—is possibly the most important aspect of effective management. Throughout any project, managers should always maintain a professional attitude and remain approachable. This will allow your team to feel comfortable communicating both successes and setbacks with you. Effective communication is also about consistency. Keep your team informed with updates and clearly articulate individual tasks and deadlines throughout the process.

Managing Your Staff

Even if you are not a supervisor by title, you may still be in a position to manage. From volunteers to interns to contract employees, your position may require you to coordinate or work with varied groups of people to complete a project. As a supervising manager you should be developing and meeting goals for the project while actively supporting staff throughout the process.

Basic Orientation

A well-oriented staff is one in which each member is well-prepared and reliable. Each team member should have a clear understanding of her duties and what role she plays within the institution. From full-time to temporary staff, training is a basic part of effective management. Your team should be made aware of and know how to use available resources (from the photocopier to the server). Anticipate what space, physical tools, and digital resources they will need to work effectively—and make

sure they are equipped from day one. They should know how their piece fits into the whole project.

Modeling Behavior

By modeling the behavior, work ethic, and motivation you want to see in the rest of your staff, you can illustrate your own commitment to fostering a positive work environment while setting the tone for your team. Your staff will notice the way you handle challenges, setbacks, and successes. This can foster better teamwork among the group and empower your staff to take initiative. Be sure you maintain the approach you would like to see modeled in their behavior.

Modeling is also an ongoing process of self-assessment. By making a conscious effort to create a positive work environment, recognize your own strengths and learn how to combat some of your own pitfalls or tendencies.

Experience as Resource

Just as your prior experience helps you perform better, recognize that the collective experience of your staff is valuable. Know what skills each staff member brings to the table, and allow room for their experience to inform the team's practice. When managing a larger team, it can be difficult to stay informed, but maintaining an open line of communication with your staff allows for these resources to emerge.

Give Feedback

Use assessment and provide feedback to maintain a high level of performance from your staff. This process also serves as a way for managers to stay connected to their staff and keep track of both short and long term goals.

Most institutions have formal methods for providing feedback and performance review. These are good tools to use, but are often tied to promotions or salary increases, which can place a certain amount of pressure on both sides. More informal types of assessment and feedback, like a one-on-one conversation, are a great way to provide your staff with support and recognition throughout the year. Feedback should always be constructive to your staff's progress, and recognition of exemplary behavior encourages desired practices.

Provide Leadership

Each of us has a different skill set to offer; an effective manager recognizes and leads with her strengths. Whether your strength is organization, public speaking, or finances, leadership is about providing the team with the confidence and motivation to complete a project. Use your strengths to develop trust and commitment among your staff.

Managing Your Peers

Working with your peers can sometimes be the most challenging type of management. One of the most effective techniques is to approach your work together as a team. While you may all be at similar levels within the institution, there can be a significant difference in working styles, motivations, and expectations. Sometimes you are working cross-departmentally, which also means each team member may be managed quite differently in his respective area. This presents a unique challenge but can also yield some of the best results, if properly managed.

Peer managing in this arena is about making team members feel valued for their contributions and specialized skills while ensuring success. Remain transparent by clearly delineating and communicating each person's role and duties to the team. Hold yourself accountable. Situate yourself as an equal and contributing part of the team.

The best way to create a sense of collaboration among your team is to respect their individual skills and role within the institution. Play on the strengths of your team and distribute tasks accordingly when you can. Understand each team member has a separate role within the institution and pay attention to any changes in their workload from other aspects of their position. Listen to your team's suggestions and feedback and be open to new ideas from your peers throughout the process. Though you may ultimately be responsible for the completion of a project, recognize that it is only possible with contributions from your team.

Manage Expectations

From deadlines to meetings, team members should have a realistic understanding of their expected time commitment and tasks for a project. It is also essential to articulate the expectations and priorities for project completion. Your team may be more flexible if they understand the priorities of the project and how iterations may be part of achieving these goals. Managing the expectations for your team also helps create a more collaborative working environment, providing a sense of pride for each team member.

Provide Recognition

Simply put, recognize accomplishments. Thank your team for their contribution and time.

Managing Your Supervisor

When working with a supervisor, understand your supervisor's management style, how she prefers to communicate, and what her priorities are. Your ability to be flexible and respond to her style of working will build a positive rapport. You can also use these opportunities to develop your own managerial skills. Just as your staff may look to you as a role model, your supervisor's example can be helpful for your own professional development. It is wise to always make your boss look good.

Respect Your Supervisor

Respect the authority and position of your supervisor. Whether or not you agree with your supervisor's management style or decision-making, recognize that you might not have a full understanding of the scope of his responsibilities. Recognize the experience he brings to the position and ask for his advice and wisdom in unusual or especially challenging situations. Observe closely. You may learn a thing or two from both his strengths and weaknesses.

Understand and Manage Expectations

When working with your supervisor, communication is key to staying on the same page. Make sure you understand your supervisor's priorities for the project, and know what is expected of you to achieve those goals. Because a supervisor might be working on multiple projects of this size, manage her expectations and be proactive about scheduling regular check-ins. Set achievable deadlines with your supervisor and be sure you have the resources you need to complete tasks. In many cases, your supervisor is relying on you to get the job done, so rise to the challenge.

Use Your Resources

Get creative when looking for solutions. Talk to peers who have experience, do research, or find other resources that can help you. Try to use the resources around you to solve problems before bringing them to your supervisor. Your supervisor may recognize your extra effort.

Developing your management skills will be an ongoing process throughout your career. Take time to find and observe supervisors who model good management and leadership. Be reflective about your skill set and learn how best to utilize your strengths. Managing at any level can be complex, but learning how to lead in varied structures will help you build essential skills needed to move forward in your career.

(This chapter is based on an AAM Career Café session at the AAM annual meeting.)

Practically Speaking: Checklist for Becoming a Better Manager

Sheetal Prajapati

There are many ways you can become a better manager. Here are four things you can do to make that happen.

Get a mentor. Find a leader in your field who inspires you and whose management style you admire. Make sure you and your mentor develop a good rapport. Over time, this person can help you develop both strategic and leadership skills.

Practice makes perfect. Take every opportunity to manage. Whether it is a small program or a long term initiative, step up to the plate and take the challenge.

Use feedback. Don't be shy or disappointed to hear and use feedback about your performance. At every level, the best managers are always looking for new ways to improve their practice, and getting feedback is the most direct way for you to be reflective about your performance.

Engage in your museum community. Develop your own museum community of peers and leaders and use available resources. Join national and local organizations, attend professional development workshops, and read. Form a community of professionals you admire, get along with, or just like. These peers will likely be looking to you for the same reasons, so enjoy the exchange and support you find among them.

Chapter 22: Leadership at All Levels

Elizabeth S. Peña, *interim director, John F. Kennedy University Museum Studies program*

WHEN WE THINK ABOUT MUSEUM leaders, we usually think of museum directors, senior staff members, and scholars who publish in museological journals. We often forget that leadership can happen on any level; there's no need to be at the top of the organizational chart to be a leader. Of course, museum directors are tasked with providing leadership to the entire institution. But other museum staff can accept or create leadership roles by choice and through example. You can think and act like a leader, even within a very small scope. Being a leader means crafting a vision, inspiring change, encouraging colleagues and challenging yourself.

Leadership comes more easily for some people than for others. At its most basic level, it is common sense: be observant, be alert, listen and learn, be self-critical and self-reflective, go the extra mile. But leadership is a balancing act that requires sensitivity and tact, particularly on a junior level. On the one hand, you must be persistent and confident; on the other hand, you must be careful not to be perceived as nagging or arrogant. While leadership brings many benefits, it does involve risks. Your idea may be rejected, your project may fail, and some colleagues will object to your vision and disagree with your plans. As a leader, you must learn to balance risks and rewards.

Models of shared, inclusive leadership strategies and suggestions for flexible organizational charts can be found in a wide variety of resources, within and outside the museum field. Some museums are developing innovative ways to identify and activate leaders who are not part of the regular senior management team. In most museums, however, you will have to navigate more traditional hierarchical models. Whatever the structure of your institution, demonstrating leadership can positively impact the museum and may bring your work to the attention of the museum director, senior staff, or other stakeholders. You may be able to ascend to positions of greater responsibility in the institution, be invited to join new project teams, or be given new and interesting assignments.

Leadership and management are closely linked, since being an effective manager requires leadership skills. The difference

between the two is in the focus: a manager is someone who uses a host of skills to help guide and implement change. A leader is someone who sparks that change, inspiring others to action through example and inspiration. The satisfactions of leadership come from this ability to create positive change, the sense of making significant contributions and the excitement of empowering yourself and your colleagues.

Know Your Museum

Knowing your institution thoroughly gives you the confidence and authority you need to do your job well and to act in the best interests of the museum. This is an important step in internalizing leadership. It will allow you to see needs that might otherwise go unnoticed, giving you the opportunity to step up and address those needs on behalf of the institution. It will enable you to take advantage of gaps, perhaps informally suggesting ideas or proposing solutions.

Understand your institution's mission and vision. Does everyone subscribe to these principles? Understand your institution's organizational chart. Pay close attention to how the museum operates on a day-to-day basis. Does it differ from the organization depicted in the squares and circles of the official institutional diagram? Be alert and observant.

Engage

Leaders are those who raise their hands, speak up, and step up to take an active role in the work of the institution, or boldly champion causes important to the community or the field. Within your museum, take advantage of invitations to attend and actively engage in staff meetings and

to participate in any staff development activities. Speak up in meetings, but be sure you have something relevant to contribute. Volunteer to take meeting minutes or to follow through on an idea or discussion. Evaluate each situation: is this an opportunity to lead by example? Or is there a danger that you might be overwhelmed with paperwork to the detriment of your regular job requirements?

Outside of the museum, engage with community leaders to discuss issues and needs or attend professional meetings and bring knowledge and enthusiasm back to your home institution. Visit other museums to see what lessons you can learn to improve your own museum. Present a topic at a conference or write an article for your local, state, or regional association newsletter. Be visible. Give back.

Contribute

Given your background, your talents, and your special skills, what can you contribute to the institution? Find ways to make these skills known. Perhaps you've taken a workshop in meeting facilitation; offer your services in that role. Perhaps you are fluent in a foreign language; volunteer to give a tour to visitors, or to translate label copy. Are you an active member of your community's historical society? Do you volunteer with an environmental group on weekends? If so, find an informal way to share this information with your senior colleagues. This kind of productive energy is often valued by senior staff. When they know that you play a leadership role outside the museum, they can more easily visualize you in a leadership position inside the museum.

Collaborate, Initiate

Work with colleagues in other areas of the museum. Collaborative initiatives allow senior staff to understand your ideas and goals, appreciate your interests and enthusiasms, and to see you as an important team player, whether or not these ideas translate into action. If you are a registrar, have a coffee break with an exhibition designer and a museum educator to discuss an exhibition program idea. If you're a marketing assistant, have lunch with staff from the museum café, the museum shop and the front desk to brainstorm ways to cross-promote these important earned-income aspects of your institution to families. Senior staff are usually so busy juggling responsibilities that they are grateful when someone else steps up to address various issues and needs. Take cues from your senior colleagues' working methods and communications. Perhaps you noticed a suggestion in an email about starting an e-newsletter. Design a template. Maybe the director expressed a concern about some educational programming. Plan a trial run. Take the initiative.

Think Strategically

The goals of building your skills and advancing your career need not be mutually exclusive with sustaining and improving the museum. Consider what abilities and experiences you would like to gain. When you know the museum well, you can contemplate how you can help improve the institution while also accruing valuable professional experience for yourself. For example, perhaps you would like to learn more about web applications, and you think that the museum would benefit from creating an online component to accompany an exhibition. Working with the museum's technology staff on such a project would improve your professional skills while creating value for the museum. Demonstrating leadership is a natural path to career advancement; however, your focus should be on promoting a project, an idea, or the institution, not just yourself. While personal ambition can certainly be a positive force, it is most successful and meaningful when wrapped in a bigger package.

Do Your Job, and Then Some

As you seek out leadership opportunities don't neglect the job you were hired for. Complete all your required tasks with excellence. Eliminate the possibility that anyone might complain that you are stepping too far out of line. With that said, go above and beyond your job description. Extend yourself. Make yourself indispensable. Pay attention to developments and trends in your area of expertise and get ahead of the curve.

Be Sensitive

Being a leader doesn't mean you have all the answers. Respect the fact that there is a lot you don't know. Be self-critical and honest, and learn from your colleagues. Some colleagues may feel uncomfortable or threatened if you stray too close to their areas of responsibility. Respect these boundaries. If a suggestion is rejected, retreat. You may have a chance to try again when the environment has changed. Conflicts are bound to arise. You will have to decide how to manage each one, and weigh the pros and cons of talking

about the problem or letting it go. Is it a temporary difficulty that will pass over? Is it a negative pattern that needs to be addressed? Are you the only person affected by the conflict, or does it have a larger impact? If you feel the need to discuss the matter, do so confidentially and as honestly and gently as possible.

But Not Too Sensitive

While it is crucial to be sensitive to others, it's important not to be too sensitive yourself. If you float an idea that is rejected, be sure to learn from the criticism. Even if your idea is accepted, it may well be the case that support is not unanimous. Commitment does not equal consensus. Some colleagues might object to the idea itself, and instead might want to support their own competing vision. They might not like the way the project is organized. They might feel that the project represents too much work, or that it is too expensive. It can be difficult to navigate workplace politics, particularly during times of disagreement. Reflect on your colleagues' criticism, and learn from it. Can you change the proposal to incorporate their views? Is there a way you can be more persuasive? Is there something you should do to alter their perceptions? What can you learn that will help you succeed with your next project?

Remember that as much as you would like to be friends with each and every one of your colleagues, it may not be possible. It is important and enjoyable to maintain cordial, professional relationships, but it is not your job to be friends with everyone. For many new leaders, this can be a very difficult lesson to learn.

Understand That Change is Hard

Across the country, museums are undergoing transformational change. Some institutions are expanding and growing their collections, others are contracting or merging, still others are crafting new partnerships. Many are working to improve their sustainability, both economic and environmental. Most are increasing their commitment to visitors, a priority expressed in a wide variety of ways.

For museum professionals, change can seem exciting but also destabilizing. Museum leaders must persuade staff to alter long-standing practices and adopt new methods. They must inspire risk-taking and encourage creative problem-solving. When you lead by example, you contribute to the success of the museum's transformational process. No matter what your position in the museum may be, you can play a leadership role by being attuned to the rhythm of the institution and finding responsive and sensitive ways to contribute. Leadership might bring you to higher positions of authority within the museum, but it is also a fulfilling act on its own. Having a voice in transformational change, exercising creativity, helping turn vision into reality— these represent powerful components of a meaningful museum career.

With thanks to John Burke, Ben Garcia, and Jill Sterrett for their helpful discussions.

Chapter 23: Working On or Managing Teams

Gary Ford and **Greg Stevens**

A TEAM IS A GROUP OF PEOPLE LINKED in common purpose. Maybe it's your immediate staff working on an interpretive plan, a cross-departmental team redesigning the museum's website, or staff packing and crating objects being loaned to another museum. Teams work well when members trust each other and hold themselves and each other accountable for the results.

In this chapter, we'll give you some practical tools to help you assess your own team dynamics.

Stages of Team Development

Identifying the stages of team development is important because how we build teams impacts how we operate within them, how we manage them, and how we achieve results. In 1965, educational psychologist Bruce Tuckman identified four stages of team development ("Developmental sequence in small groups," *Psychological Bulletin*, 63, 384-399):

- *Forming* happens when teams come together—there's excitement but people are a little unsure; they don't know whom they can trust and they don't necessarily know how they're going to work together. In the forming stage there is little real focus (yet) on actually completing tasks, and little focus on building relationships beyond an exploratory level.
- In *storming*, the team has moved on to the next stage; they're now focused on getting work done and completing tasks. But they may be pulling in different directions and there may be conflict that is either open or unresolved. Teams may be choosing artificial harmony over building relationships.
- In the *norming* stage, teams take a step back from the work and focus on how they are working together. How is each team member contributing to the results? Given that most American workers tend to focus on "getting the job done" and shy away from emotional openness, we have to step away from our teamwork long enough to get into the norming stage *before* we can get to the performing stage.

■ The last stage, *performing*, occurs when team members have figured out how to pull in the same direction. Team members leverage complementary skills toward shared goals and create the synergy that comes with a high-performing team.

Where would you place your team?

Typical Team Dynamics

In team dynamics workshops held at the AAM annual meeting each year, typically 40-50% of participants place their teams in the storming mode (not a scientific sampling, by the way). Some are just forming (+/-40%). But on average, less than 20% indicate that their teams are really performing. That's no surprise: many museum colleagues are dealing with budget and staffing cutbacks, and doing more with less. As a result, there seems to be frustration in departments, in teams, and across the institution. Now more than ever is the time to step back from the work and spend some time figuring out where you are individually and collectively, by assessing and addressing team dynamics.

Team Dynamics

One way of better understanding team dynamics is to start with a definition of what high-performing teams look like. In *The Five Dysfunctions of a Team* (San Francisco: Jossey-Bass, 2002), Patrick Lencioni suggests there are five areas of focus for teams.

■ The first one, *trust,* is the most foundational. Lencioni defines this as the ability to make yourself vulnerable with one another, to admit mistakes and to ask people for input into how you can do your work better.

■ The second level is healthy debate or *conflict*. Strong teams engage in healthy debate because they trust each other enough to know that conflict is natural and essential to achieving results. Members of healthy teams say what's important and aren't afraid to confront issues face-to-face with colleagues.

■ The third level is a *commitment* to group decisions. With commitment (not to be confused with consensus) people are more likely to support decisions because they have shared their thoughts and have agreed to move forward, even if they "agree to disagree."

■ If everyone is committed to the group decision, people are more likely to hold themselves and their peers *accountable* for the decisions and subsequent actions.

■ Lastly, high-performing teams tend to prioritize *team results* over personal agendas. If you begin the work of your team with the end in mind, it's easier to move your team to results.

Team Dynamics and Organizational Culture

Does openly assessing and addressing team dynamics have to be part of the culture of the organization before a team can expect to perform at a high level? The answer is yes and no. Buy-in and support from museum or departmental leadership is essential in all cases, but even more so when an organization is in transition or there exists a conflict-adverse culture, one in which people who aren't very skilled in resolving differences can exacerbate problems by trying to resolve them on their own or by simply avoiding them altogether.

Team Dynamics in Action

In these times of doing "more with less," it is increasingly common for museum staff to be placed in cross-functional teams that must make and implement major decisions quickly. When team members have not had a history of working with each other on smaller projects that permit positive team dynamics to form, dysfunctional behaviors can surface rapidly. Taking even initial steps toward decision-making may be difficult. Here are some steps you can take as a team member or team leader:

- *Help build trust.* Even people who have been working side by side for years may not know a thing about each other. This is a great opportunity to get people to open up on some level to build the trust necessary to any successful team. Try asking team members to share their strengths and passions about their work or areas of their lives. Ask each person to take an online personality test to share with the group.
- *Perform an assessment activity with your team* and evaluate its results. Pay particular attention to team members who are "not into the 'touchy-feely' stuff."
- *Define what is and what is not within the scope of the team's control.* In some cases, boards and executives may have been working for some time on a needed transition, but have not yet shared details with the museum's full staff. Teams may be appointed to implement a decision when team members may not yet have adjusted to the reality of the decision.
- *Mark a clean break with the past.* When faced with change, try to move forward with the team, even if you don't fully agree with all the decisions. If you're a team member or the team leader, you may be so far ahead of others in making your way through the transition and it may be difficult for you to be empathetic with people who process information and take action differently. Allow some adjustment time for people to cope with the new reality.
- *End debates when they devolve into simple naysaying.* Wherever the team needs to come to a decision, have a process in place so you can collectively arrive at, "Okay, we've gotten all this out on the table; now let's decide what we're going to do."

What about team members who simply will not change? The first thing to do is listen for what your team members are saying and what they're not saying. If your team is dealing with change, you might hear someone say things like, "This is ridiculous. There's nothing wrong with the way we're doing things." That's a sign that the individual is stuck in transition. If you're hearing things like "I'm overwhelmed, I feel completely lost, I don't know how to get things done anymore," the team member is in the neutral zone where the new way has started to take hold but the old way is not quite gone. At some point you may need to have a one-on-one conversation in which you'll say something like, "This change is going to happen and we need you on board. Your unhappiness about it or your resistance to it is not going to stop it from happening. It's only affecting your reputation within this organization."

There may come a time when everyone has moved on and one person is holding the team hostage. You cannot permit that to happen—even if the person is you. Look

ahead to implementation of the decision—
something likely not fully under the control
of the team members. Make sure that the
team includes or consults with those who
will be affected the most by the decisions
you're making.

A Checklist for Team Leaders

What can you take away from this chap-
ter and contribute to improving your
team dynamics? Here's a short list from
participants in past workshops and web
conferences.

- Assign clear roles.
- Celebrate small achievements.
- Try to be positive, honest, and open.
- Present a clear message.
- Get clarity about information
 and decisions.
- Give specific assignments.
- Help enact change.
- Own it.

What would you add to the list?

(This chapter is based in part on transcripts from the AAM Web conference, **Straight Talk: Communicating with Your Staff, Your Teams, Your Boss,** *available online in the AAM Recorded Webinar Library; and on the AAM Career Café session "Understanding Team Dynamics.")*

Practicum: Assessing Team Dynamics: Spider Chart Activity

Gary Ford

This activity is a simple way to assess your team dynamics by getting all team members engaged. It can reveal important information about how members perceive the team and their roles in it. Create this on a piece of paper if you're doing it for yourself, or on a flip chart if you're working with your whole team. In this way, the team can visualize strengths and growth opportunities. If your team is in the forming stage, it's probably premature to do this type of assessment, but this activity is definitely something to do when your team is in storming mode.

If you engage in this activity with your team, what do you think you will discover?

Assessing Your Team Dynamics

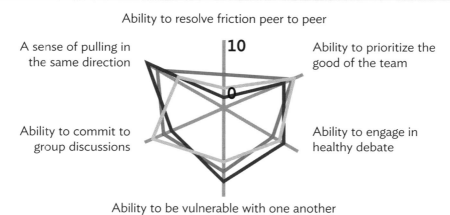

Ability to resolve friction peer to peer

A sense of pulling in the same direction

10

Ability to prioritize the good of the team

0

Ability to commit to group discussions

Ability to engage in healthy debate

Ability to be vulnerable with one another

Spider Chart Activity

1. As the diagram shows, your spider chart is like a wheel with several spokes. Draw three intersecting lines, creating six spokes. At the end of each spoke, write one of the following phrases:
 - Ability to resolve friction, peer to peer
 - Ability to prioritize for the good of the team
 - Ability to engage in healthy debate
 - Ability to be vulnerable with one another
 - Ability to commit to group decisions
 - Ability to pull in the same direction

2. Next, assign a value to each of those spokes based on your perception of your team's collective abilities. In the center is 0, representing lack of ability in any area; at the outer ends of each spoke is 10, meaning high ability.

3. Consider your team's abilities in each of the areas, and (each team member using

a different color pen/marker) mark a dot on the spoke indicating where you/ they think your team's collective abilities are currently. For example, if your team is good at follow-through on tasks, you might mark a dot at "10" on the spoke labeled "Ability to pull in the same direction." Alternately, if your team fights constantly with no resolve of real issues, you would mark a dot at "0" on the spoke labeled "Ability to engage in healthy debate."

4. Now (each team member using their color pen/marker) connect the dots with a line. At a glance, what does the spider chart look like with this overlay of each team member's contributions? At a minimum the chart will reveal overall strengths of the team as well as fairly clear growth opportunities.

5. Take time to discuss the team's reactions to the chart, individually and collectively. What does the chart tell us? Where are our strengths? Where can we improve? What actions do we need to take to make that change happen?

An important point to be made here is that not all teams (and team members) need to operate at a "10." "Seven," "8" and "9" are great, while still leaving room for growth. We may not be a "10" in the ability to resolve friction peer to peer, but we may still accomplish our goals.

Practically Speaking: Working on Project Teams

Myriam Springuel, Springuel Consulting

You have been assigned to your first project team! Congratulations. Now what exactly is a project?

A project is temporary, and consists of related tasks with a clearly defined end-result that solves an identified question or problem. The writing of a new curriculum-based tour might be a project involving multiple departments and the school district; giving the tour every weekday morning is not project work. Developing a new brand for the museum is project work; advertising individual exhibitions is not.

Project Teams in an Ideal World

In an *ideal world,* everyone on a project team develops and agrees to a scope of work including schedule, budget, and specifications. When you walk into a team meeting, the project leader follows an agenda, you ask questions, get answers, participate in making decisions, and go back to your office to implement your clearly defined responsibilities.

Project Reality: Ten Team Tips

1. Figure out where in project development you are. Officially a project has planning, implementation, and evaluation phases; all team members start on planning at the same time. In reality, people are added to teams mid-stream and need to catch up with the work.

2. Figure out what the project expectation really is. Officially there is a project "charge." In reality you may be trying to solve a related problem. Listen carefully for what else you are supposed to be solving.

3. Figure out who is really in charge of what. Officially it is the team leader. In reality other people are highly influential. Who are they? What are they looking for? How can you help them?

4. Figure out how what you do impacts what others do. Officially there are agreed-upon project schedules. In reality some tasks can "slip" more than others. What impact does "slippage" have on your work, on others' work?

5. Figure out who is responsible for what. Officially team member responsibilities are clearly defined. In reality, certain members are more responsible for some things than others. Who does what piece of work? What information do they need to make a decision?

6. Figure out how to communicate. Officially there are formal procedures for project communication. In reality, some people hold information that would make another's job easier. If it is

you, share information. Communicate informally. Ask questions respectfully.

7. Honor procedures for making changes to the work. You may not know the impact of the seemingly small change you would like to make. Others are making assumptions about their work based on what they assume you are doing. If you need to do something differently, make sure everyone knows and agrees to the change.

8. Be patient. Working in a group takes time, dialogue, numerous meetings, and a lot of listening.

9. Be a team player. Assume everyone wants to do good work. Help others shine. Sometimes they have too much work (and sometimes you do, too). Working in a collaborative spirit helps move the project forward.

10. Keep a sense of humor.

(This section is based in part on Myriam Springuel's Project Management session at AAM Career Café at the AAM annual meeting; and on the four-part AAM Project Management webinar series available online in the AAM Recorded Webinar Library.)

Chapter 24: So You Want to be a Director Someday?

Diane Frankel, associate, Management Consultant for the Arts, and Linda Sweet, partner, Management Consultants for the Arts

AS CONSULTANTS IN EXECUTIVE searches for museums, we have spent many years working with boards to determine what it takes to be a successful museum director. The first question we ask individuals is "Why do you want to become a director?" The responses are always revealing, and range from "I know that I could do a better job than my current director" to "I have a vision and I want to carry it out." In these responses, the motivation is similar: I want to lead. I want to be in charge. This drive has always struck us as critical. Without it, aspiring directors are unlikely to focus objectively on the skills and experience they'll need to plan their careers. Nor will they build the passion and commitment necessary to compete for the position or be successful once in it.

The question a search committee begins with is "What do we need in our next director?" By that they mean a combination of personal attributes as well as experience. But the position descriptions they develop concentrate on the responsibilities to be carried out. In this chapter, we will try to identify both the actual experiences and the more subjective characteristics that can help future directors think more comprehensively about who they are, what they need to know, and how they can arrive at their destinations. We acknowledge that while we are focusing on those characteristics that apply to those wanting to become museum directors, the truth is that these same attributes, skills, and experience apply to leaders at all levels, regardless of where you are in your career or your current position (see Chapter 22).

Among the critical characteristics for success as a museum director are:
- Passion
- Vision
- Perseverance
- Patience
- Decisiveness

Passion

A director must be a passionate advocate for the institution, the collections, audiences, communities, and the museum field. She has to believe strongly in the *mission*

and be able to clearly articulate it and its importance to all stakeholders, including the board, funders, the community, and staff. She spends a great deal of time overseeing all aspects of the museums' operations and programs.

At the same time, she fosters leadership throughout the institution to implement the strategic vision and achieve the institution's goals. As an advocate for the institution, the director has to be able to show passion for all parts of the job. Her passion takes the form of enthusiasm and optimism that translates into the energy to move forward and the excitement around the effort.

Vision

A director must have a clear sense of where she wants to take the museum. She has ideas and is excited about the ideas, but the vision is not hers alone. It emerges from observations, from discussions she has both internally and externally, and from her own experiences. The vision will guide the course for the future and must be set into a clear, thoughtful, exciting plan that spells out how the vision will be attained. The director must establish both a vision and plan that is broad and flexible enough to incorporate new opportunities and possibilities while anticipating unexpected obstacles.

Perseverance

Perseverance in the face of obstacles is critical for a museum director. It is easy to get waylaid, especially if others believe adhering to the plan is too hard or even impossible. By providing a steady course of action, she helps everyone work with longer-term goals in mind.

Of course, blind adherence to a course

of action without listening to others or looking at the external environment is not at all what we are advocating. Rather we are suggesting that if a course of action has been agreed upon, even though the course may be difficult, it is important for the director to persevere and help others push forward.

Patience

Reaching institutional goals takes patience, especially if these goals are new or potentially risky. The director oversees a great many pieces moving at once, and it is her responsibility to ensure that anyone and everyone impacted by decision-making is on board. The director must be patient and persuasive, often taking/allowing the necessary time to bring people around to accepting a new plan or program, or a new way of working. Patience means getting people involved early in the process. It also means the director must be a good listener, fair, open, and honest.

Decisiveness

A director must be willing to make decisions, but must do it through a process that involves gathering the necessary facts, listening to the opinions of others, weighing options, assessing the outcomes, and recognizing that there are no "perfect" decisions. Once a decision is made, it is time to move on to the next decision.

Leadership

The attributes outlined above are among the characteristics of a good leader. A director should be a leader, but not every leader is a director. A leader is the person who provides direction and motivates others, and then guides and supports them.

A leader makes sure everyone involved is provided with the necessary resources to do their jobs and achieve the institution's goals.

A director who is a leader recognizes the strengths and weaknesses of the institution and its people, and sets goals and allocates tasks accordingly. She must be willing to manage risk and to cope with uncertainty. Being a leader is essential to being a successful museum director.

Some people are born leaders; most are not, but over time can attain the characteristics of a leader through awareness, objectivity, attention, and effort. The important message here is that being a leader of a museum takes dedication, a willingness to learn, and tolerance of mistakes. Tolerance of ambiguity is a key attribute of a museum director, as is the ability to continuously strengthen oneself and the institution.

Management

To be successful, a director also needs management skills and experience. She needs to understand and be able to meet the basic expectations for a good manager. Typically, a board wants to be sure the new director can take on the following responsibilities:

- Oversee the development and management of a vital and engaging exhibition and education program.
- Assure the preservation, conservation, and growth of the collection and the appropriate use and care of the facility.
- Recruit, retain, and provide support for a professional staff and take responsibility for hiring, evaluating, and terminating staff.
- Prepare an annual operating budget as well as capital and project budgets, and monitor and dispense institutional funds

in a prudent manner.
- Keep the board abreast of national and regional trends as well as developments that affect the museum, support and motivate the members of the board, and work with them to build the capacity of the board.
- Supervise and actively participate in comprehensive fundraising and audience development programs.
- Maintain the highest ethical and legal standards in all professional actions of the staff and board, and in the corporate actions of the museum.
- Work with the board, staff, and community to develop and implement a strategic plan.
- Be the chief spokesperson of the museum.

Personnel, fundraising, planning, marketing, communications, finance—all are areas that candidates for directorships must be able to demonstrate mastery of, or at least the potential for achievement. In addition, professional expertise in a relevant subject area and in the operational and/or programmatic work of the museum is essential.

Paths

There are many paths to the director's office. More often than not the best person to be a museum director has prior experience working in a museum. She can come from the curatorial ranks, from education, or from the business side of the museum, and will have spent five to ten years in positions with increasing responsibility and authority. Along the way, the aspiring director will need to take on tasks that involve administration, budgeting, fundraising, and staff supervision, and will have found

opportunities to engage with the board and with the public.

Years ago an individual could be in the "right place at the right time" and land the perfect job, or be hired for a directorship without the relevant experience; today that is highly unlikely. Almost all directors have graduate degrees in a content area, in arts administration, in museum education, or in management. Some have multiple degrees and they have gained experience by running a department or division.

Mentors

Identifying a mentor and calling upon that individual for advice can be invaluable. A senior professional with experience and credibility can provide insights and objective advice, help with important decisions, suggest others to talk with, identify opportunities, and act as a reference. Careers seldom follow a straight line. Interests change, opportunities present themselves, unexpected decisions need to be made. One mentor may be right for one segment of a career. Someone else may be more helpful at another.

In sum, the best museum directors have vision, training and experience. They are patient and open. They persevere, they take risks, they engage in inclusive decision-making, they make others feel valued, and they are curious and interested in people. They have passion and look to the future. They are leaders.

Career Path: Educator-Turned-Director

Nathan Richie, *director, Golden History Museums, Golden, Colo.*

I remember that starting around age 10 I got it into my head that I wanted to be a ranger in the National Parks. I loved visiting the amazing natural and cultural treasures and relished the great adventures with my family. So I started a trajectory to follow that career path.

In high school, I worked as a tour guide and volunteered at the zoos to gain any experience that could help me become a ranger. In college, I pursued a degree in Natural Resources and secured two back-to-back internships with the National Parks. I loved both experiences and learned more about myself than I anticipated. I also learned another important lesson: I didn't really like working for the National Park Service. Although I loved interpretation, nature, and visitors, I didn't like the isolation, the seasonality of the work, and the intense competition for jobs. Lesson learned: discovering what you don't like is as important as discovering what you do like.

I decided to leap into the museum field, which turned out to be a great career move for me. When I graduated from college, I

moved to California and earned an MA in Museum Studies from the John F. Kennedy University. After finishing my thesis, I followed my girlfriend (now wife) to Indiana. After a few panicked months of looking for work, I landed my first true museum job as a curator at a small art museum. Although I was less than enthusiastic about living in Indiana, I learned another valuable lesson: by moving to a less-desirable part of the country, I was able to step into a more senior position as a recent graduate than if I had stayed in highly desirable, market-saturated San Francisco. I also learned I enjoy being a big fish in a small pond and that a smaller town affords more opportunities to become involved in the community and make a difference.

After five years, I moved to Chicago to accept a position at a start-up museum. It was a step down in title but a huge step up in pay (and, frankly, in terms of places to live). I was promoted to a departmental director and became a supervisor. Managing people was a new frontier for me and a skill that did not come naturally. One of the best pieces of advice I was given: emphasize individual strengths, tackle weaknesses head on and don't fall back on familiar, comfortable roles. I spent a great deal of time developing leadership skills—a practice I consider a work-in-progress.

In 2010 I found a great job opportunity that allowed me to return home to Colorado. I accepted a director position at a history museum in a beautiful mountain town. I'm not sure when I decided that I wanted to become a director, but I knew I wanted to expand my horizons, skill set, and marketability. I also wanted to earn more money. Becoming a director gives

me a great deal of empathy towards all of my former bosses—both the ones I liked and didn't like. I never realized how many decisions I would confront on a daily basis. I even find that I have to make decisions about what I am going to make decisions about. And I have to confront the reality that I can never please everybody.

Ironically, it was my love of exhibits and education that drew me to the museum field, but now I spend only a fraction of my time doing those tasks. But, as an educator-turned-director, I am able to effect institutional change that prioritizes our educational mission. I can move forward agendas of audience advocacy, participation, and community relevancy. I've also found new creative outlets that are even more challenging and just as rewarding, such as forging relationships with community and business leaders, shaping institutional vision and setting priorities, and building and growing resources that allow the rest of the staff to carry out our important mission.

I am not certain where the path leads from here, but I think I have learned to be more mindful and appreciative of the journey.

PART FOUR: CAREER CHANGES

So let us go forward quietly,
each on his own path,
forever making for the light.

—**Vincent van Gogh** (1853–1890), from a letter to Theo van Gogh, April 3, 1878

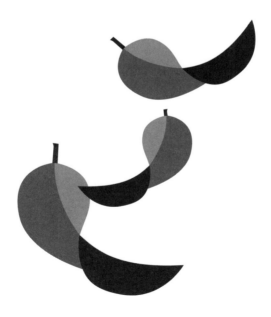

Chapter 25: Navigating Within Your Institution

Nik Honeysett

THE CLASSIC CAREER DILEMMA FOR ALL of us: when is the right time to think about a career transition? If there is no particular event that is forcing a decision to move on from your current position, the time to move on is when you are not learning anything new. Your next decision then becomes to move up in your current institution or out to new pastures.

What does it take to get a promotion? Getting promoted within an institution is a process that starts on your first day of work, for the simple reason that by the day you attend your promotional interview, the interviewer's mind will likely have already been made up about your suitability for the position. Never assume anything for an internal interview. Take it as seriously as you would any other interview and do not assume you have an "in" because you already work in the institution. In fact, an internal interview is much more challenging. Aside from the danger that it may be purely a courtesy interview, internal interviews present a bigger risk. There are many topics that you want to avoid that you might normally discuss in a regular

interview, particularly around your motivations for moving up. Ensure that you don't say anything that you can't live with if you do not get the promotion. Your singular challenge is persuading your interviewer that you are bigger and better than the job you are in—that you have capacity.

Getting promoted is less about performing well in the interview and more about having performed well and conveyed the impression of capacity from Day One—the impression that you can handle more scope and responsibility. You can create this impression by doing your job effectively, periodically going that little bit extra, and by effectively managing up. The classic saying "dress for the job you want, not the job you have" is just another way of saying create the impression of capacity. The key to effectively managing up is not about being a sycophant (although some bosses may respond to this), it is about being a low-maintenance employee: preempting tasks and objectives, taking responsibility, and making your boss feel comfortable relying on you and managing you. A boss will feel comfortable managing you if you ask

difficult questions of yourself, for example: "how could I have done that better?" I ask my boss the same question every morning: "What do you need from me today?"

The simplest way to find out whether you are a candidate for promotion is to ask your boss exactly that question. Anything other than a straight answer is probably "no." If that's the case at least you know where you stand, so it's up to you to do something about it. To make the case for a promotion, think of your job as having width and height; the width represents the amount of work you do, the height represents the responsibility you have. If your job gets wider, that means you get more work at the same level of responsibility. A wider job does not translate to a promotion; it may just translate to overtime. If your job gets taller, that means you have work at a higher level of responsibility (e.g. you begin to supervise someone, you begin to manage budget, your make more decisions affecting your department or institution—a taller job can translate to a promotion. If your job is getting taller, make the case to your boss. If it is not, ask your boss what you need to do to get promoted; what are the specific deliverables? Again, anything other than a clear answer probably means "no," so consider your position and your value.

The ultimate question is: are you more valuable with more years at your current institution or at another institution? The answer: it all depends, and what it depends on circles back to what you choose about your career future. Your career is a work in progress. At retirement you want to look at your career as a finished work of art, so what decisions can you make now that will help you complete that work of art? Setting a long-term career goal will help you make decisions about what your next move will be.

My last and final piece of advice is about exiting your current job: exit gracefully and professionally. Never give notice until you have a signed offer from your next institution. Never use your resignation as an opportunity to tell your boss what you really think about him. Like your social media presence, that behavior follows you around and lingers in individual and collective memories.

Practically Speaking: Intent vs. Perception on the Job

Wendy Luke and Greg Stevens

As you work on collaborative projects, develop programs, or brainstorm ideas about the next exhibition, take a moment to reflect on this simple concept: intent vs. perception. What you intend is not always how others perceive you. In any job, how colleagues perceive you and what ultimately adds value to the work you do is based entirely on the combination of your attitude, behaviors, and skills. Here are a few words of advice from the "trenches" to help you think and act more holistically on the job.

Be Aware

Be grounded in reality. Be aware and observant of yourself and others, of emotions, stories, assumptions, and facts. There is almost always more than one point of view, and frequently three truths: your truth, their truth, and the real truth, which lies somewhere in the middle. Understanding multiple views adds to creative problem-solving and collegial relations.

Make Choices

Choice is all about you. You can choose to take on new work and new challenges because you want to continue to learn and grow your skills. If you make this choice, do your best to live up to expectations—of yourself and others. You may not like the choices you have to make at times, but you still have a choice to make. You might not like the fact that you are working a reduced workweek; rather than be miserable, you could choose to use your days off to volunteer for an organization that you care about. You may not like your boss; what can you choose to do about your attitude or behavior that will help you manage up and improve the relationship for all involved? If you don't make a choice, you are likely to feel like a victim. If you make choices, you are likely to see options and feel empowered.

Know Your Agendas

That's right—you have agendas, plural. These include your work agenda, volunteer agenda, family agenda, friend agenda, and social agenda, among others. Think in terms of what you want to get and learn, as well as what you have to give. At different times, one agenda may take precedence over the others.

Be Able

Believing that you can do something contributes to a sense of personal power, performance, and confidence. Knowing what you're good at and passionate about are first steps to knowing and communicating where your true strengths lie. Focus on these strengths (what you *can* do) as you develop your self-confidence, not just from

the skills and experience you have developed, but also by acquiring knowledge and skills from others (see Chapter 5).

Be Willing

As author John Maxwell puts it in *The 360 Degree Leader* (Nashville: Nelson Business, 2005), "Successful people do the things that unsuccessful people are unwilling to do." Another guidepost: "Take the tough job—you learn resiliency and tenacity during tough assignments."

Be Right

Knowledge is power. In whatever role you play at your museum, knowing how to find, analyze, and disseminate information is essential to your success. Keep up with issues and trends, both within and outside the museum field. Whether you aspire to a museum career or you're in your third museum job, be a lifetime learner— a voracious reader—from journals and magazines (in print and online), to blogs, newsletters, list serves, and the arts and science sections in the *New York Times*. Read books in your field and discuss them with colleagues. Attend annual meetings, workshops, seminars; listen to webinars and podcasts. Demonstrate that you are a continuous learner.

Be Wrong Sometimes

In our culture, we are not conditioned to admit our mistakes or defeat. We see being wrong as a character flaw, when in reality being able to admit when you failed or underperformed is a healthy sign of a reflective practitioner. Exposing this level of vulnerability is the foundation of trust in any relationship, but it is only as valuable as your demonstrated willingness to learn from your mistakes and move on.

Chapter 26: Should I Stay or Should I Go?

Claudia B. Ocello, *President and CEO, Museum Partners Consulting*

The Dilemma

Should I stay or should I go? You probably ask yourself this question when you're having a bad day, and sometimes even when you're having a good day at work. It's a tough call; you are finally working in a museum, and those jobs are hard to come by. You're excited about parts of your job, but other parts are just plain annoying. You get along with your co-workers, but your boss—wow, stay out of her way! You're not making a lot of money, but you love what you do. You feel stuck. Here are some clues that may help you see through the fog and make a decision.

You get up in the morning and look forward to some parts of your job, like teaching a school group, cataloging new acquisitions, or working on a grant proposal. Or maybe those are the parts of your job you really dread. We all have those aspects to our work, so honestly examine if they are things you can put up with, or things that are dragging you down overall. I don't like the parts of my job (as a consultant) that

have to do with asking people where my invoice is in the payment queue, nor do I enjoy figuring out project budgets.

But the positive aspects of my job— meeting new people, working with diverse organizations and working on an exhibition or education program—are so enjoyable that I can overlook the others. Try making a pro and con chart of your job responsibilities and add the rough amount of time you spend each month/week/day doing the unpleasant versus the pleasant. Maybe you can decrease the time you spend on some of the "cons" and increase the time on the "pros," for a better balance. Asking your boss to help you with this balance could increase your job happiness quotient.

The Boss

Speaking of your boss: remember we can never get along with someone 100% of the time and we all have good and bad days. I had some tough bosses when I worked full-time and there were days that I wanted to quit or move on to another job. Try to look

168 | Chapter 26
Should I Stay or Should I Go?

at your boss holistically. Does he have the same fundamental beliefs as you? Does he look out for your best interests as well as his own? Is he serving as a mentor to you, even indirectly? If the answer is no, then it might be time to move on. If you are having a hard time with your boss, he might also be having a hard time with you. If you think it might help to talk with him, communicating honestly and openly during a calm time might clear the air for both of you, and improve your outlook about your job.

The Challenges

It may be time to move on when you're not challenged anymore at your job. Or maybe the job is too challenging and you need to make a lifestyle change to find a better work-life balance. It is hard to step back and honestly examine your soul and do some reflection. In my case, I was not being challenged enough nor was I growing in my career. I thought if I worked more hours I would be more challenged and might be viewed as indispensible. So I overscheduled myself, but that just made me more miserable!

If you're not feeling challenged anymore at work, think honestly about whether approaching your boss and explaining the situation might lead to some changes and improvements. If you don't speak up, you might never know if things could get better.

If you decide it's worth staying, then take some time to reflect on what you can do to improve the situation. What are some small steps you can take that might have a positive effect on your attitude and how others perceive you at work? What are one or two small things you can do to help you manage your time while at work?

The Decision

If you are thinking it's time to move on, it's a good idea to examine closely what you like about your job in order to make sure the next place you go to is a good fit. Thinking more broadly than specific roles or functions will expand your job search. What are you really good at, and what are you passionate about (see Chapter 5)? For example, if you like designing exhibitions, maybe it's really just about being creative; look for jobs that will allow you this flexibility. You're more likely to thrive in an organization if you like what you are doing.

If you have the choice, it's a personal decision and one that at some point everyone goes through. Gone are the days when the job you get out of graduate school is the job from which you retire or even the job you stay in for 20 years. There's nothing wrong with you or with the field. If you decide to stay at your current job, and have spoken to your boss about changing some responsibilities or aspects of your position, you might consider setting a time frame to reassess if it's working out or not. At one museum, when I cut my position from full-time to part-time as a money-saving measure, I met with my boss after three months to see if the situation might improve enough for me to go back to full-time. When I was told that the organization couldn't hire me back full-time, it was time for me to move on, painful as it was. Be honest and open with yourself and you'll make the right decision. In the end, you're the only one responsible for your career, your integrity, and your happiness.

(This chapter is based in part on a Mentoring Roundtable discussion at the AAM Career Café at the AAM annual meeting.)

Practically Speaking: The Kaizen Way to Performance Improvement

Wendy Luke

"Kaizen" is Japanese for "a small and important change." It is an example of a continuous improvement process used by organizations and career coaches to emphasize the value of implementing incremental change toward positive results.

Kaizen is a philosophy that can be used to help you look for a job, live a healthy life, or tackle a challenging project. It rests on the concept that if we take the small steps toward a goal, we are far more likely to reach it than if we take one or two large, life-disrupting steps. It's an approach that eases the path to success.

Use Kaizen to Work Toward a Goal

You may already have a list of items that would help you improve your job performance. It probably includes things that frustrate you, like the need to waste less time. It may also include items that your manager has mentioned during a performance review, like the need to adhere to deadlines.

The first step in a kaizen is to identify the specific actions behind the problem. Identify the times of day when you are not performing productive tasks. What are you doing during those periods?

Let's say you spend time searching for documents in the piles of papers on your desk. A resolution to clean up your desk and keep it clean is far too big to accomplish in one step, so you put it off. Instead, use a kaizen approach: at the end of each day, spend just five minutes clearing your desk. Set the timer function on your computer. Suddenly, clearing your desk doesn't mean hours on a Saturday working at a boring task. It's just five minutes. Granted, your desk still has piles of paper, but there aren't as many, and they are smaller. It's faster now to go through the piles to find the documents you need.

Let's take a second example: a failure to meet deadlines. Like many people, you may miss deadlines in part because you don't manage your time well. Here again, kaizen can help. For example, your report on the recent family day program is due at the end of the week. Every time you sit down to start the report and write the summary paragraph, what you produce is not worth saving. And now you have four days left before delivering the report to your director. A kaizen approach would be to skip the summary statement and write one sentence on the background section. Just one sentence. Later, you can write another sentence. In my experience, once I've written one to three sentences on a section of a report, the rest of the writing comes more easily.

Use Kaizen to Establish New Attitudes

Kaizen can also help you toward a more positive approach on the job:

- If you berate yourself with negative questions, ask: What is one thing I like about myself today? Write down your answer.
- If you are unhappy at work, ask: What kind of job could bring me pride and pleasure?
- To pay attention to others or to hear their voices, ask: Is there a person at work whose input I rarely get? What small question could I ask this person?
- If you have festering conflict with another person, ask: What's one good thing about this person?
- If you feel pessimistic or negative, ask: What is one small thing that is special about me (or my organization)?

You cannot change the habits of years— much less a lifetime—overnight. Setting huge, complex goals or trying to change everything at once is a recipe for failure. Small steps get you to your goal far faster than do large steps that you may never take.

Chapter 27: So You (Think You) Want to be a Consultant?

Mary Case, co-founder, Qm²: Quality Management to a Higher Power

THE MUSEUM WORLD HAS SEEN ITS share of downsizing and outsourcing in recent years. Many of these displaced workers chose not to return to someone else's employ. These independent professionals fill all sorts of temporary staff roles. You may be one of them.

Looking back on the last decade of my museum career, I never imagined I would end up as a happy member of what author Dan Pink calls the *Free Agent Nation* (New York: Warner Business Books, 2002). As I see what's facing people entering the field, consulting seems to me as good an option as any—if you have the skills, the stomach to live with ambiguity, and the courage to compose your own life rather than take a path that others have paved. In this chapter I'm going to give you an idea on how to start the process and provide a framework for aspiring independent professionals to build a consulting practice, whether you intend to develop work purposefully while looking for another full-time job, to facilitate a mid-career shift, or to create a post-retirement practice to stay connected to the field.

My Backstory

For 18 years, I enjoyed a steadily increasing salary with good benefits. At the Smithsonian Institution, as director of the office of the registrar, responsibilities included care of the National Collection—eight million ticks, Dorothy's Ruby Slippers, the space shuttle, First Ladies' gowns, American, Asian, African art—the whole shebang. The jobs I had involved working with many admirable colleagues, my own alliance to mission, the efficiencies of routine and structure, challenging work, and readily supplied equipment and office space. Actually, I found myself having achieved well beyond my own imagination and highest expectations.

Nonetheless, the obvious question "What's next?" lived in my head for months as I passed the 10-year, then 15-year, then 18-year thresholds. I'm drawn to the next new thing, the next challenge. I love to work. I had skills, reputation, courage, curiosity, and drive, but I was struggling with what to do next. My internal dialogue finally came to clarity in three points:

- Nonprofits, especially museums, were in my blood;
- Teaching and learning were central to my happiness;
- Fulltime employment meant I could work at the top of my form too infrequently. My time as an employee was often taken with duties I was competent to do, but didn't hold much interest, let alone creativity or passion.

During my last years at the Smithsonian, I worked with Will Phillips, eventually my consulting partner, presenting a workshop called "Project Success Through Problem Solving." Watching him work opened the possibility of composing a similar life for myself. We remember the genesis of Qm² differently: Will thinks it was my idea; I think it was his. Qm² began as a consulting community: Quality Management for Quality Museums evolved into Qm²: Quality Management to A Higher Power. However it came to be, the result is a vibrant and thriving community of practice, with colleagues in the Qm² family and our clients (both individuals and institutions) who come with a wide range of expertise and from whom we learn every day.

Know Yourself

Before you make the leap into consulting, you need to know or learn about yourself. First and foremost, know what you have to offer of value that is relevant to the museum industry. Earlier in this book, we explored helping you identify your personal brand (see Chapter 5). Now is the time to revisit that chapter so that you are well-prepared with what you are good at, what your passions are, and how you can

communicate those skills and passions with distinction, relevance and consistency.

To build a successful museum consulting practice you need proficiency and the ability to take pleasure in technical competence, human interaction, problem solving, thinking on your feet, refer-ability, and letting go of old ideas. Some combination of these qualities coupled with your experience and skills constitute your unique capabilities.

Technical Expertise

As a museum consultant, you need the highest level of technical expertise within your consulting area: planning, research, education, registration, etc. Your computer technology needs to be fast and efficient. Plan on buying a new computer every two years. Plan on dropping your laptop, spilling coffee on the keyboard, and leaving behind your power cords, cell phone, and kit bag at least once a year. Get an insurance rider that will cover these "Murphy's Law" episodes, which inevitably affect your precious equipment. Remember, as an independent professional, you'll be working without the support of an IT department. Where will you turn for help when technical difficulties impede productivity?

How do you judge and demonstrate your level of technical competence? Here's a few questions to ask yourself:

- Do you keep up-to-date with technical advances, theory and professional practice?
- Do you subscribe to trade publications (like AAM's *Museum* magazine, *Curator*, *Harvard Business Review*)?
- Have you published in your field?
- Have you received awards or recognition

in your field?

- Are you a member or an officer of your professional association?
- Have you been active in standards development or peer review activities (like AAM's Peer Review program)?
- Do you have the right degrees and professional credentials? (See the earlier chapter on graduate school for more thinking on this subject.)

Human Interaction

Technical skills alone suffice for hermits. People occupy the workplace. As a consultant, you'll be working with people in sometimes short- or long-term capacities; either way, your ability to effectively connect and communicate with clients is critical to your success. Technical virtuosity becomes value only when it connects with people, when you train others or transfer skills and, most importantly, when you work with staff, volunteers, and board in building a commitment to act.

Understanding your working style contributes to understanding how you might cope with the consulting life. It pays to understand the natural styles of human interaction, which we think of as learning or leadership styles. According to the pioneering research of Ichak Adizes (www.adizes.com), four management functions exist in every organization and in every life. Consider the following to help understand your own strengths and how you may want to work with client organizations:

1. To produce results the organization requires and to satisfy needs.
2. To administer, establish, and maintain systems focusing on how to do things efficiently.

3. To initiate change, adapting to new opportunities and threats.
4. To integrate, connecting people to their work, to systems, to change, and to each other; to move the organization from mechanistic to organic thinking and operating; to synergistically connect internal stakeholders and to build energy from diversity.

Alan Weiss, in *Getting Started in Consulting* (New York: Wiley & Sons, 2000) provides an equally valuable set of traits to consider:

- *Humor and perspective*: indicates intelligence and mental agility.
- *Influence*: can you "work a room" or persuade an individual?
- *Confidence and self-esteem*: your success depends upon being seen as a confidant and peer, not as a sales person.
- *Fearlessness*: you will be required to walk away from business; do so graciously and honestly.
- *Rapid framing*: to re-articulate client concerns is to help them discover that they need you to work with them further.
- *Value generation*: to provide value from the moment of client contact; the only reason to hold back on what you know is to avoid overwhelming your client.
- *Intellect*: intellectual firepower, the ability to paraphrase, cite historical analogies, point out weaknesses in arguments, and ask penetrating questions are qualities that attract consulting contracts.
- *Active listening*: reflective listening, paraphrasing results in nodding, smiles, deeper conversation, and ultimately, work.
- *Proof*: if you can provide concrete examples of theory or ideas, people will

be turning to you to help them.

- *Responsiveness*: If you want work, respond within two hours and you will get work.

Problem-Solving (or Solution-Finding)

The core of any consulting practice is problem-solving or helping the client find solutions to their challenges. A good consultant develops the skill to determine when to listen and receive information, using a repertoire of questions that encourages dialogue, as well as the skill to know when to move from information-gathering to problem-solving. Each solution is specific to its problem or opportunity. There is a vast body of material available online and elsewhere to explore techniques of decision-making, problem-solving, and execution.

Refer-Ability

Virtually all consulting business comes because someone, pleased with the results of your work, has referred you. Consultants get hired when someone wants to work with them. Refer-ability makes the difference. You will rarely receive work from directories, ads or fancy brochures. You probably won't get work from cold-calls or blind emails to potential clients. Therefore, your real focus should be on building your refer-ability. Understanding the following about yourself can increase your percentages. Fill in each statement with honest percentages; your answers will help you better identify your strengths and growth opportunities as a consultant.

I show up on time __ percent of the time.

I deliver value __ percent of the time.

I deliver value on time __ percent of the time.

I do what I say __ percent of the time.

I finish what I start __ percent of the time.

I say please and thank you __ percent of the time.

Know the Market

Market misinformation is among the leading causes of new business failure, so undertake a rigorous search for the truth about your potential market and your own skills. Confidence that someone needs you requires data to help you define your market:

- Explore www2.guidestar.org and www.charitynavigator.org. These sites provide information on nonprofits, nationwide. This can help you identify potential nonprofit clients in your region or in your disciplinary specialty.

- Develop an applied research project that relates to your consulting interest. I decided that conducting staff and board retreats was something I could do. So I called up 50 museum directors in the Washington, D.C. area and asked them four questions about their use of retreats. I wrote a brief report and shared it with anyone who took the time to speak with me. This, of course, got my name in front of close to 50 museum directors (twice), reminding them in a subtle way that I was looking for work and that managing their retreats was something I could do.

- Understand how people use consultants, what they pay for services, the pros and cons, and what might be offered that currently isn't. For

example, if a consultant developed a policy manual, would the client want assistance in the implementation? If a consultant designed an exhibition, would research assistance also be desired? If a consultant studied the visitor experience, could she also train volunteers to implement the recommendations of the study?

To define your potential market you need to know some answers to the following questions:

Who, and how many, will likely hire you? What evidence do you have?

What annual budget range do organizations need to have the capacity to hire you?

Where are they? What is your desired geographic range?

What is the mission area of your desired clients? Cultural organizations? Will you work for any nonprofit? Will you work for businesses, too?

What do your potential clients need?

What opportunities and threats face the client?

What consulting do they now pay for?

What other consultants or firms can you team with to strengthen your services or support your own learning?

Letting Go

As you embark on your museum consulting career (and periodically throughout it) you will make mistakes—guaranteed! When this happens, you need to own your mistake, truly learn something valuable from it, and move on. *Let it go.* Time is a precious thing; don't use it to worry about mistakes, perceived slights, or your own shortcomings. Don't spend energy on something you

can't do anything about. Here are a few examples of letting go, based on the actual experiences of fellow consultants I have known:

You'll spend a week working on a proposal and learn that the client used the proposal to a plan in-house work instead. Fume for an hour or two and then let it go.

You're sure, after conversations with your client, that a new piece of business will start on the first of the month. It doesn't, and if you spend time worrying about it, you won't be able to concentrate on the work you do have. Let it go.

You foolishly gossip about a client (forgetting for a moment that you no longer work inside the art world, which operates on gossip and innuendo) and it gets back to the client. Grovel, apologize, and let it go.

You miss a meeting or double-book yourself. Let it go.

Once or twice (you won't let it happen more) you'll realize that the client really wants you to confirm his opinion and isn't interested in new information or alternative viewpoints. Unless you agree with him, you can't do your work with integrity. Do what you can and get out. Let it go.

In Closing

Here's the final point (and the bottom line): why not build your consulting career on something you care about, something that interests you? Where do your passions lie? Your passion, coupled with your unique abilities and client needs, could provide

a living. The challenge is to connect your skills and passions with client needs. If you work toward creating that connection—the sweet spot of all work—you are on your way toward creating a rigorous vision for your independent work.

(This article is adapted from a longer technical leaflet published by the American Association of State and Local History, and can also be found on the Qm² website.)

Chapter 28: Rebounding After Losing Your Job

Claudia Ocello, President & CEO, Museum Partners Consulting

Lemonade: *2 tablespoons fresh lemon juice, 1½ tablespoons sugar syrup, 1 cup water. Put the lemon juice, sugar syrup, and water in a glass and stir. Add ice to chill. Float lemon slices.*

—From The Fannie Farmer Cookbook, 1990.

Updated Recipe: One pink slip, 8 boxes of books and office decorations, one mass e-mail, an overwhelming outpouring of sympathy, one new website, 250 business cards, 500 personalized sticky notes, and as much good, sweet, positive karma as you can add. Store boxes, pink slip and office decorations in basement. Send mass e-mail to colleagues, read overwhelming outpouring of sympathy; cry, laugh, strategize carefully. Design and launch new website, order business cards and custom Post-its, and continue to spread and receive good karma. Yield: a new business venture, several interviews and four of your first consulting jobs.

On a Friday in November, I approached the door to my office and mentally outlined my morning priorities. The office manager greeted me, saying that my boss would like to see me first thing in her office. I kept my coat on as I put down my briefcase, walked down the hallway and knocked on her door.

In 20 minutes, it was essentially all over. My position as associate director of education and public programs at Save Ellis Island in New Jersey was being eliminated. I was being laid off effective immediately, our COO and my boss told me at 9:15 a.m. I signed some papers, turned in my keys and ID, and cleaned out my office.

I personally sought out each staff member and said thank-you and goodbye in a positive and graceful manner. My family always told me if life gives you lemons, make lemonade. This looked to be as good a time as any to start. If you are the giver of the lemons, please remember to say thank-you to your employees and let them go early in the week so they can start looking into unemployment and other assistance programs the next business day.

Once I got over the shock, next came anger and tears. I needed to be upset for a little while, but then I realized all my negative energy was not getting me where I wanted to go. If you are in this situation, go ahead and complain, mourn, be angry,

cry—but then send out positive and happy signals to the universe and rise above the bad vibes.

Suddenly there were many forms to fill out, phone numbers and new e-mail addresses and websites on which to register. I started to compile notes and to-do lists in a new notebook dedicated to this phase of my life: heat assistance, food stamps and documentation of my filing for unemployment. The notebook helped me stay focused and organized, since most of my professional career was now in boxes in my basement.

My Rolodex is just a model or two beyond the original version created in 1958. It was the first thing I put in my box as I packed up my office. At first I was embarrassed to tell people I had been laid off, especially after receiving a national award six months earlier. But I decided I needed to send a mass e-mail to my contacts to let them know what happened, provide new contact information and see if anyone had leads on jobs. If you use a computer system for your contacts, print it out or download it once a week to another source. Employers, please let your employees have at least a half hour of supervised computer time before you shut off their access so they can pull out contacts.

That impersonal e-mail landed me not only an incredible outpouring of sympathy from my friends and colleagues, but my first definite consulting job and another possible one. Those replies kept me connected to the museum community even though my world had been overturned. (I actually wouldn't be writing this chapter if I hadn't been vocal about my situation.)

Here's my advice: Start planning now for your layoff. Since we can't predict the future, hopefully you have been saving money from your paycheck each month, meeting new people and maintaining professional contacts. Think about postponing your vacation; you could be paid for your unused vacation days if you get laid off—there's a little unexpected money you'll need sooner or later.

If you qualify for unemployment, file ASAP. At first I was ashamed to look into heating/utility payment assistance, food stamps and other programs like these. But that's what the programs are there for. Tell people you are out of work: I got offered a job by the person in the next chair when I went to get my hair cut, and a supermarket checkout clerk suggested I give him copies of my resumé, since he sees lots of people over the course of the day. You never know where the next job will be or who will help you find it.

Thanks to telling my yoga class that I was out of work, I got the opportunity to work part-time—as my schedule allows—in the office of a friend's furniture store. I'm not switching careers to sell or place orders for beautiful leather sectionals, but I am finding ways to apply my interpersonal skills and I'm learning new ones, like the computer program Quickbooks.

Transitions are part of the process. I've gotten used to a different pace to my days and work schedule. Talking to new and former mentors has helped me stay focused and given me a boost. Unfortunately there are more colleagues out there than we think who have lost their jobs. Perhaps you know some of them—please reach out to them and spend some time with them. Your reaching out sends the signal that our colleagues haven't forgotten us. Staying connected is harder when you're not

working full time in a museum.

I decided to start my own consulting business. I pick up new clients thanks to word of mouth, my contacts and my new website, and have been going strong since 2009. Think about ways you could reinvent yourself in the museum world or otherwise. Maybe there is another type of job altogether or an angle within the museum world you'd like to explore.

Museums can show others how to make the best of a bad situation. Whether you're the one still employed with the increased workload or the one who got laid off, assess your situation and show the world how to make something bad into something good.

(This chapter was originally published as "Making Lemonade" in Museum, *July/Aug 2009.)*

Chapter 29: Mentoring Matters

Amanda Kodeck, *manager of school programs, Walters Art Museum; and* **Wendy Luke**

SMOKED SALMON AND POACHED salmon are not the same fish.

Lori Gross, director of arts initiatives at the Massachusetts Institute of Technology, remembers this life lesson as one of many shared by her beloved mentor, Stephen E. Weil. Gross says the maxim's meaning—it isn't the ingredient but what you do with it that matters—correlates directly with the relationship she and Weil shared after she became director of the Museum Loan Network in 1995.

"I turned to Steve for guidance, and over a decade the leadership he instilled in me—often through osmosis, always through example—transformed as our relationship did," she remembers. "We became collaborators, colleagues and perhaps even conspirators, allowing me to foster my own mentees and pay it forward.

"A mentor may not be able to change your essence, but he or she can be essential in assuring you that help is there when you slip so that you don't fall too far, and reminding you to cook ideas correctly when you fear that you may have lost the recipe," Gross says.

Mentoring is a sustained relationship between two professionals, ideally of mutual benefit. With roots dating back to Homer's *Odyssey* (Ulysses trusted the care of his son to Mentor, a guiding friend), the mentoring partnership surpasses other career development opportunities, such as workshops and conferences, with its promise of ongoing, one-on-one support. It is perhaps the best way to transfer skills from a more experienced colleague to a newcomer, ensuring the continued application and development of this knowledge.

There are mentoring programs that are organized through a museum or professional museum association. While formal mentoring programs are prominent in the for-profit world, they are not as prevalent among museums. There are a few museums, such as the Metropolitan Museum of Art, the National Gallery of Art and the Indianapolis Children's Museum, that have developed formal mentoring programs for their interns or fellows. These programs are endorsed by senior management and are an offshoot of the museums' efforts to encourage a more diverse pool of museum professionals. A few people volunteer to participate as mentors; many others are asked or even cajoled into it, fearing that being a mentor will require too

much time. Those who do commit to such programs tend to find them surprisingly painless, even gratifying. Mentors thrive on witnessing their mentees' energy and creativity.

At small institutions, the main obstacles to mentoring programs lie in typically small staffs, whose priorities are exhibitions, programs, and public education, and whose demanding schedules and tight budgets often preclude supporting such programs. There are many mentoring relationships that happen outside of formal organization-sponsored mentoring programs.

Though generally aware of how mentors could enhance their professional success, many emerging and mid-level museum professionals do not search for one—or simply do not know how. Others fear that attempting to establish this relationship will make them appear inexperienced, leaving them vulnerable in a competitive field. Yet these same professionals find themselves in meetings seated across from colleagues 20 to 30 years their senior. These less experienced professionals feel that they lack the confidence and know-how to contribute.

Mentoring could advance the museum field on a long-term basis. The mentorships that are established in museums, such as those for interns or informal partnerships, consistently and greatly benefit their participants. By drawing and expanding upon these instances, museums could aid not only their own staff members but also the field at large. There is much to be learned from the experiences, both successes and failures, and perspectives of seasoned colleagues. Good mentors support the transfer of information, wisdom, and skills, providing advice and inspiration. They satisfy mentees' desire to learn and grow, to

achieve more than they thought possible. It is largely mentees' responsibility, however, to drive the mentoring process. They must determine the type and amount of guidance they need and take the initiative to ask for it. Most mentoring relationships start and develop because the mentee initiates communications—via e-mail, telephone or in person.

Gen-Xers and Millennials sometimes shy away from mentoring, valuing input from their peer groups instead. The younger generations may rely more heavily on one another in part because the field has grown dramatically and responsibilities at senior levels have increased, leaving little time for staff at different levels to meet and talk. But less experienced professionals who want to acquire sophisticated thinking and make quantum leaps within the field must gravitate toward and be exposed to professionals with higher skill levels and experience.

Communication is easier among peers in a technical sense, as well. Emerging professionals often prefer to communicate by e-mail, listservs, Facebook, and texting versus a face-to-face or phone interchange. Some young professionals find it easier to get advice about mistakes online versus in-person discussions. If the potential mentor is a Baby Boomer, he or she might not naturally use technology to communicate, relying instead on one-on-one meetings or phone conversations. A mentor/mentee must work out the preferred style(s) of communication that will work best for them.

There are challenges and misconceptions to finding a mentor or being a mentee. Along with not knowing where to locate them, young professionals said they

fear rejection from potential mentors, and they worry that more senior professionals might think junior colleagues are after their jobs. Mentors, on the other hand, are often unaware that the interest in such a relationship even exists. Both sides doubt they will have enough time to commit to the partnership.

While some of these concerns are valid, others are solely assumptions. Many leaders take pride in being a mentor and are disappointed when they are not asked. To avoid suspicion or confusion during this initial stage, dialogue is key. The mentee must go in knowing and being able to clearly state what he or she wants to accomplish. While these objectives will likely change over time, at the outset a mentee typically needs help achieving a development plan, opportunities to strengthen skills and gain technical knowledge, insights into institutional culture or simply feedback to increase self-awareness. To build confidence before asking a person to be your mentor, try practicing communicating these objectives to a peer before officially asking.

If the response is a simple, absolute "no," the mentee should ask that person to recommend someone else. It is more good practice, as finding a mentor is a process that will be repeated over time. Over your career, you will find that you will benefit from having different mentors. In the beginning, it is important to have someone who can teach you how to follow, and later in one's career someone to teach you how to lead.

Similarly, finding a mentor doesn't have to be as difficult as some perceive. Those seeking a mentor should look for competent, senior professionals they respect and can learn from, and who have strengths

that they would like to develop. Potential mentors don't necessarily need to be in the same institution—or even the same field— as long as they possess these qualities.

Another way to find a mentor is to ask someone to find you one. Wendy Luke and Kate Goodall (formerly of AAM and now with ASTC) partnered on a mentoring session for Southeastern Museum Conference in 2008. Because of Kate's career interests, Wendy asked a recently retired director of a Smithsonian museum to be Kate's mentor. And Kate asked an emerging professional at the Smithsonian National Postal Museum to be Wendy's mentee. Kate posted the mentor/mentoring concept on a listserv; Wendy made phone calls and sent follow-up emails. These mentor/mentee relationships are still thriving. Kate didn't have to face rejection. If Wendy got a "no," she would have asked someone else to be Kate's mentor.

When a museum professional asks another to be a mentor, the arrangement is a type of formal mentoring—referred to as Mentoring with a capital "M."

There is much more informal mentoring, or small "m" mentoring, in the museum field than there are Mentoring relationships. In mentoring, the mentee often does not even let the mentor know that he/she is regarded as such, yet thinks of the mentor as a wise and trusted advisor/coach/cheerleader. These relationships start in many ways, including phone calls to ask for advice, discussions at conferences, or simply meeting in one's own museum with someone one to two jobs ahead. They help the mentee grow—at the institution, in the field, and as a person. Many emerging and mid-career professionals consider their boss a mentor, and the mentoring

relationships frequently continue when the emerging and mid-career professionals move on in their careers.

In the corporate world, mentoring is used as a tool for succession planning. The present generation of museum leadership should consider the value of mentoring in creating the next generation. Directors should make it known that they want to be mentors, serving as models and letting staff know how much they have personally benefited from these relationships. Senior staff should provide and engage in mentor/mentee training, advising potential mentors on how to coach and guide mentees and instructing mentees how to track down, approach, and work best with a mentor.

Promoting mentorships in museums would not only prepare the field for the future; it also could help retain its rising stars. Museums' notorious lack of monetary compensation often leads to the loss of promising newcomers. Mentoring can counter this trend. It's a way of keeping people engaged.

(Originally published as "Mentoring Matters: A Call for Backup" in Museum, *Mar/Apr 2008.)*

Practically Speaking: Open-Sourcing Your Mentorship

Cecilia Wichmann, *Publicity and Marketing, The Phillips Collection*

When my organization gave me a series of sessions with professional coach Wendy Luke, I was ready to embrace a major growth opportunity. High performing in my role, I had mastered tactical skills over four years in publicity and marketing, but needed to develop a more strategic vision. Wendy empowered me to identify a role model outside of my organization and ask her to mentor me for a discrete amount of time.

I took this sage advice, and it paid off. My new mentor, Suzanne Hall, chief communications officer, Virginia Museum of Fine Arts, wasted no time in modeling strategic thinking—she proposed that we seize the moment to reinvent mentorship for the 21st century. As part of our formal mentoring relationship, we set topics for each session:

- The Communications Plan
- Brand Management
- Crisis Communications

- Media, Networks, and Continuing Education
- Keeping it Creative

Until recently, I thought of mentorship as a secret society, a covert operation of two. You had to wait for Obi-Wan to come to you, and for that to happen, you must be born Luke Skywalker. Mythology aside, I've benefited from many mentors in my five-year museum career. These relationships evolved organically, spurring professional development and confidence. Still, I had never thought of mentorship as an open network, a reality show.

Then I reached out to a new mentor with 30 years experience in the field. I was struck by Suzanne's expertise, genuine manner, fresh energy, and experimental instincts. She asked me to reimagine the whole concept of mentorship. Rather than restrict ourselves to one-on-one confidences, we decided to blog our work together over six months and invite participation from our social networks.

We met in person and identified a series of topics for monthly discussion via Google Hangout, from a nuts and bolts examination of the everyday communications plan to a boot camp on crisis preparation and response. Topics are shaped to accelerate my learning curve and engage our peers in healthy debate about how we do our jobs now.

We built the blog on WordPress right then and there and launched Talking About Talking: A Communications Reality Show three days later (talkingaboutalking. wordpress.com). Weeks in, we have a small but active group of followers, participating through Facebook, LinkedIn, and blog comments. We're about to hit 1,000 page views. We've published six posts, with two drafts in process and innumerable ideas for more.

It doesn't hurt that we're communications professionals. Storytelling is the heart of our jobs. By conducting an open mentorship, we hope to crowd-source best practices, create a useful record of our work together, and test communications channels. Along the way, I'll learn not only from Suzanne, but from her peers, her mentors, her social network, and she will learn from mine. We've asked each other what outcomes will deem the project a success after six months and agree: with an experiment like this, it's about the journey.

Chapter 30: Strategizing Me: Making a Personal Career Plan

Anne Ackerson, *independent consultant and director, Museum Association of New York (MANY)*

THE ONE THING THAT CAN BE SAID universally about people who work in the museum profession is that they're here by choice. Nobody really twisted anybody's arm to work among beautiful objects or bewildering specimens, with fascinating or curious stories, or in interesting, even unique spaces. We're here because we've been drawn to this work. And many of us have come from a dizzying array of backgrounds to call a museum our professional home.

But once you're in the profession, what then? Whether you're just starting out or you've been around for a while, there are career crossroads to be navigated, some sooner rather than later, some by choice, others not. What's the career prize you have your eye on, and have you figured out the directions you can take to eventually grab it? How important is it to have your career all planned out? And don't we negate the serendipity, the excitement, and sometimes the fear of the unknown by being overly prescriptive? Besides, how can anybody plan like that in a time when looking ahead

even six months is a futile business?

It wasn't until I had been in the field a couple of decades that I created my first professional and personal mission statements, and drafted a timeline noting past turning points and future desires. I was just so happy to have an interesting and demanding job, my own income, and place of my own that I didn't even think I needed anything more than that. I'd been on a pretty satisfying career trajectory, I felt, but little did I realize until much later that I had been mostly on autopilot, except for the job changes that I made primarily for more money. I wasn't even thinking about skill development!

External forces, as it turned out, brought me to thinking about "my career" as something I could, in fact, steer, shape, or even throw over.

It's those crazy, sometimes unforeseen, external forces that can provide a launching pad or knock you for a loop. Planning of any type, whether it's about a career, an institution's future, or just going to the grocery store, is difficult and often

fruitless if it's done without taking external forces into account. In fact, people and organizations best weather storms when they've already given some thought to how they'll respond to any number of variables, good and bad. Called "scenario planning," although "discovery-driven planning" is perhaps more apropos, it is imperative to do now when few jobs are lifetime locks, when museums may choose contract labor instead of salaried staff as a way to contain costs, and when many institutions are looking to be more nimble in developing and delivering programs and services.

People get together all the time to share information, network, and help sort out career questions. Our families and friends often are our sounding boards, mostly because they're convenient, they care about us and are, therefore, likely (or required) to listen. But they may not be as helpful as colleagues or mentors who bring the worldview of our respective professions, as well as some critical distance, to our seeking.

So where might you start in creating your own personal strategic plan?

Put Together a Career Planning Posse

Sure, you can create a plan on your own. But if you're really after some critical distance, then it makes sense to enlist trusted colleagues or mentors (who may be going through this, also) to help you bring yourself into focus. So think of this as a 360-degree evaluation—now *that's* something that's almost impossible to do alone! You'll be the beneficiary of insights from people who see you in a variety of situations and from a variety of angles (just think about that three-way mirror in a clothing store dressing room).

Take Stock

Every solid planning effort begins with an unvarnished inventory of internal strengths and weaknesses, and external opportunities and challenges (or threats). What are the skills and attributes you've got going for you? What needs work? How might you play to your strengths and mitigate those weaknesses? Do you have growth opportunities in your current job or will you need to move on to gain skills and experience? Are you in an organization where the career ladder has been stunted by staff reductions, or has an increasing workload brought opportunities to learn new skills? Does small-bore thinking pervade leadership or are you able to lead effectively from where you are?

It's tough to do this type of inventory by yourself, although you certainly can. However, this is a great activity to do with your posse. Remember, your posse is here to help you evaluate yourself, not decide on your value.

Make an assessment of where your career has been and where it is now, using a format that is most comfortable for you: a narrative, a flow chart, a mind map, story boards, charts or graphs and the like can all help (take a look at www.mindtools. com). Once you've completed your assessment, can you discern any patterns in your choices, successes and pitfalls? Any preferences emerge? Any situations you want to stay away from in future? In your past, can you see preludes to future directions?

Create Your Vision

What is your vision for your work? Your life? Take some time to play with these questions. In order for you to break free of

the habitual stories you might be inclined to tell, it can be quite helpful to work with visual images or other creative activities that can help you move you from where you are to where you want to go. Always start with a prompting question like the first one in this paragraph. Other useful prompting questions might be: What do I offer a group or team? What am I passionate about? What motivates me at work? The new insights and ideas that emerge by weaving the visual and the verbal can be truly enlightening and energizing!

Now write your vision statement. Keep it short and powerful. Show it to your posse and ask for feedback.

Build Your Plan

You are armed now with the knowledge about your strengths and weaknesses, an understanding of where your career has been, is now, and where it could go, and why it's important to aim in certain directions and not others. You're ready to plot out the next steps in more depth. This is the most difficult piece for most people, because it requires that you weave together a number of seemingly disparate strands into one very strong tapestry. Your goal in building your plan is to play to your strengths by aiming them at opportunities that will support your vision for your work.

You may not be successful at this personal planning stuff on your first try. That's to be expected. You must build a plan that you, and only you, are most comfortable with, that will encourage you to follow it, to make changes to it, and to otherwise keep it as a constant companion for as long as you need it.

For some, getting a handle on the next

six months or year is plenty. A piece of poster board with your vision at the top and a month-by-month grid of six or twelve boxes might be all that's needed to organize a handful of tasks that will start the process of refocusing your career goals. For others, a plan that articulates goals, strategies, and tasks might make more sense. The key: all must flow from your vision and all must have some kind of timeframes attached (otherwise—you know the drill— all that good stuff is likely to slip by).

Ask your posse to rip it apart and help you weave it back together.

Work It

There's an old saying that goes, "Plan the work and work the plan." No plan can be helpful if it never sees the light of day. It's now time to start completing those tasks. Put them on your calendar and start ticking them off. Did you say that you wanted to contact six people and ask for an information interview or a "pick your brains over a cup of coffee" conversation? Methodically reach out and ask for those appointments. Need more information about putting your skills to work as a consultant? Block out that research time on your calendar and keep that date with yourself and your search engine. Want to add a new skill to your toolbox? Take on a volunteer assignment that will expand your skill set *and* your network.

Here's where your posse can keep you honest. There's nothing like a periodic check-in with them to motivate you.

And last, but not least, particularly for you mid-career types and museum veterans:

Disrupt Yourself

When I read these sentences by a former Wall Street analyst-turned-entrepreneur, I found myself nodding in agreement: "Nearly everyone hits a point in their life where they examine their trajectory and consider a pivot. We typically label this mid-life crisis, but isn't it more often a re-thinking as to which performance attributes matter? Perhaps earlier in your career the metric was money or fame, but now you want more autonomy, flexibility, authority, or to make a positive dent in the world." (Whitney Johnson, "Disrupt Yourself," *Harvard Business Review* Blog Network, August 22, 2011).

I had the good fortune to make a little bit of a disruption in my career trajectory that included some time off to recharge my batteries and re-enter the field as a servant to the museum profession rather than to a single institution. It's a type of disruption not many think they can take, for any number of reasons (or excuses), but I can't tell you the number of colleagues who whispered to me, "I wish I could do that!" or "You're so brave!"

Bravery had nothing to do with it. I was completely motivated by my need to "align my ladder to a new wall," as Marc Freedman so aptly described it in his article, "A Gap Year for Grown-ups" (*Harvard Business Review* Blog Network, July 14, 2011). It was scary and I didn't know where my "gap year" would take me or how hard I would land. But few people knew that I had spent the previous twelve months planning

my gap year.

I developed my first personal mission statement and timeline during that year. I recently returned to that work, now almost 15 years old, to help inform my new personal strategic plan.

Of course, a year off is not practical for most of us. Some would consider it professional suicide, not to mention a fast track to financial ruin. But there's a great deal to be said for the periodic "step back," which we routinely associate with academia as the sabbatical. The opportunity to disrupt ourselves, even for a few weeks, is beneficial. I'm heartened to see that some institutions and nonprofit funders are offering support for short-term sabbaticals, but there's not enough of it going on in our part of the sector. There needs to be.

As each generation lives longer, many will keep working longer, too. As Freedman implores employers in his post, "help us forge a new map of life, one that builds in breaks more sensibly along a much longer trajectory, that is fitted to the new lifespans of the 21st century—and not just for all those flagging boomers approaching the big six-oh. After all, half the children born since 2000 in the developed world are projected to see their 100th birthdays. Let's pass on to them a life course that's sustaining and sustainable, that pays off on the promise of the longevity revolution, for now and for generations to come."

What would you do if you walked into work tomorrow to learn that you'd been given a four-week break to focus on your career? Whether the impetus comes from your institution or from that little voice deep inside yourself, one thing is certain: you'd better get planning.

Practically Speaking: Painted Picture

Wendy Luke

Occasionally you attend a session at an annual meeting and you come away with an idea that impacts your life. This happened to me in 2010 when I heard entrepreneur and business coach Cameron Herold talk about his "painted picture."

In concept, the painted picture is a three-year snapshot of your life, your career, your business, your relationships, and your self. What's magical about three years? It is long enough to make aspirations a reality and not so long that things become stale.

Listening to Herold inspired me to create my own painted picture. It is a detailed, high-level overview of my business and how my life will look and feel in three years. It covers what I really want in my life—experiences and accomplishments in many spheres, including professional, emotional, physical, in my relationships, my hobbies, and others. I review my painted

picture regularly and I've shared it with many people. Sharing my painted picture has been scary. What if people think I'm over-reaching? What if I don't achieve my vision? What will my friends and colleagues think of me?

How to use your painted picture

My painted picture is a written narrative. Yours could be a collage of pictures/photos, a mind-map, or any format you are comfortable with. Your painted picture is valuable because it allows you to declare what you want, to yourself and others. As you think about it and share it, you increase the probability that you will make great things happen. By sharing your painted picture, you open up the possibility that people can help you achieve your vision.

Examples of elements that might be in your painted picture

- The job you will be in
- What you have published
- The quality of your relationships with friends
- The quality of your relationships with family
- The quality of your relationships with your spouse/significant other
- With whom you collaborate

- Your volunteer activity
- The fulfillment you get from your hobbies
- Your physical well-being
- Your spiritual well-being

It took me some months to envision my painted picture. Some of it was drafted on the back of an envelope while traveling. Some of it came from lists of words I wrote on the computer. I shared the concept with a number of friends. It was helpful to me to tell people I was working on it. When I found myself running a tape in my mind that said, "Oh, you won't be able to do that," I had a conversation in my mind that said, "Oh, yes you can." After a number of drafts, it seemed to me that it would never be perfect. And so it became my painted picture.

I'm not quite a year in to my three-year painted picture. It's vivid. And it is becoming my reality.

Co-Editors

Wendy Luke, founder of The HR Sage, has 20 years experience working with museums solving their toughest people problems. From recruitment and employee handbooks to facilitating board meetings and coaching top performers, Wendy has worked with both non-profit and for-profit organizations. She is noted for helping organizations address transitions, both big and small, to reach their goals. An active member of ArtTable, AAM, and MAAM, Wendy is a frequent speaker at conferences and a regular contributor to publications. Wendy partnered with Steve Weil in working with museums around the world, until Steve's death in 2005.

Greg Stevens has directed the AAM Professional Development program since 2007, addressing career, management and leadership development, professional skills-building and mentoring for the museum field. Innovative programs he has launched include AAM's first online education programs, the AAM Career Café at the annual meeting and National Emerging Museum Professional (EMP) Career Workshops. In addition, Greg plans and presents career workshops to museum organizations and universities nationally. Prior to AAM, Greg held education positions at the National Museum of the U.S. Army, Mid-Atlantic Association of Museums, National Building Museum, Smithsonian National Air and Space Museum, and Kellogg Performing and Visual Arts School in San Diego. He earned his MAT in Museum Education from The George Washington University and his BA in Theatre Design from San Diego State University.

Contributors

Sandra Abbott is curator of collections & outreach at the Center for Art, Design & Visual Culture, University of Maryland, Baltimore County, where she also teaches museum studies courses. Previously, she worked in the department of contemporary art at the Indianapolis Museum of Art and graduated from Harvard University's Museum Studies Program. She attended the school of, and worked for, the museum of The Art Institute of Chicago and is an alumna of the Smithsonian American Art Museum's Advanced Level Program. Additionally, she holds a graduate degree in art history.

Anne Ackerson served as director of several historic house museums and historical societies in central and eastern New York and now currently serves as the director of the Museum Association of New York. She is also an independent consultant focusing on the organizational development issues of smaller cultural institutions. Anne writes regularly about management and leadership issues in her blog, *Leading by Design* (http://leadingbydesign.blogspot.com).

Anne Baber is the co-founder and managing partner of Contacts Count, LLC. For the past 20 years she's worked with corporate, association, government and university clients to help them put the tools of networking to work in the service of business goals. Anne is the co-author (with Lynne Waymon) of *Make Your Contacts Count* (2nd Edition, AMACOM) and of *Job Hunt: 50 Networking Tips*, a free iphone app and also downloadable at www.ContactsCount.com.

Michael Balderrama is a programs coordinator at the American Association of Museums (AAM), after interning in the professional development and government relations and advocacy programs. He is a freelance cartoonist, and provided illustrations for the AAM publication *Speak Up For Museums: The AAM Guide To Advocacy*. Mike holds a MA in Art and Museum Studies from Georgetown University, an Art Business certificate from the Sotheby's Institute of Art, and a BA in Classics from Wheaton College, MA.

Carol Bossert is a planner, facilitator, writer and teacher with 25 years of experience working in informal learning environments. Her consulting practice, CB Services, LLC provides service in interpretive planning, content research, asset management, writing, and editing to museums, cultural institutions, and educational organizations. Carol is a member of The Museum Group, a consortium of senior museum consultants offering museums individual expertise and collective wisdom. She holds a doctoral degree in biology from the University of Texas at Dallas, a BA in zoology from DePauw University, and is a graduate of the Getty Museum Management Institute.

Wendy C. Blackwell is the director of education and programs at the National Children's Museum in Washington, D.C. Since joining the NCM staff in 2005, she has been developing the Center for Learning and Innovation and is the author of *Family Literacy Projects on a Budget: A Trainers' Toolkit*, a publication that provides educators and families with affordable resources and activities designed to foster literacy at school and in the home. Blackwell is writing a second toolkit collaborating with illustrator Mark Hicks. Previously, Wendy was director of education at Port Discovery in Baltimore, and school improvement coordinator at Frederick Douglass High School.

Mary Case co-founded the museum consulting community Qm² in 1993 after a long career working in museums that include the Mercer Museum, the Strong Museum, IBM Gallery of Art and Science and the Smithsonian Institution. Since co-founding Qm², Case has consulted exclusively with boards and senior staff on leadership issues, improving decision making and strategic thinking initiatives. She holds an MA with honors, Museum Studies, SUNY, Cooperstown and a BA magna cum laude, American Studies, Temple University. She is widely published in museum journals. Her books include *Registrars on Record* (1988, AAM) and *Building On Strength: Constructive Change for Nonprofit Organizations* (2003, iUniverse.com).

Colleen Dilenschneider is a director of IMPACTS Research & Development and a recognized voice in the realm of audience engagement using social media technologies within zoos, aquariums, and museums. She has built symbolic capital as a Generation Y museum aficionado, published numerous industry articles, and serves as a frequent speaker and contributor to podcasts, conferences and webinars. Colleen writes about the evolution of online engagement practices in cultural organizations at Know Your Own Bone (www.colleendilen.com).

Amy Duke is the museum educator for adult programs at the Kemper Museum of Contemporary Art in Kansas City, Missouri, where she formerly served as collections manager and registrar for eight years. Prior to relocating to Kansas City, she was coordinator, and later director of Special Exhibitions at Holocaust Museum Houston. Her introduction to the field came as an intern at the Umlauf Sculpture Garden & Museum in Austin, Texas, while earning a BFA in Art History from the The University of Texas at Austin.

Linda Downs is executive director of the College Art Association. She received her MA in the history of art at the University of Michigan and Ph.B. at Monteith College, Wayne State University. Previously, Linda was curator of education at the Detroit Institute of Arts, head of education at the National Gallery of Art, Washington, D.C. and director of the Figge Art Museum, Davenport, Iowa. She has been a museum education consultant to museums in the US, Mexico and Europe. She is the author of a monograph on Diego Rivera's *Detroit Industry* murals and has organized exhibitions including a major retrospective of Rivera's work.

Gary Ford is currently a management consultant and trainer as principal of GLFord Consulting. Gary's practice focuses

on developing strong leaders, building high performing teams, and creating optimal work environments. His workshops are highly interactive, and participants walk away with practical tools relevant to their daily work. The bulk of Gary's experience comes from his 16-year career at Nintendo of America, where Gary managed teams from ages 2 to 65, and where for eight years he headed the learning and development function.

Diane Frankel is an affiliate of Management Consultants for the Arts with 25 years of experience in the non-profit arena, having previously served as the director of graduate programs in museum studies at John F. Kennedy University, the founding director of the Bay Area Discovery Museum, and as head of the Institute of Museum and Library Services as an appointee of President Clinton. Ms. Frankel has also directed the Children, Youth and Families program at the James Irvine Foundation, served as interim director at the di Rosa Preserve, and served as executive director of the Artists' Legacy Foundation. Ms. Frankel is a graduate of the University of California at Berkeley and earned her MAT from The George Washington University. Additionally, she attended the Getty Museum Management Institute.

Joseph Gonzales is the director of the Museum Communication Masters Program at the University of the Arts, current president of the Museum Council of Philadelphia and the Delaware Valley and has worked for numerous museums and cultural organizations over the past 20 years. He earned his Ph.D. in Anthropology

from Temple University in 2008 for his dissertation, *Complicated Business: Chicanos, Museums, and Corporate Sponsorship,* and has served on many museum advisory committees.

Phyllis Hecht is director of the online graduate program in Museum Studies at Johns Hopkins University. Prior to coming to Hopkins, Phyllis was at the National Gallery of Art, Washington, and has more than 25 years of museum work experience. She currently serves as chair of the AAM Professional Network Committee on Museum Professional Training (COMPT) and was previously on the board of the AAM Media and Technology Professional Network Committee (M&T). Phyllis co-edited and contributed to *The Digital Museum: A Think Guide* (AAM, 2008) an anthology on museums and technology.

Nik Honeysett is head of administration for the J. Paul Getty Museum in Los Angeles, overseeing personnel and administrative services across the Getty's two sites. He is a former chair of the AAM Media and Technology Professional Network Committee (M&T); a former chair of the AAM Standing Professional Committee Council, and currently sits on the AAM Board of Directors. His hobbies include writing short summary paragraphs about his career and referring to himself in the third person.

Janice Klein has over 25 years of museum experience, including ten as registrar of the Department of Anthropology at The Field Museum, Chicago and eight as the executive director of the Mitchell Museum of the American Indian (Evanston, Ill.). She

currently runs her own consulting company, EightSixSix Consulting, which specializes in collection management and small museum administration. She has served as chair of both the AAM Registrars Professional Network Committee (RC-AAM) and AAM Small Museum Administrators Professional Network Committee (SMAC-AAM), as well as on the American Association for State and Local History's Small Museums Committee. She is central region director of the Museum Association of Arizona.

Amanda Kodeck is manager of school programs at the Walters Art Museum, where she oversees all of the museum's K-12 programming. Ms. Kodeck frequently presents and writes on topics relating to the next generation of museum leadership. She holds a MA in Art History from The George Washington University and a MS in Education, Museum Leadership from Bank Street College. She completed the Getty Leadership Institute's training program, Museum Leaders: The Next Generation and is the 2012 National Art Education Association's Museum Educator of the Year for the Mid-Atlantic Region.

Nicole Krom received her MA in Museum Studies from the University of the Arts, Philadelphia, Pennsylvania. She is currently the manager of visitor services and facility rentals at the Fleisher Art Memorial. She has previously worked with the Shofuso: Japanese Gardens, Mayor's Office of Cultural Affairs in Wilmington, Delaware, and the Chester County Historical Society. Nicole also serves as the marketing chair for the Museum Council of Philadelphia and tutor for the Delaware County Literacy Council.

Maggie Limehouse joined the Smithsonian as assistant manager of the African Art Museum Shop and later became the museum shop's general manager. Maggie was drawn into personnel work by a long-time federal personnel specialist who developed the Smithsonian's formal trust personnel policy. As a personnel specialist and then labor/employee relations specialist in the central Smithsonian Office of Human Resources, she worked with a variety of Smithsonian organizations before coming to the American History Museum as personnel manager.

Kimberley McCray is a doctoral student at Lesley University pursuing a Ph.D. in educational studies. Her areas of interest include adult learning and development and museum public programs. Most recently (from 2007-2011), Kim worked as director of interpretation and education at the Nantucket Historical Association. Prior to that, she spent six years as the public programs coordinator at the Smithsonian Institution National Postal Museum.

Patrick McMahon began his career at the Isabella Stewart Gardner Museum in 1991 and joined the Museum of Fine Arts, Boston in 1999 after holding numerous positions there. Since 2006 he has been the MFA's director of exhibitions and design and is responsible for exhibitions, renovations, and the staff who carry them out. He is a Getty Leadership Institute NextGen alum (2005) and has served as an Institute of Museum and Library Services peer grant reviewer.

Katherine McNamee serves as assistant director of human resources at the American Association of Museums (AAM) in Washington, D.C. Prior to joining AAM in 2005, she worked in the financial industry for 13 years. Katherine is a graduate of Rutgers University and earned her MA in Organizational Management at Trinity University in Washington, D.C. She has held her Professional in Human Resources (PHR) Certification since 2002. She admires the dedication and commitment of her colleagues in the museum field and enjoys helping people find the "right fit" in their organization and career.

Erika Mack-Dillaber has been with the Smithsonian Institution since December 1988 as an HR professional. She is currently the assistant personnel manager at the Smithsonian National Museum of American History in Washington, D.C., providing a wide range of personnel and administrative services to staff and applicants, with an emphasis on recruiting a diverse workforce. Erika lives in Fredericksburg, Va., with her husband John and daughter Mariah.

Elizabeth Maurer is an independent museum professional who specializes in museum project management, interactive programming, and employee/volunteer recruitment and development. Elizabeth regularly researches, writes, and presents on issues related to visitor experience and immersion. Over a 20-year career, she has worked for museums that include the Colonial Williamsburg Foundation, George Washington's Mount Vernon, and the National Museum of Crime and Punishment. Liz draws upon her experiences in both the non-profit and for-profit

sector to share insights into the business of museums.

Amy Rogers Nazarov covers high tech, food and cooking, museums, and adoption from her home in Washington, D.C. Her byline has appeared in *Cooking Light, Washingtonian, The Washington Post, The Writer, Cure, BizTech, The Baltimore Examiner, Media Bistro,* and many other publications in print and online. Before she went freelance, she worked at the Smithsonian Institution and United Business Media in Washington and the Bay Area. Find her blog at www.word-kitchen.net and her Twitter feed @ WordKitchenDC.

Lin Nelson-Mayson is director of the University of Minnesota's Goldstein Museum of Design, part of College of Design and director of the University's museum studies graduate program. She has worked at museums and museum service organizations including ExhibitsUSA, Minnesota Museum of American Art, Columbia Museum of Art (SC), Art Museum of South Texas, and Ross County Historic Society (OH). Lin has been involved professionally with AAM, AAM's Curators and Small Museum Administrators Professional Network Committees, Association of Midwest Museums, Southeastern Museum Conference, Minnesota Association of Museums, South Carolina Museum Association, and South Carolina Abandoned Cultural Properties Board.

Claudia Ocello is president & CEO of Museum Partners Consulting, LLC. Claudia has over 20 years' experience working in museums on education programs,

exhibitions, accessibility issues, and evaluation projects. Her clients include museums, libraries, historical societies, and schools. Claudia co-teaches in the Masters in Museum Professions Program at Seton Hall University and won multiple awards from American Association of Museums and the American Association for State & Local History. Claudia earned an MS in Museum Education from Bank Street College of Education.

Elizabeth S. Peña, Ph.D. is interim chair of the Museum Studies Department at John F. Kennedy University in Berkeley, California and a consultant at the Phoebe A. Hearst Museum of Anthropology at the University of California, Berkeley. She has served as director of the Art Conservation Department at Buffalo State College, State University of New York; curator of anthropology at the Buffalo Museum of Science; and co-director of archaeology at Old Fort Niagara State Historic Site.

Sheetal Prajapati is the associate educator for teen and adult programs at the Museum of Modern Art in New York City. Previously she was the director of educational programs at the Mary and Leigh Block Museum of Art at Northwestern University and also spent three years at the Museum of Contemporary Art in Chicago. Sheetal sits on the board of the AAM Education Professional Network Committee and was appointed to the National Program Committee for the 2012 Annual Meeting. Sheetal is also active in AAM EMP activities and regularly presents career and management development sessions at the AAM annual meeting. She earned her BA at Northwestern University and her MA from the School of the Art Institute of Chicago.

Nathan Richie is director at Golden History Museums in Golden, Colorado. He holds a MA in Museum Studies from John F. Kennedy University and a BA in American History from Colorado State University. Previously, Nathan served as Director of Exhibits and Programs at the McCormick Freedom Museum in Chicago and as Curator of Collections and Programs at the Swope Art Museum in Terre Haute, Indiana. Nathan is the current chair of the AAM Education Professional Network Committee (EdCom). He has been awarded the Association of Midwest Museums' Promising Leadership Award and the Governor's Award for Tomorrow's Leaders.

Laura Roberts works as a consultant with cultural nonprofits on strategic planning, assessment, staff and board training, and organizational development. She teaches at Harvard University Extension, Bank Street College of Education and, previously, the Tufts University Museum Studies program. Laura was the executive director of the New England Museum Association and director of education at three history museums in New England. Laura holds an MBA from Boston University and an MA from the Cooperstown Graduate Program.

David Robertson retired as The Ellen Philips Katz Director of the Mary and Leigh Block Museum of Art at Northwestern University in 2012 after a 30-year career working in academic museums. He is immediate-past president of the Association of Academic Museums and Galleries, and a member of the Association of Art Museum Directors and the American Association of Museums. Dr. Robertson (Ph.D. Pennsylvania) has held museum positions at Northwestern,

Chicago, Oregon, Loyola, Dickinson, Yale, and the Victoria and Albert Museum. He was Fulbright Professor at the University of Munich in 1989-90, and has published widely in the fields of art and museum history.

N. Elizabeth Schlatter serves as deputy director and curator of Exhibitions at the University of Richmond Museums, Virginia. Previously, Elizabeth worked at the Smithsonian Institution Traveling Exhibition Service (SITES) in Washington, D.C. and the Contemporary Arts Museum in Houston, Texas. In addition to articles and reviews in various art and museum publications, she authored *Museum Careers: A Practical Guide for Novices and Students* (Left Coast Press, Inc.) and the on-line publication Become An Art Curator (fabjob.com).

Marsha L. Semmel is director for strategic partnerships at the Institute of Museum and Library Services (IMLS). From 2006 to 2011, she also served as deputy director for the IMLS Office of Museum Services. Ms. Semmel has been president and CEO of the Women of the West Museum and Conner Prairie, director, Division of Public Programs at the National Endowment for the Humanities and a Fellow at the National Endowment for the Arts. She also worked at the Smithsonian Institution, the B'nai B'rith National Jewish Museum in Washington D.C., and The Taft Museum in Cincinnati, Ohio.

Myriam Springuel is principal of Springuel Consulting, bringing 25 years of experience in museum planning, management, exhibitions, education, and staff training. She now facilitates and implements strategic

planning, collections interpretation, and related staff and board training. Previously, as associate director for programs at the Smithsonian Institution Traveling Exhibition Service (SITES), Myriam translated SITES' mission into strategic planning, supervised 30 project directors, and was responsible for 60 exhibitions annually that travel to museums of all sizes and disciplines. Prior to SITES, she curated fine arts exhibitions and developed education programs at the John and Mable Ringling Museum of Art. She holds a MA in Art History from the University of Maryland.

Linda Sweet joined Management Consultants for the Arts, Inc. in 1984, where she specializes in executive search for top management and professional personnel, strategic planning, board development, and organizational analysis. Ms. Sweet began her museum career as an educator at the Brooklyn Museum and was dean of public education at the Museum of Fine Arts, Boston. Linda was a founder of the AAM Education Committee (EdCom), was elected to the Council of the Association and served on the membership committee. Ms. Sweet earned her BA in art history from Barnard College, her master's degree from New York University and a certificate from the Columbia University Graduate School of Business Administration Institute for Not-for-Profit Management.

Lynne Waymon is co-founder of Contacts Count, LLC and internationally known as an expert on career development and networking skills. In keynotes and workshops she gives government, association, university, and corporate audiences practical strategies for networking. The company has seven Certified Trainers in the U.S.,

two in India, and one in Portugal. Lynne is co-author (with Anne Baber) of *Make Your Contacts Count* (2nd Edition, AMACOM). Their Networking Competency Assessment measures skill in networking and is available at www.ContactsCount.com.

Cecilia Wichmann has five years of experience communicating about art museums. Since 2008, her professional home has been at The Phillips Collection in Washington, D.C. As publicity and marketing manager, Cecilia is an advocate for art—a collaborator, storyteller, and risk-taker. Cecilia's undergraduate studies in art history and German at the University of Toronto were punctuated by PR and marketing internships with museums, galleries, and public art projects in Washington, D.C., New York City, and Toronto.

James Yasko has been the director of education at The Hermitage, Home of President Andrew Jackson, since March 2009 after spending the previous three years as the manager of visitor education at the National Baseball Hall of Fame & Museum in Cooperstown, New York. James holds a BA in history from Abilene Christian University and a MA in Museum Studies from the University of Oklahoma.

Index

39 97